15 TO LIFE

HOW I PAINTED MY WAY TO FREEDOM

15 TO LIFE

HOW I PAINTED MY WAY TO FREEDOM

By Anthony Papa
with Jennifer Wynn

Feral House

From the Author

This is a work of nonfiction. The events it describes are real. The life it portrays is mine. Some names have been changed to protect the identity of the innocent and the guilty.

Contents

American Dream, American Tragedy

HE DRANK. I DRANK. He turned to me. "So?" he said. "You wanna make some money or what?" Polinski wasn't much to look at. At six feet tall with a beach ball gut, he was pretty damn ugly in fact. He sported a thin moustache on his pasty mug, which only seemed to collect food crumbs and call attention to his cheap toupee, yet he always had beautiful girls around. I took a swig from my beer. "What do I have to do?"

Polinski smiled.

He told me everything would be arranged. He'd call me on Wednesday and then drop off a package at my garage that day. All I needed to do, he said, was drive it up to Mount Vernon and give it to some of his friends.

"What am I delivering and to whom?"

"If anybody asks you, you're delivering a package to my uncle's hat factory. As for the guys, don't worry about them, they're from the bowling alley."

That's how I'd gotten to know Polinski. We used to gamble in the bowling alleys around Westchester County and the Bronx. Any day of the week, there were different bowling houses you could go to for action: Gunpost Lanes in the Bronx, Yonkers Bowl and Larchmont Lanes in Westchester. You could make a fortune or go broke fast. For me it was part of the American Dream.

Polinski went to the alleys to flash money at the bar and buy drinks for the players. I went to bowl, to bet on other players, or let people bet on me. Some people gamble on horses, but others like to bet on people. For me, it was the same as going to the racetrack, except that I was the horse. I felt powerful standing on the lanes, knowing that the crowd behind me was betting on me, on my game, my skills.

At the time, I was in my late twenties and in great shape. Every day, no matter how bleak life seemed, whether I was hung over, broke or fighting with my wife, I pumped iron in my garage, a big old barbell with a hundred and fifty pounds of weight. And I was a pretty good bowler, though lately I'd been on a bad losing streak. The stress was starting to get to me.

"So what else?" I asked. Polinski continued.

One of his friends owned a towing company in Westchester. He would be waiting for me on Morris Avenue in a tow truck in front of the hat factory owned by Polinski's uncle. All I had to do was to give him the package.

I had a lot of questions: Why not deliver it himself, especially if these guys were his friends? And what was in the package? Drugs? Money? Some guys said that Polinski made his money working with his uncle and father at the hat factory, but I knew there was more to the story. He would have had to sell a lot of hats to afford his flashy lifestyle.

Despite my misgivings, who was I turn down an easy $500? My radio repair business was slow and my gambling had wiped out my bank account. The winter storm that had recently hit didn't help. Just that morning my wife had given me an ultimatum: Either come up with the rent money or she was leaving. The timing was right, even though it meant breaking the law. I was desperate and Polinski picked up on it. I told him I'd do it and left.

By the time Wednesday came around, I was ready to call it off. Truth be told, I was scared. Every time I thought about it, I felt uneasy. When Polinski called me at the garage to confirm the arrangement, I said I was having trouble with my car. It was the truth: the battery was

dead and I couldn't get it started. There was no way I could do the job that night, I told him, breathing a sigh of relief.

"I'm really sorry, Tony," he said. "What's wrong with it? The battery?"

"Yeah."

An ugly silence followed. I could tell he wasn't too happy and suggested he find someone else for the job.

"There's not enough time. They need this tonight. I was counting on you, man. Listen," he said, "here's what we're gonna do. I'll have my guy José Pontes drop off the package. He'll give you a jump. Remember, this is five hundred bucks, easy money. If everything works out, it could become a steady thing. All your problems could be solved."

The words hung in the air: "All your problems could be solved."

"All right," I said, and put down the receiver. While I waited, I kept thinking that something still didn't fit. Why couldn't this José guy just deliver the package himself? I thought about the possibility of getting arrested but figured if Polinski had arranged the plan, it had to be okay. He was older than me and had tons of dough. He might be a slob, but he wasn't stupid.

I'd had a few brushes with the law, but it wasn't as if I had a record. When I was twenty, a buddy and I got busted for smoking a joint in his car. We got off with a slap on the wrist. Five years later, trying to avoid Department of Motor Vehicles rigmarole, I stupidly accepted some license plates from my boss. The plates, I soon discovered, had belonged to a stolen car. Luckily, I was issued a Disorderly Conduct and fined twenty bucks.

Was this going to be another stupid mistake? I wondered. No, this would go smoothly. I was due for a lucky break.

At about 6 p.m., while my wife and daughter were at the grocery store, Polinski's friend knocked on the door. He introduced himself as José Pontes. We shook hands and I let him in. We walked to the kitchen; José looked around suspiciously. "There's no one here," I said. He nodded.

José Pontes struck me as shady from the start. He was of average

height, stocky, with black, slicked-back hair and a thick beard. I thought he was Italian until he started talking. He was Puerto Rican.

He pulled a manila envelope from inside his jacket. "Here's the goods," he said, dropping the envelope on the table.

I picked up the package, a 5" by 7" manila envelope with a square chunk of something inside. "What's this?" I asked.

José looked around and lowered his voice. "Four-and-a-half ounces of cocaine."

I guess I'd known all along that this was going to involve drugs, but when faced with the truth, I panicked. I thought about my wife, Marylou. Yeah, we fought all the time, but I still loved her. Plus, there was our six-year-old daughter, Stephanie. Why risk all this? Was it the adrenaline rush that was drawing me in? The same thrill I got when I gambled? Something wasn't right. "So about this job …" I started.

"Forget it," Pontes said, and then reached into his jacket. I froze, thinking it might be a gun. Instead, he pulled out five $100 bills and slapped them in my hand.

Immediately I was back in.

"Now … you know these guys, right?" Pontes asked. I frowned. Polinski had said that the guys bowled in the league. "I know them from the bowling alley," I answered.

Again, a wave of panic rushed through me. I told José that my car battery was dead, that I'd told Polinski that earlier. He nodded like I was pulling his leg. He got up, grabbed the envelope and tossed it to me. I caught it and placed it in my jacket.

"Come on," he said. "I'll give you a jump." After fifteen minutes, we gave up. My car wouldn't start. "Sorry about this," I said, trying to sound regretful. "Better call Polinski and tell him to deliver it himself."

José looked at me. "Listen, if you're worried about the car," he said, gesturing to his own car, a brand new Riviera parked across the street, "I'm going that way myself. I'll give you a lift."

"Can you drop me off at Yonkers Bowl after the … the deal?" I asked. "I have to bowl in the league tonight."

"Sure, no problem." He slapped me on the back. "Let's go."

"Just a minute, I'll be right back." It was freezing outside and I wanted to get my red cap.

I could feel Pontes' eyes on me as I walked back to the apartment. Inside, my wife and daughter had returned from the store. They were sitting in front of the Christmas tree we hadn't bothered to take down from the holidays a month back.

My wife turned and looked at me. "You're going out again?"

"I'll be back later," I said, wondering if she could detect the nervousness in my voice.

"Don't forget we have to give the landlord some money tonight."

I went into the kitchen and put the money José had given me on the table. "It's in the kitchen," I said, and left.

Mount Vernon was a twenty-minute ride over the Bronx border. On the way, José pulled over and asked for the envelope. I handed it to him and he opened the seal.

"Like gold," he said, removing the block of coke from a plastic bag. Light from a street lamp overhead made the slab glitter. I looked around to see if anyone was on the road, but the area was desolate.

"Fuck it," José said, breaking off a piece of cocaine and placing it on the dashboard. "Let's get high on Polinski's customer." He laughed and switched on the radio. He re-wrapped the slab, slid it back into the envelope and placed it under the seat. "He'll never miss it." He reached into his jacket and pulled out what looked to be a pillbox.

"A grinder," he explained. He opened the lid, put the rock on the screen, and then cranked the miniature handle. The coke broke down into a small pile of fine powder. With a credit card, he cut the coke into two six-inch lines. He took out a silver straw and snorted.

"Your turn," he said, passing me the straw. It took me five or six tries to snort my line. It burned my nose and made my eyes water. Laughing at my reaction, José popped in a Latin tape, turned up the volume to a deafening level, and pulled away.

José was flying, but the coke had the opposite effect on me. I started to freak out. I'd never really messed with cocaine. My mind raced with

thoughts of the deal. What if it went bad? I mean, I didn't really know what I was getting into. I thought about my daughter, my wife... *This is crazy*, my subconscious screamed.

José must've seen the expression on my face because he lowered the volume. "Look, don't worry about nothing," he said. "Everything's gonna be all right, pal."

He took a wrong turn. We were forty minutes late by the time we got to the hat factory in a desolate industrial area. It was so dark I could barely make out the factory at the end of an unlit street. About sixty yards down, just as Polinski said, a tow truck was parked in front of the factory. José pulled over, grabbed the envelope from under the seat and handed it to me. "I'll wait here," he said.

I thought I was going to puke. The coke was starting to drip down the back of my throat and I was paralyzed with what-if's. What if I get shot? What if the cops come?

"Put a move on it, bro," he said.

"Who's that?" I shouted. A figure suddenly emerged from the front door of the factory and walked toward the tow truck. He approached the driver's side, stood there for a few moments, then turned and headed our way. It was Polinski. "What's he doing here?"

José shrugged.

Polinski walked to my side of the car and leaned toward the window. He motioned to me to roll it down.

"Everything's set," he said. His eyes were bloodshot; his high forehead glistened with sweat. He looked just as wasted as José.

I didn't get it. Why was he here? And why should I deliver the goods if he was here, himself? I looked at José, who didn't say anything. I looked back at the tow truck.

"The guys in the tow truck are cool," Polinski said. He sounded like he was trying to assure not only me but himself. He wiped the sweat off his brow with the back of his glove. It was freezing outside and he was sweating.

"Polinski..." I started. "I don't get it. If you're here, then..."

He waved at the air. "Listen, I didn't think I'd be able to make it. My plans fell through."

As if that explains everything, I thought. I took the envelope out of my jacket and tried to hand it to him.

"No," he said sharply, and stepped back. "Don't give it to me." Then he smiled like a used car salesman. "We already made our plan, let's stick to it." He told me to walk with him to the tow truck and give the envelope to the driver. He'd take care of the rest, he said.

As I walked away with Polinski, José rolled down the window and told me not to forget "to count the goddamn *dinero.*" I nodded and kept walking. My legs were shaking. I didn't know whether it was from the coke, the fear, or both.

The inside of the truck was dark, but I could make out two figures in the front seat, both of them white men, maybe in their thirties. When we reached the truck, the door on the passenger side swung open. I looked at Polinski. He motioned toward the open door. I headed around the truck as Polinski moved toward the driver's side.

"José?" one of the guys inside asked me. He had broad shoulders and an ugly, pockmarked mug.

"Ah, no, I'm Tony," I said, thinking I should tell him that José was in the car.

He stared at me briefly, and then turned to the driver. They looked at each other without saying anything. Something wasn't right.

The passenger turned back to me, nodded and then opened the glove compartment. My eyes were glued to his hand ... I envisioned him pulling out a gun. I started to think they were gonna rip us off, kill us, who knew?

But instead of a gun, he pulled out a stack of cash fastened with a red rubber band. He handed it to me and asked if I wanted to count it.

"No," I said, remembering José's last words. I'm getting the fuck out of here, I thought.

"Seventy-five hundred," he said. "It's all there."

Seventy-five hundred? My head was spinning. We weren't talking about chump change. "Whaddya got for me?" he asked.

My body felt like lead, but I reached into my jacket and pulled out the envelope. I prayed. *God, if I get through this, I'll never put myself into*

a position like this again. Shakily, I passed him the envelope. He snatched it from my hand and dumped the contents into his lap. He held up the block of coke and began to unwrap it.

What if he notices the piece Pontes broke off? What if he pulls out a gun? Shit, shit, shit! My heart was pounding so hard it felt like I was being punched. He raised the slab to his face and inhaled deeply. If he noticed anything missing, he didn't say.

"Wow, this is some good coke," he said. He turned to the driver, who nodded in approval.

My job was done. When I turned to walk away, he reached toward the dashboard. With a twist of his wrist, he flipped on a switch that activated the overhead lights on the truck. The lights blinded me. I took a step backward and almost tripped. Suddenly, both men leapt out of the truck. I turned to run but before I could even take a step, I felt the cold barrel of a gun in my left ear.

"Freeze!" a voice shouted. And then, sure enough: "Police! Don't move, motherfucker! You're under arrest."

CHAPTER 2

Nightmare of Justice

SUDDENLY, A DOZEN COPS EMERGED from the shadows and surrounded the truck. "Move out with your hands above your head!" one of them shouted. At the other end of the street, three cops were pulling Polinski off a fence that he was trying to scale. I was in shock. I thought of my wife and daughter. I thought of jail.

The passenger in the tow truck stepped out and opened his jacket. He stuck his chest in my face and forced me to look at his badge— Detective Yasinski, it read.

"You have the right to remain silent," he said.

Please God, let this be a dream.

"Anything you say can and will be used ..."

Let me wake up.

"Against you in a court of law. You have the right ..."

Find myself at home with Marylou.

"To speak to an attorney before answering any questions."

I promise I'll treat her right. I'll work harder. I'll take better care of her and Stephanie.

"You have the right to have your attorney present during questioning."

Oh, God! Stephanie, it's almost her birthday.

"If you can't afford an attorney, a lawyer will be appointed to you."

What am I gonna do?

A flash of pain ripped through my shoulder as a cop wrenched my arms behind my back. I felt the cold metal of handcuffs. "Did you hear me, motherfucker?" he shouted.

"Y-yes," I stammered.

"Let's go," he shouted, pulling me by my arms. I winced in pain as he growled in my ear, "We're going for a ride."

There were more than enough police cars to transport me, Polinski and Pontes separately to the Mount Vernon police station. "You're in deep trouble," Yasinski said once we got in the car. He turned to the driver, his partner, Detective William Maher.

"Yeah," Maher said, shaking his head in disgust as he glanced at me through the rearview mirror.

"Guess you know you should cooperate," Yasinski said.

I stayed silent.

"You could go to prison for the rest of your life."

"That's right," Maher added. They were trying to scare the hell out of me. I'll get out of this, I kept telling myself. I have to.

At the station, I was stripped of my property, keys, wallet, whatever I had in my pockets, then fingerprinted and photographed. The whole time, Yasinski kept warning me that I'd better cooperate, telling me how prison would ruin my life. "You know you're facing a long prison bid," he said. "New York has the toughest drug laws in the country."

I didn't know then about New York's draconian drug laws, and I really didn't care. I kept thinking I'd get out of it. Of course I'd get off. I didn't have anything to do with Polinski's operation.

Yasinski led me upstairs and opened the door to an office. A sign on the door said LIEUTENANT RIVERA. Yasinski left and Rivera motioned to me to sit while he fixed himself a cup of coffee.

"Coffee?" he asked.

"A glass of water, thanks," I said. My throat was burning.

"You don't need me to tell you the trouble you're in."

"No, sir."

"Do you have a family, Mr. Papa?"

"Yeah."

"Wife? Children?"

"Yeah."

"I see," he said. Unlike the other cops, Lieutenant Rivera spoke to me decently. "You can make it a lot easier on yourself if you cooperate, Mr. Papa." He sipped his coffee and waited for me to respond. I said nothing. He leaned back in his chair and pulled out a pack of cigarettes.

"Smoke?"

"No, thanks," I shook my head.

"We have information that you're Mr. Polinski's main connection."

"What?" I was stunned.

He gave me a sympathetic look. "Doesn't ring a bell, huh? Polinski's drug ring? The operation he runs in the bowling alleys throughout Westchester County?"

"It's not true," I said. I shook my head in disbelief. I wanted to tell Rivera he had it all wrong, that I was nothing but a sap who'd got caught up in something I knew nothing about. But I had a feeling he wasn't going to listen.

"Make it easy on yourself, Mr. Papa," he said in a conciliatory tone. "Just give up the supplier."

"I don't know what you're talking about. I really don't know anything."

"All we want is the name of the supplier." His tone remained calm. "We just want to know who is supplying the drugs."

"I don't know anything about the drugs," I said.

"Just tell us, Mr. Papa. Tell us where the stash is and we'll let you off easy."

"I want a lawyer."

With that, he turned. The good cop role was over. Now he would resort to threats. "You know you're looking at fifteen years to life under the Rockefeller Drug Laws," he said.

My stomach became queasy. I started to sweat.

"You're dealing with a dangerous crew … but no matter how dangerous they may be, they're nothing compared to what you'll come up against in prison."

I sat there grinding my teeth. "It's a lie ... I'm not ... it's not true," I sputtered, my words rushing out so fast I couldn't string a sentence together.

"The choice is yours," he shrugged. "Cooperate or go to prison."

"I want an attorney."

He continued interrogating me, relentless as a pit bull, but I refused to give him anything except a few grunts. In disgust, the Lieutenant called for Detective Yasinski.

"So is he gonna cooperate?" Yasinski asked.

"Afraid not."

"Damn shame," Yasinski said, shaking his head.

"Get him out of my sight," Rivera responded.

Detective Yasinski led me down a flight of stairs and shoved me into a holding cell. Before he left, he shook his head and mumbled something I couldn't make out. I sat on the old wooden bench in the dingy cell, closed my eyes and held my head in my hands. My mind went blank. And then I heard a familiar voice from across the corridor.

"Hey."

It was José Pontes in the holding pen opposite me. He rose and walked to the bars. "You say anything?"

I was thankful there were bars between us. I could have killed him. My fists clenched and I felt a surge of adrenaline pump through my veins. I glared at him and said nothing.

"You better not say anything," he warned. "Remember—you got a wife and kid out there. You better be fucking quiet. You hear me?"

My throat tightened and I sat back down. Pontes sneered and turned away.

I was in the holding pen for about fifteen minutes before they took me away again. I figured they just wanted to see how I'd interact with Pontes; they were probably watching the encounter through a one-way mirror or videotaping the whole thing for all I knew. I was taken to a cellblock in a damp, dark basement of the precinct house. Before taking me to a cell, the cops made me remove the laces from my shoes. They also took my belt.

"Cold in here, huh?" The voice belonged to a black kid in the next cell. He motioned to an open window high on the opposite wall.

"Why did they take my shoelaces and belt?" I asked. He looked at me like I was stupid. "So you don't hang up, man."

The thought of killing myself hadn't occurred to me, but after a few hours in the cell, it did. My worst fears had materialized; the kid next to me wouldn't shut up. He recounted story after story about prison life, all kinds of crazy stuff that went on inside the joint: killings, rapes, gang fights, beat downs by guards, or "tune-ups," as they're called. Shivering in the freezing cell as the kid filled me with prison horror stories, I was at the lowest point of my life.

"Hold up," I said, interrupting his monologue. "Aren't they supposed to give me a lawyer?"

"They're supposed to do a lot of things, but they don't."

I imagined that included the one telephone call prisoners always get in the movies, which I wouldn't receive until hours later. A few minutes later, a beefy guard shuffled down the cellblock with dinner: a piece of bologna between two slices of dry white bread and coffee as black and thick as motor oil. He told us we'd be shipped off to the county jail in the morning.

I curled up on the bench and tried to sleep. *Just shut your eyes. Stop thinking. Just sleep, count fucking sheep, stop thinking.* It's gonna be okay, I told myself. *You're gonna wake up and realize it was all a bad dream.*

"Papa," a male voice shouted. "Rise and shine. Maybe you wanna use the phone before we haul your ass outta here?" The voice belonged to the guard; my stiff back and the cold sweat on my face told me I hadn't been dreaming. It was a real life nightmare and I was in trouble. I called Marylou.

She was frantic. She'd been up all night worrying when I hadn't come home. I rushed through the chain of events as quickly as possible, fearing we'd get cut off before I could tell her that I needed a lawyer as quickly as possible. But she kept interrupting me, questioning me, asking me how I could be so stupid and when was I coming home. I held my breath so I wouldn't shout at her.

"I'm not coming home, Marylou. They're taking me to Valhalla County Jail."

"Oh my god …"

"Honey, please. Listen to me. I need a lawyer. You have to find me a lawyer. Immediately. This is serious. Do what you can, please."

They handcuffed and shackled about ten of us together and marched us onto a bus. It looked like a school bus but there was wire over the windows and a gate with bars separating us from the driver. When we arrived at the jail, a guard told us to shut up, although no one was talking, and to "sit tight," as if we could do anything but. From the grimy window, I gazed at the next destination stop on my journey through hell: a low-lying brick building with the words Valhalla County Jail in stark, bold letters.

"Holy shit!" I shouted. A few of the others turned to look at me. Is that Polinski? It was. He was walking out of the front door; with him was a guy in a suit. His lawyer, I figured. The fucker made bail and was going home. Already? Wait a minute, I thought; maybe this was a good thing. Maybe the judge would release me that quickly, too. I felt a surge of hope.

"Everyone off!" the guard yelled. He unlocked the gate and marched us into the building for processing. They ran me through the machine again: fingerprints, mug shots, and another body search. Processing took most of the day. I spent hours sitting and pacing in a tiny holding cell with a dozen other prisoners. The bullpen stunk of human sweat and the stench from a filthy toilet bowl in the corner. I sat on the wooden bench that was bolted to the floor; the guy next to me started telling me about his case and then asked me about mine. Before I could answer, a Latino at the other end of the bench snapped his head up. "Yo, don't tell that motherfucker nothin'. He's a rat."

The guy who'd been talking looked the other way and shut up.

"Yeah, you better be quiet," said the Latino, getting up and squeezing in next to me. "This your first time in jail?"

"Yeah."

"Thought so," he said. "One thing you need to know is, never tell anyone nothin' about your case. Rats like him," he pointed to the guy,

"will give information to the DA in a heartbeat. He'll try to knock some time off his sentence by giving you up. I remember him from my last bid. Man's a low-life snitch. He'd give up his own mother for a deal."

"Thanks, man," I said. He told me his name was Blackie, that he was a three-time loser in on a burglary charge. I hung around him for the rest of the day until another guy pulled me aside.

"Watch out for him, man," he whispered. "It's not about friendship. Blackie wants to hustle you for money." I shook my head in disgust. I couldn't trust anyone.

The next day I was arraigned, even though I still didn't have a lawyer. Naturally, Polinski was nowhere in the courtroom, but Pontes was there with a lawyer. When he saw that I didn't have counsel, he asked his lawyer to speak for me at the arraignment. Even if I'd had the chance to thank him, I wouldn't have. I knew he was just looking out for himself.

The judge set bail: Pontes' was set at $25,000, and my bail, incredulously, was set at $250,000—a quarter of a million dollars. The figure was absurd. I could barely pay my rent.

A few days later, Marylou told me she found a lawyer.

"Who is he?" I asked.

"A guy by the name of Mike DiNoulis. He said he'd meet you in court tomorrow morning." This was part two of the arraignment process, when the District Attorney would submit preliminary legal motions.

The next morning, Mr. DiNoulis met me in the bullpen at county court. We shook hands and I started to tell him about my case. He held up his hand, cutting me off midstream. "I'll need ten thousand to represent you," he said.

My jaw dropped. "My wife, didn't she…?"

"Your wife's check for fifteen hundred dollars barely covers my retainer fee, Mr. Papa."

"Ten thousand?"

"That is correct." He sat back in his chair and shrugged. "You're looking at fifteen years to life, my friend."

"Can you get me out of this?"

"I don't know. But I might be able to get you a good deal. Maybe cut your sentence in half, if we're lucky."

"You must be joking. You're gonna charge me $10,000 and I'm still going to prison?"

"That's the way the system works."

I didn't like him and I didn't trust him. I was sure he was lying and told him I'd talk to him the next day. That night I called Marylou. "I don't want this lawyer. Put a stop on the check and please, find me someone else."

While Valhalla County Jail isn't known for any notorious riots, uprisings or other jail scandals, it's no country club for the 1,400 inmates it houses. Some of the inmates, known as "state readies," have been sentenced to prison and are awaiting transfer. They're housed in maximum-security cellblocks and locked down twenty-three hours a day, save for an hour of court-mandated recreation in an empty outdoor cage. The other part of Valhalla, large dormitories lined with hundreds of cots like army barracks, housed detainees like myself, individuals who have been arrested but not yet convicted of a crime and can't afford bail. Mixed in are people who've been sentenced to a year or less for misdemeanors. Essentially, Valhalla is a melting pot of hustlers, junkies and career criminals.

Because it's a jail for short-term inmates, rather than a state prison where people are serving long sentences, Valhalla, like most jails, has no programs or work details to keep the inmates occupied. A dorm with one hundred idle men, angry, detoxing, and disoriented, makes for a dangerous environment. You can count on seeing a fight nearly every day, and usually for the pettiest of reasons. A guy can get his head bashed in because he looked at another guy the wrong way, or because somebody stole his soap.

Despite the hostile atmosphere, most of the prisoners were not there for violent crimes. Many of them were drug addicts. I was there less than an hour when a white guy, a heroin addict, gave me a piece of advice. "Make believe you got a habit and they'll let you get high," he said.

"No thanks, I don't mess with drugs."

His droopy eyes lit up. "Yeah? Then how about gettin' me some meth then, huh? Tell 'em you got a habit, and give me the stuff."

I wasn't sure what he was talking about, but I learned soon enough. To keep the junkies sedated, the jail gives them methadone, a synthetic form of heroin used for detoxification. It can ease painful withdrawal symptoms and block the craving for heroin. However, unless the dosages are carefully controlled and monitored, a person is likely to get just as high from the methadone as from heroin, and this goes a long way in beating the jailhouse blues. So most guys just say they are addicts and score their drugs legally from the jail clinic, where nurses hand out methadone "biscuits" like homemade cookies. The guards have a vested interest in the methadone program, because it makes their jobs easier. Prisoners on methadone are submissive and easier to control. It was wild seeing them stumbling around the dorm, dazed and glassy-eyed.

In addition to the large contingent of junkies, the other sizeable group was comprised of chronic skid bidders, petty thieves and assorted marginalized individuals from the fringes of society who cycle in out of jail every six months when they need a rest, food, shelter or health care. Society's rabble.

I also learned that there was a hierarchy in jail based on one's crime, or "jacket" as it's called. Drug dealers stood at the top of the hierarchy and commanded the most respect. For the first time since my arrest, I was glad to be known as a drug dealer. Word travels fast behind bars, and it didn't take long for most of the guys in my dorm to learn what I was in for. And like most information in jail, it gets distorted.

Rumor had it that I was a kingpin caught in a major bust. All the loafers came by, trying to get on my good side, hanging out longer than they should have. But I'd learned my lesson in the bullpen: trust no one, especially guys who want to hook up with you. They were looking to make a connection on the streets when they get out. The jail was like a convention for local criminals.

I remember one guy, a black dude, who asked if he could work for me when he got out. "Heard you from moneymaking Mount Vernon," he said. "I can push a lot of drugs in that town." I nodded and didn't

say much of anything but decided to play the role. He gave me his number; I added it to the rest of numbers I eventually threw out.

Wearing the drug jacket helped keep me safe. That and a large jagged scar on my forehead from a car accident several years before. My wife always said it made me look mean. But neither the scar nor the false reputation would protect me from being tried.

I was on my way back to the dorm one day when Jerry, one of the few guys I spoke to, caught me in the hallway and pulled me aside. "Check out your bed," he said. I walked cautiously into the dorm and looked in the direction of my cot. A muscular black dude was lying naked on top of it, slowly masturbating.

"What the hell…?"

Jerry pulled me away. "It's Primo, the booty bandit," he said. "You let him get away with that, and he'll be fucking you before you know it. Trust me. I've seen it happen before. He does this to new guys."

"So what am I supposed to do?"

"Come with me …"

Jerry led me to his cell. Because he was a trustee, an inmate with special status, the administration gave him his own cell with a key. He was a good man to know. He shut the door and peered quickly over his shoulder to make sure no guards around were around. Then he lifted his mattress and removed a shank: a five-inch piece of metal with a sharpened edge.

"No man, I don't want to stab nobody."

"Yeah, yeah," he said. "I hear ya. But you gotta do something. How about this?" He grabbed a dirty sock off the floor and two cans of tuna from the windowsill. Stuffing the sock like a Christmas stocking, he wrapped the open end around his hand and swung. "Try it," he said, and whacked the bed with a deadening thud.

"Jesus," I said.

"Listen, if you don't do something," he said, "that guy's gonna fuck you. And if you get fucked by him, it'll be open season for the others. You'll be looking to *him* for protection."

ANTHONY PAPA

I grabbed the sock from his hands and headed for the dorm. Primo, finished stroking himself, lay sprawled across my bed, a heap of charcoal flesh. I charged him, but then stopped in my tracks, more out of shock than fear. A wide grin wrapped around his face. He licked his lips, turned onto his side and wiped his dick on my blanket. "I want your ass," he said.

Without thinking and with no regard for the consequences, I swung. Two cans of tuna connected with his skull in a sickening whack. His head opened up and blood oozed out. He screamed and stumbled off the bed, holding his bleeding head in his hands.

"You come near me again, motherfucker," I shouted at his naked backside, "I'll kill you."

I dropped the weapon and tore the soiled blanket off the bed. I was disgusted at him, at myself, at the entire hellhole of Valhalla County Jail. I was surprised at how easy it'd been to seriously hurt another human being. I started to panic. What if the guards found out? What if he charged me with assault?

He didn't. Nor did he ever come back.

It was a rough time for Marylou. She had no money and the bills were piling up. I felt like a failure not being able to provide for my family. Christ, I could barely take care of myself.

Apparently, José Pontes got out on bail shortly after arraignment. I knew this because he paid Marylou a visit. He gave her a measly three hundred bucks to help her out, he said. But I knew the real reason he went to our house. He was sending me a message: I remember where you live.

Marylou continued searching for a lawyer. Through one of her girlfriends, she found a former assistant district attorney from Queens, Brent Blackbird. He agreed to take my case after she wrote him a check for five thousand dollars. And that was only to retain him. This time, my sister Angela came through and loaned us the money.

A legal visit was arranged in the conference room of the law library in the jail. A guard escorted Blackbird into the room, but before I could even introduce myself or shake his hand, he put a finger to his lips.

"Sshh," he said. "Don't say a word." He placed his briefcase on the table and got on his knees, running his hands along the legs and bottom of the table. He nodded and then checked the corners of the room. Confident the room wasn't wiretapped, he sat back down. "You can never be too careful," he said.

I figured he knew what he was doing; either that or he was a nut. When he said he was a former assistant district attorney with fifteen years of trying drug cases, I started to relax. In fact, as I listened to him speak, his confident, smooth tone lulled me into thinking that he was going to save me.

"Tell me about the facts," he said.

I told him everything from the beginning, from the night I'd met Polinski at the bar.

"That's it?" he asked when I finished. "Sure you didn't omit anything? We'll both be better off if you tell me the full extent of your involvement." I reassured him that my only involvement was taking the envelope to Mount Vernon and handing it to a guy in a truck. He was a seasoned prosecutor, but the case seemed to surprise even him.

"That's the whole story," I said.

Brent removed a newspaper clipping from his briefcase and spread it out on the table. "MOUNT VERNON DRUG BUST" shouted the front-cover headline. According to the Westchester Gazette, the arrest was the second biggest bust in the history of Mount Vernon. Cops seized a quarter of a million dollars of drugs, and I was the alleged ringleader. He said that cops have a habit of elevating drug cases and trumping up the charges to make themselves look like heroes. The fact that Westchester County was one of the state's most prestigious and pristine communities, which I was purportedly poisoning with drugs, didn't help. And regardless of the minor role I played, he said, I was the one the cops accused. The charges may be false, but I was still charged and facing hard time.

"It makes no difference to the state whether it's four ounces or four kilos," he added. "Fifteen years to life is the sentence. You can thank Governor Nelson Rockefeller for that." New York's Rockefeller Drug Laws, he said, were the toughest drug laws in the country.

My heart pounded wildly as the words "fifteen years to life" raced through my mind like a tickertape I couldn't stop.

"Is there any possibility of getting out of this?" I asked, unable to repress the desperation in my voice.

"For now, let's just concentrate on reducing your bail and getting you out of here," Brent said. He gave me his card and told me to call him the next day.

Nearly a month passed before he was able to secure a date on the judge's calendar for a bail reduction hearing. When we walked into the courtroom, the judge didn't seem to notice us. He was leaning back in his chair, feet outstretched on the massive desk in front of him, reading a newspaper.

Brent spoke very well. He told the judge that I was a first-time offender, that I had a family to support and that the charges were grossly exaggerated. The whole time, the judge continued flipping through the newspaper, scanning the pages before turning them with an audible swipe. It dawned on me that every encounter I'd had with the criminal justice system was even worse than what was shown on TV.

After a while, the judge put down his newspaper and nodded when Brent made the motion for a bail reduction. Immediately, the assistant district attorney protested, saying that I was a violent criminal, part of a massive drug ring that operated in the bowling alleys of Westchester County, emphasizing that the bust was the second biggest in Mount Vernon's history. "It's all here, your honor," he said, placing a copy of the newspaper on top of the judge's reading material.

"How much was found?" the judge asked. "Ten kilos? Twenty?"

Brent answered before the prosecutor could speak. "Four-and-a-half ounces, your honor."

"Four-and-a-half ounces?" the judge repeated, raising his eyebrows and squinting. He turned to the prosecutor for a response.

"The police, ah, somewhat exaggerated, your honor."

The judge shook his head and declared a recess.

About fifteen minutes later, the judge emerged from his chambers. "Bail is reduced from $250,000 to $10,000."

It was a victory, of sorts. Brent had done his job, but I had no idea how I was going to come up with ten grand. At this point, my wife became as important to my freedom as my attorney. Gone were the stupid arguments, the tension and bitterness that had eaten away years of our marriage. For the first time in a long time, I felt close to her again. Marylou went all out for me, asking friends and family members for the money to get me released. In the end, my Uncle Frank came through, putting up most of the cash.

And so, after thirty-three days in the snake pit of Valhalla County Jail, I was released on bail and went home.

Searching for an Answer

THE EXPERIENCE OF SITTING IN A JAIL CELL for a month was enough to cure me of any criminal tendencies I might have had. I wasn't an angel, but I wasn't a bad guy either. I grew up in the South Bronx in the early sixties. My father split soon after my birth. My mother moved in with her brother, Frank, and her mother, Angelina. My mom worked as a meat wrapper in a supermarket, where she got me a job when I was sixteen. We lived in a two-bedroom railroad flat in an Italian neighborhood where crime was part of the culture. The neighborhood was full of cheesecake mobsters who ran numbers and gambling spots. Around the corner from Johnny Boy's candy store was a scrap metal store that was once a hangout for Legs Diamond, the notorious gangster during Prohibition. It was actually the grandmother of my best friend Vinny who showed us how to gamble and instructed us in the ways of the streets. In our early teens, we gambled more than we played baseball. If we raised her in a game of poker, she'd look at us with contempt in her black eyes and curse in her mangled English, "You should desire your mother!" She was a tough old gal.

Despite the exposure to a criminal lifestyle, I grew up to be a good kid, and I respected the law, thanks to my grandmother. Angelina kept me in line with constant browbeating and the occasional belt beating. How could I have gotten into this mess? I'd had a few run-ins with the law before, but nothing serious. I swore to God I would never do wrong again if he would help me through this.

Knowing that I was facing imprisonment made returning to normal life a struggle. The idea of losing my freedom haunted me every day, even in my sleep. I had depleted my bank account and was working fourteen-hour days to try and catch up with the bills. It wasn't long before I started drinking heavily. My relationship with my wife suffered, and my life began falling apart.

My attorney said it could be a year before a trial date was set. Our next move depended on what sort of deal the DA's office was going to offer, if any. They were playing hardball. Their current position was that I plead guilty to a fifteen-year-to-life sentence. I couldn't believe it. I didn't kill anyone. How could I face so much time for a first offense? To me, it was a death sentence, plain and simple. I pleaded with Brent to get a better offer from the DA. In the meantime, I went on with my life as best as I could. I started going to church and praying to God to help me out on this one. Much as I tried to push things out of my mind and stay focused on the present, I knew I would eventually have to deal with the situation. The waiting was agony.

It was nine months after my arrest when I got a phone call from my attorney. "I just got through talking to the District Attorney's office," he said. "They want to make a deal." His voice sounded hopeful. For a second, I thought the scales of justice had tipped in my favor and things might just work out. "They're offering you three years to life … if you cooperate."

"Cooperate? What's that supposed to mean?"

"And plead guilty," he finished.

"What are you talking about? Plead guilty? Cooperate?"

"They'll give you a break if you give them information, leads on various drug operations."

"But I don't know anything," I said. "You know that. How can I tell them things I don't know?" I felt angry. The cheerfulness quickly left Brent's voice. Did he think I'd be happy about this?

"Listen, this is how the system works, Tony. Believe me, I know. I was an assistant DA in Queens for ten years. If you agree to help them, they'll cut a deal and you'll get a reduced sentence."

"They want me to make something up?" I asked. "I can't do that. You remember what I told you about Pontes threatening my family? He said he's connected with the Colombians. And you know these guys. They kill first and ask questions later." I was heated.

"Calm down, Tony."

"Easy for you to say. You're not going to prison."

Brent said he'd try to salvage the DA's offer and tell them I didn't have any information to trade. "I'll call them back tomorrow," he said, "I'll tell them that you somehow got involved in something you knew nothing about. They could go for it," he said, "but even so, you'll still have to plead guilty."

I started to protest again, but Brent cut me off. "Listen to me!" he shouted.

"Why? You're telling me to go to prison!"

"Take the deal, Tony. You got to take the deal," he said.

"How is three years to life a deal?"

"It's better than fifteen years. Which is what you're gonna get if you go to trial."

"But ..."

"If you go to trial, it's a whole different ball game. Fifteen years, your life will be over. But three years? You do the time, go to prison, and maybe get early release if you're good. You'll be out before you know it."

Prison—the thought of it, the reality of it—made me dizzy. I was near tears. "What about my wife and daughter, how are they going to survive without me?"

"I understand, but you'll get out in a couple of years and still have your life. You can't win in Westchester County," he said. "The county's conviction rate is 98 percent, they treat drug dealers worse than murderers."

I told Brent I'd have to think about it. He said I didn't have much time; we were scheduled to see the judge in a week.

In a panic, I started asking everyone I knew if they thought I'd really have to do the time. Naturally, everyone told me what I wanted to hear: they couldn't lock me up that long for such a small amount of

drugs. I decide to go see Sam, a local bookie who ran numbers out of the corner candy store. Sam was a middle-aged Italian from the old neighborhood who'd spent a lot of time in prison. I went in for a newspaper, advice and to play my lucky number.

"Sam, you think they're actually going to give me fifteen-to-life?"

"Nah, you'll never go away for that amount of time. I know plenty of gangsters who murdered people and never did half that time. It was a small amount you got picked up on, right?"

"Yeah, four-and a-half ounces of cocaine."

"That's no weight at all," he said. "If it were kilos then you might have a problem."

I asked if he thought my lawyer was doing his job.

"The guy's no good if that's the best he can do." he said. "But don't worry about nothing, just wait it out and things will go your way. It's all a waiting game with the system. Believe me, I've been there."

Sam told me what I wanted to hear, same as everyone else. "No way you're gonna get that much time. They'll make a better offer."

But they didn't.

I went in to see Brent a week later to see if anything had changed. It was a wasted trip.

"They won't budge," Brent said apologetically.

"Did you tell them I don't know anything?"

Brent nodded. "Take the deal, Tony. It's your best bet."

Everyone told me to get another lawyer. It seemed the obvious choice. I guess if I had a lot of money, hiring a new lawyer would've been an option. But I was flat broke and my relatives had already laid out ten thousand dollars for bail and five grand for Brent's retainer fee. I couldn't go looking for a new attorney at this stage of the game, or could I?

Fate is a funny thing. Before I could find a new attorney, a new attorney found me.

One week after Brent's phone call, an Oldsmobile pulled up to the garage. As it inched up the driveway, I noticed that the tires were nearly flat. When the window on the driver's side rolled down, I could see why. Inside were two of the most obese human beings I'd ever seen. A

pungent body odor emerged from the open window. I took a step back.

The passengers introduced themselves as Aileen and Paul, a mother and son team who operated a cab service. They were enormous; I estimated they weighed close to five hundred pounds each. They said they'd heard about my radio repair business through my sister, Angela. I remembered her telling me about them. Angela was a nurse's aide and had helped Aileen take care of Paul when he was bedridden because of his chronic obesity. At the time, he was five-foot-four and weighed nearly seven hundred pounds. To help Paul wipe himself, Angela got her boyfriend to build a hoist over his bed so that he could be lifted while Aileen used a crowbar to cock up his leg.

Aileen said she needed me to check out the two-way radio system. "No problem," I said, staring in amazement as she struggled to remove her bulk from the seat. While I checked out the wiring, Aileen said that my sister had told her about my legal problems. I stopped working and looked up to see Paul wobbling around the shop, looking as though he might lose his balance at any moment.

"You shouldn't have to settle for that plea bargain," Aileen said, blowing smoke from her cigarette.

"Yeah, I know."

"Your lawyer obviously doesn't know what he's doing."

I shrugged and continued working.

"I know someone you should meet," she said.

"Yeah, who?"

Aileen smiled and flicked her cigarette butt. "I have the perfect lawyer for you. A real sharp guy. His name is George Bloomstein."

"That's great, Aileen, but I don't have the money for another attorney."

Her son raised his arm; the extra flesh made it look more like a wing. "You gotta meet him. He's just like Perry Mason on TV!" My eyes opened wide. I watched that show all the time. Mason was a larger-than-life legal TV hero that won every case he took on.

They continued to pressure me and finally I gave in. What was the harm in a simple meeting? "Okay," I said, "Here's my number. Have him call me."

A few days later, I heard from Aileen, not from George. She arranged the meeting for the morning of the day I was to appear before the judge with my answer to the plea bargain. I thought it was odd that she was acting as the intermediary. I mean, it wasn't like she was his secretary. It only dawned on me many months later that Aileen in all likelihood was receiving a finder's fee.

She told me to meet George Bloomstein in front of the Westchester County Courthouse. I arrived at 9 a.m., just as his Jaguar pulled up. The window rolled down and the driver stuck his head out. "Tony?" he asked.

"Yeah, you George?"

"That's me. Come on in," he said, flicking open the automatic lock.

George Bloomstein looked like a million bucks. He had a thousand-dollar suit on; his wrist flashed a Rolex. When I closed the door, his car phone rang. He answered and said he was with an important client and would call back later. The hook was in. I was impressed.

"Aileen told me about what happened to you," George said, shaking his head in disbelief. "By any chance, I had to ask you, are you related to Vincent Papa?" Vincent Papa was the main guy in the French Connection, a highly publicized case involving narcotics trafficking between France and the U.S. A movie was made about it and Gene Hackman played the lead role.

"No, I'm not," I said.

"Well, the reason I ask is because I represented several clients in that case. I've represented a lot of high-profile cases in my twenty-five years of defense work."

I was awed and thought George Bloomstein was the answer to my prayers. Screw Brent Blackbird.

George asked me the details about my case. I let him know about Brent, too, and the plea bargain. He listened intently the whole time and nodded frequently in a show of agreement. When I finished, George looked me in the eye. "You need to go to trial," he said.

"Yeah?" I was surprised.

He explained that what I needed was a plausible alibi, a story that would sound good to the court. Copping out and pleading guilty

would guarantee me a prison sentence, he said. "You've got a great chance, why not at least try?" he said.

I motioned to the courthouse. "I'm supposed to give the judge my answer today. What am I gonna do?"

"Not to worry," he said. "Go inside. Tell the judge you need a week to get your affairs in order. Then, tomorrow, come to my office. We'll work on that alibi." He smiled and shook my hand. "Don't you worry, this is a no-brainer."

The man had me sold. He was the guy who was going to save my life.

The next morning, I took the subway from the Bronx to George's office on Wall Street. The secretary buzzed him and politely asked me to take a seat. I'd waited less than a minute when George came barreling out of his office, all smiles and charm.

"Tony, good to see you," he said, giving me a hearty handshake like we were the best of pals. "Let me show you around." He gave me a tour of his office. The walls were covered with pictures of him and his clients. Each picture, he said, represented a winning case. I was impressed and felt comfortable with him. George was the man. He had a way of making you feel like you couldn't lose with him on your side.

He motioned me to sit in a large leather chair facing his massive walnut desk. He lit a cigar and offered me one. "No thanks," I said. "Don't smoke."

"That's great," he said. "I admire you. Wish I could stop ..." He made some more small talk and I became even more relaxed. If he wasn't anxious about my case, why should I be?

Then he looked at me and his voice grew serious. "Look, Tony, I'm gonna be very honest with you."

"Go ahead."

"If you take this three-year-to-life plea offer, you'll regret it. Five, six, seven years down the road, you'll be banging your head against your cell door wishing you'd gone to trial."

I found myself rubbing my head as if it were the very spot I'd some-day be banging against the cell door. "You think so?"

"I sure do."

"Do you think we can win? I mean, in court ...?"

"Of course we can! We just need a solid alibi, like I said."

In ten minutes, he'd whipped one up. Since I'd had car trouble the night of the arrest, George said, wouldn't it be reasonable to say that I was having my car towed up to Westchester County that night, and that José Pontes offered me a lift to meet the tow truck drivers? In exchange, he asked me to deliver the envelope for him, and I had no idea what was inside. It was a total bullshit story, thinking back on it now, but he'd convinced me that it was plausible. I was desperate and didn't want to leave my wife and daughter. I would do anything not to go to prison.

"Okay," I said, exhaling. "I'll do it. I'll go to trial. What do I do about my other lawyer?"

"Give me his number," he said. Still sucking on his cigar, he dialed the number and put it on speakerphone so I could hear. Brent answered himself. Unlike George, he probably couldn't afford a secretary.

"Is this Brent Blackbird?" George asked.

"Yes ... and who's this?"

"George Bloomstein. I was just retained to represent Anthony Papa in his criminal appeal. He will no longer be needing your services."

"Excuse me?"

"You heard me, Mr. Blackbird," George said. It sounded like a threat. "What about my fee?" Brent asked. "What about the work I'm doing right now?"

"What work?" George asked, looking at me and rolling his eyes. "You got paid five thousand dollars, didn't you?"

"Well, uh, yes."

George shook his head and told Brent that there was nothing more to discuss. He hung up the phone and turned to me. "So much for that," he said. Wow, I thought. This guy is impressive. "Now," he continued, "it's time to discuss *my* fee."

I froze. It was the first time he brought up the money issue. My situation hadn't changed; I was still broke, more so than ever. "How much

do you charge?" I asked. If he thought I was loaded because this was a drug deal, he was dead wrong.

"If you were going to trial with Brent, how much would he have charged you?"

I honestly couldn't answer that question. Brent hadn't wanted to go to trial. We'd never even discussed it. I made up a figure. "Ten thousand," I said.

George nodded. "Done deal." He smiled and shook my hand. I was elated. I felt as though I'd hit the lottery. I was going to be represented by George Bloomstein, king of criminal defense attorneys with over twenty-five years of experience. I could tell that his polished demeanor and aggressive style would work well in the courtroom.

"Now, how are you going to pay this fee?" he asked.

"Huh?"

"Cash or check?"

I didn't respond. What could I say? "I'm flat broke and don't have a dime to pay you with"? George saw that something was wrong and chuckled. "Not to worry, Tony." He said, leaning back in his chair. "Aren't you out on bail?"

"Yeah."

"Wasn't your bail set at $10,000?"

I nodded, and he smiled. "Well, that's it. Just bring in the bail receipt and it'll cover my fee for trial."

A wave of relief passed through me. I quickly agreed and left George's office a happy man. There was hope after all. "This was the best move you've made so far," I said to myself.

Godly Arbitration

THE TRIAL WAS SET FOR February 2nd, 1985, three weeks away. Along with Tommy Polinski and José Pontes, I was charged with Criminal Sale of a Controlled Substance in the First Degree and Criminal Possession of a Controlled Substance in the First, Third and Seventh Degrees. The District Attorney's office assigned assistant DA James Bolen to the case, a hard-nosed son-of-a-bitch who sought victory at any cost. I learned that George had recently humiliated Bolen in the courtroom when he won a major case that Bolen had spent months working on. George pulled off the win when Bolen made a strategic error in his trial strategy. The courtroom was now a place where Bolen would seek revenge.

Before the evidentiary hearings for the trial took place, I met with George on several occasions so that he could coach me about what to say. During our meetings, he never failed to remind me that we'd win. "We will beat this charge! I know we will." George seemed so confident that I failed to realize that I was being taken for a ride. I trusted him with my life but to him I was just another fee. He knew we had no shot. How could we? The evidence was stacked against me. I had made a direct sale to undercover police officers. But who was I to doubt him? I was young, uneducated and desperate, and George was an experienced trial attorney with pictures of happy clients on his walls.

Before trial, we spent several days in court dealing with motions that would set the tone for the trial. The sessions were intense because the outcome of these motions would contribute to the final determination of the jury. The first hearing was held on February 4, 1985 in the Westchester County Courthouse in White Plains. The judge assigned to the case was the Honorable Carmine C. Marasco.

The courtroom was a large, cavernous room dominated by the judge's bench, which seemed to tower a good twenty feet above everything else. Although it was bitterly cold outside, the air in the courtroom was stifling hot. I wore a cheap blue suit, the only suit I owned. It was a tight fit. Worse, my shoe had a hole in it. I'd worn the shoes not only because they were the only dress shoes I had, but because they were my lucky shoes. Years back, I'd worn them on a trip to Atlantic City where I won $2,000. Later that night, I used the electric shoeshine machine in the hotel room and kept my shoe in the grinding wheel too long, causing the leather to disappear.

Originally, I had been charged with both Tommy Polinski and José Pontes. During the hearings, it was revealed that Pontes had been dismissed from the case. His lawyer had managed to convince a judge that he played no part in the crime. Pontes agreed to testify against me before the Grand Jury. He testified that he had driven me to Mount Vernon in exchange for one gram of cocaine and knew nothing about the drug sale. He played it off like he was the victim instead of Polinski's main guy. The court believed him despite the fact that he had a string of drug-related arrests. Pontes' dismissal left Polinski and me to take the fall, or so I thought. By the time the trial began, I was standing alone.

Polinski was in deep trouble and he didn't want me to make any waves. He wanted to shut me up and be the one to take the fall. During one of the pretrial hearings, he sent a girlfriend to see me. She slipped in the row behind me and leaned forward. "Papa ..." she whispered.

I turned and knew who she was immediately. I'd seen her with Polinski in the bars around the bowling alley. "What do you want?" I asked.

"Polinski says he knows you're a little hard up for cash."

I'd heard that line before. "So?" I asked.

"He says he'll give you five thousand dollars," she said.

"If I do what?" I narrowed my eyes.

"Take the fall," she said with a shrug. "You're going down anyway. Might as well make some money out of it."

"Tell Polinski to go fuck himself," I said. "Money is the reason I got myself into this mess in the first place. I want my freedom, not his god-damn money! Tell the son-of-a-bitch there's no way in hell I'm taking the fall for him. Fuck off," I growled.

Polinski's back was against the wall; the DA was threatening him with not one but *several* life sentences. The only way out of it for him was to take a plea bargain in return for cooperation. His "cooperation" meant adding more lies to the ones Pontes had already told the court. As it turned out, Polinski had been involved with the law long before this incident. The same undercover cops who'd busted me bought drugs from Polinski on three separate occasions. Facing a life term with three solid indictments against him, Polinski would do anything for a reduced sentence, including ratting out innocent people. My friend Vinny from the bowling alley told me that he got a call from Polinski asking him to get him some cocaine. Vinny hung up on him.

I didn't know how many other guys Polinski ensnared in the sting operation. All I knew was that he was desperate not to go to prison, even if it meant framing other people. He was a snitch and if he went to prison, he knew he was going to pay a steep price. During my time at Valhalla, I saw how prisoners treated snitches. Polinski was right to fear for his life.

In exchange for a three-year sentence, Polinski became the people's main witness against me. Bolen kept him in the nearby county jail so he would be available to testify against me. He was now being used to bring me down. All of the evidence that had been collected against *him* was now being used against *me*. The prosecutor pulled it off by using a legal doctrine known as the "co-conspirator's exception to the hearsay rule." His strategy involved using a disparaging twenty-nine-minute tape recorded on the night we were arrested. My lawyer argued against the legality of using Polinski's statements against me, but the prosecutor

argued that in a *prima facie* case of conspiracy, such action was totally legal and justifiable under the co-conspirator's exception.

"Don't worry," George said. "They can't prove a *prima facie* case against you. There just isn't enough evidence." To admit such evidence, he said, they would have to show an overt act between Polinski and me that took place before the sale I was being charged with. Despite George's analysis, the judge ruled that they had met the burden of proof. The way they did it blew my mind.

According to testimony from undercover cops who bought cocaine from Polinski on a prior occasion, they saw me at the same bowling alley on the night of the transaction. I was standing near the bar wearing a black fedora hat. They said it was the same hat that I'd worn the night of the arrest. Some time later, Polinski appeared with the cocaine and sold it to them, saying that his connection had just delivered the drugs.

It was true that Polinski and I were in the bowling alley that night. After all, we bowled in the same league. It was also true that I occasionally wore a black fedora hat, but it was not true that I was wearing that same hat on the night I was arrested. I was wearing a red stocking hat. The cop lied, but the judge accepted his testimony and I was suddenly a co-conspirator.

The most damaging evidence they had was a tape of Polinski lying about my being his main connection. On the tape, he said that I moved "big weight" and that I'd pulled off sales of *kilos* of cocaine. These lies became the crux of the people's case against me. My lawyer argued that the tape was inaudible. Another hearing was conducted, and Judge Marasco ruled that although some parts of the tape were indeed inaudible, the majority of it was clear and would be used as evidence against me. The inaudible part, the last minute of the tape and the only part attributed to me, would be transcribed and edited by the arresting officer, with no input from me. This practice was contrary to established law, but the judge overlooked it. When I read the transcript, I knew my chances of winning were diminishing rapidly. The transcript included many prejudicial assertions made by the cops that were not even on the tape recording:

(Subject approaches the truck.)

JY [Joseph Yazinski]: What do you got for me?

AP [Anthony Papa]: A package of cocaine if you got cash for me.

JY: The seventy-five hundred is all here.

AP: Okay.

(AP reaches into his jacket and pulls out cocaine. Hands to JY who opens the package.)

JY: Wow! It looks like good shit.

(JY unzips plastic bags containing cocaine and inhales the contents.)

JY: This really smells great. Polinski says you had the best coke around.

AP: Plenty more kilos around if you're interested.

JY: You want to count the money?

AP: No. I trust you.

(The driver of the tow truck reaches over and flips on the overhead strobe lights signaling the go-ahead for the arrest.)

It was surreal. These lies were being admitted as evidence against me. The cops, the District Attorney's office, and the court were putting words in my mouth!

The use of the tape recording was debated for days between the judge and my attorney, and whether admitting it as evidence would violate my rights, especially if Polinski would not be called to the stand. George argued that being denied the opportunity to cross-examine a witness would violate my constitutional rights. Despite this, the judge admitted the tape into evidence. I asked George if there was any way to challenge the judge's decision. He told me that he'd deal with it at a later point. George never responded to the issue in court again.

Later in the trial, I realized that this was a fatal mistake, when neither the prosecutor nor my attorney had Polinski testify. The case against me was built on hearsay derived from a largely inaudible and dubiously transcribed tape recording.

A week later, twelve jurors and two alternates were picked: five women and seven men. One male was Hispanic; two were black. During the selection process, questions were asked of the potential jurors. I sat and listened as both Bolen and Bloomstein questioned these men

and women. It was surreal. My life was in the hands of these ordinary men and women, individuals who didn't know anything about me. One by one, the jury was selected. They came from different walks of life, from plumbers to housewives to corporate executives. I'll never forget when Bolen picked one juror whose hobby was collecting tin cans. Great, I thought. My life will be decided by a guy who collects tin cans. It was hard to keep my composure in the courtroom, but George had told me to keep a constant helpless look on my face, a look that portrayed an individual who suffered and had great remorse. He said that it might to neutralize the DA's contention that I was a drug pusher selling poison in their community.

The trial lasted two weeks. It was a struggle, both in and out of the courtroom. Polinski's lies about drug parties, after-hour clubs and adulterous acts tainted my relationship with my wife. I had to close the garage for the trial and had no income. We struggled to buy groceries. I even had to borrow carfare to get to court. On top of everything, I found out that George wasn't quite the genius in court as he'd said. Before the trial began, he described his trial strategy. He was going to make the cops look dirty and make Bolen sound like a first-year law student by showing that I'd been set up by Polinski and Pontes.

"Don't you worry, pal," he said, wowing me with his legalese. I didn't understand his strategy but told myself that George was a legal expert and he would save my life. I trusted him. I had no other choice.

It was a different story in court. Every time George made a legal point, Bolen shot it down and the judge would agree. Bolen was aggressive and prepared. The tables we sat at told it all: our table was barren; Bolen's table was covered with law books and file folders. Every time Bolen made a point, he'd flip open one of his damn law books and proudly cite a case to support his argument. George would respond, but the judge would disagree on almost every issue presented.

George said that the most important part of the trial would be my testimony. It was essential that I testify as to how I wound up with a package of cocaine. George developed the story partly based on facts that I'd told him. At the time, it sounded good to a desperate man like me,

but now, in the courtroom facing my accusers, it sounded ridiculous. I knew that lying wasn't right, but neither was the fifteen-year-to-life sentence I was facing. My life was on the line, along with my wife's and daughter's lives. How would they survive if I went to prison? I sat there tearing myself apart, cursing myself for putting my life and family in this situation. The question was, could I pull it off and convince the jury?

When it came time to take the stand, I was terrified. George had made it clear that my testimony would make or break the case. The moment of truth had arrived. The assistant district attorney called me to the stand. "Do you swear to tell the truth, the whole truth, and nothing but the truth, so help you God?" My hand touched the bible as the clerk swore me in. I looked at the book and thought about God, the concept of forgiveness and redemption. I knew it was wrong to lie, but my life would depend on the words I was about to speak. I was facing fifteen years of hard time because of a single mistake. The twelve men and woman made eye contact with me. It seemed as though they were trying to focus in on my face, and it made me panic. I sat straight up in the chair, my fingers clutching the armrests. I looked DA Bolen in the eye.

"Mr. Papa," he started, "could you tell the jury what took place on January 24, 1984?" Even though I'd rehearsed the answer a dozen times, when the question was asked in a real context, my mind went blank. I slumped in my chair and looked out at the courtroom. My mouth opened but no words came out. I started to hyperventilate. Suddenly, I found myself gasping for breath as the room began to spin. Bolen stood before me, grinning, his arms folded, waiting for a reply I couldn't find. It seemed as if eternity had arrived: me sitting in hell, frozen in a helpless position, my mind spinning out of control. Through the fog, I saw George and my wife frantically waving their arms, trying to help me snap out of it. The movement of their arms brought me back to reality.

Suddenly the words came, and slowly I began to speak. I admitted that I had passed the envelope of cocaine, but that I thought it contained glue for Polinski's hat business. That Wednesday night, I said, I had to bowl in a league in Yonkers. My car wouldn't start and Polinski

had offered me a ride to the league. He said a friend of his named José was coming up to see him at his uncle's hat factory in Mount Vernon, and since José lived in the Bronx he would ask him to give me a lift to the bowling alley.

So José picked me up. During the ride, he asked me to do him a favor since he was in rush. Polinski's factory was on a narrow street, he said. He couldn't make a U-turn, so he suggested that he drop me off in front, and I'd go inside and give the envelope to Polinski while he drove to the end of the street and turned the car around. Then he'd drive me to the bowling alley. It was all a lie and as much as I'd rehearsed it, I couldn't make it sound like the truth.

The jury could tell; they looked at me in disbelief. Even the two jurors who George had said were on our side shook their heads in disgust. They knew I was lying. The ADA approached.

"Mr. Papa, how old is your daughter?"

"Seven years old, sir."

"You know that when this trial is over the next time you'll see her is when she's twenty-two?" The words hung in the air like a noxious gas.

"Take the plea now, you'll never win. I'll make sure of that." I hung my head low and began to cry.

The evidence was stacked against me. The facts remained: On the night of January 24, 1984, I'd driven with José Pontes to 310 Morris Avenue in Mt. Vernon and handed over an envelope containing four and a half ounces of cocaine. In return, I received a bundle of bills totaling $7,500 from two undercover narcotics officers posing as tow truck operators.

The last day of trial, I sat in the foreboding courtroom and stared at the panels of cold dark wood and the towering judge's bench. My eyes focused on the gold plaque over the judge's desk. "IN GOD WE TRUST." I started wishing I'd listened to Brent Blackbird and taken the three-year deal, but it was too late. I knew I was going down.

After the final arguments, Judge Marasco briefed the jury on deciding a verdict. I sat there, dry-mouthed, the world spinning out of control, catching only snippets of what he was saying:

"... must prove ... beyond a reasonable doubt ... consider the evidence ... agree on a verdict ... should be as follows ..."

I tried to focus, but part of me already knew I'd lost.

" ... the first count, criminally selling a controlled substance in the first degree, either guilty or not guilty. On the second count, criminal possession of a controlled substance in the first degree, either guilty or not guilty ..."

The jury left the courtroom at 2:43 p.m. A half-hour later, the jury sent a note to the judge asking to hear the tape and see the transcripts again. They did this four times, concentrating mainly on the tape. Some jurors even timed the alleged transaction, opening and closing an imaginary envelope and smelling its contents. At the end of a grueling day, the judge recessed until the following morning. I knew it was my last night as a free man.

I thought about running. I called up Johnny Payne who was a bowling buddy. "You gotta lend me some money," I said, my voice cracking. "I gotta run away." He tried to discourage me, told me I was overreacting. And besides, he said, did I want to spend the rest of my life as a wanted man? It seemed like a better choice than fifteen years in prison, I said.

I stayed up all night. My wife and daughter lay on each side of me in our bed. I clutched my arms tightly around them and stared at the religious candles my wife had lit, praying for strength and guidance. I had no money, no place to go. My only real choice was to go back to court and pray for the best. My wife and daughter needed me. It wouldn't do them any good if I ran.

The next day, deliberations on *People vs. Papa* continued until 3:30 p.m., when a verdict was finally made. At the time, I was sitting with my wife in the hallway. The doors of the courtroom swung open and two court officers came out.

"If you have a wallet," one of them said, "you better give that and any other personal belongings to your wife."

"Standard procedure," assured the other when he saw the look of panic on my face.

I was scared. I handed over my house keys and wallet. Now, I wanted to run. I sized up the two armed court officers and looked at the exit. The officer must have read my mind. He put his hand on the gun sitting in its holster. His gesture made my legs wobble. I was too weak to struggle. I knew it was the end.

The officers escorted me into the courtroom and steered me into my chair, each of them placing a hand on my shoulders.

Judge Marasco addressed the jury. "Ladies and gentlemen, I have your note, which reads as follows: 'We have reached our decision.'" He then turned to the clerk. "The clerk will please read the verdict."

The clerk nodded and addressed the leader of the jury. "Madam Forelady, please rise. Members of the jury, have you agreed upon a verdict?"

"Yes, we have," she said. It seemed ridiculous that none of the jurors knew that I was facing fifteen years to life. The judge told them that they should only be concerned with whether or not I was guilty, not with the terms of punishment. On some occasions, I'd ridden the elevators up to the courtroom with members of the jury. I'd been tempted to shout: Do you know what I'm facing? But the judge had given me a direct order not to speak to them.

The clerk continued reading my fate:

"Members of the jury, as I read each count of the charges, please tell me how you find the accused under each count." The forelady nodded.

"One, criminal sale of a controlled substance in the first degree."

"Guilty."

"Count two, criminal possession of a controlled substance in the first degree."

"Guilty."

It was over.

Prison.

"Sorry pal," George said, laying a hand on my shoulder. His other hand wiped a crocodile tear from his eye.

The court officers grabbed hold of my arms and told me to follow them. I was so shocked, fighting and running was the last thing on my

mind. As they pulled me away, I turned to Marylou. She was crying. That last vision of her, holding her face in her hands, tears streaming down her cheeks, was one that would haunt me for years to come.

"I love you, Marylou," I said.

Through choking sobs, she told me she would never leave me. She reached forward to embrace me but the guards blocked her. I was handcuffed and taken away. It was the end of my life as I knew it.

CHAPTER 5

Metamorphosis

I WAS PROMPTLY TRANSFERRED BACK to Valhalla. This time, however, I was sent to the maximum-security part of the jail to await sentencing. The housing unit was different from the one I had spent thirty-three days in almost a year before. It was run by a single officer who sat in a booth. The booth had huge Plexiglas windows enabling the guard to view the entire floor and from where he electronically controlled the opening and closing of about forty cells. When I arrived, I was sent to the day room until my cell was in order. The day room was where prisoners spent "down time" outside of their cells. To make his job easier, the guard permitted only half of the prisoners outside of their cells at any given time. When I walked in, about half a dozen men were watching television; others were playing cards. I sat in a chair in a corner of the room and buried my face in my hands, reliving the events that brought me here. Over and over, I kept seeing myself pass the envelope of cocaine to the undercover cops; I felt the cold snow in my face as the detective held my head down. I felt numb, like I was going out of my mind. Then someone tapped me on the shoulder.

"Hey, you're new, huh?"

I snapped my head up. "Yeah."

"Name's Bosco," he said. "I'm the porter. I take care of the unit, sweep, clean, all that crap. Actually, I run the place."

I nodded, not looking at him, continuing to grip my head with my hands.

"What'd they get you for?"

I lifted my head and looked at him: a young black man dressed in state-issued greens. Bosco said he'd been transferred down to Valhalla from a prison upstate to go to court. To pass the time, he decided to become the unit porter. Porters had more freedom than regular prisoners, he said. I told him I'd just blown trial and was facing fifteen years to life.

"So that means you either murdered someone or you got a drug beef," he said. "You don't look like a murderer, so I bet it's drugs."

"Yeah."

"Me, too. Most everybody in here has a drug beef," he said. "These motherfuckers are crazy, giving out telephone numbers for sentences! Look, man, you're waiting to be sentenced, right?" he asked.

"Yeah, my lawyer said it would take a few weeks."

Bosco lowered his voice and looked around to make sure no one was listening. "It's a long shot, but if you're willing to try anything to beat this case, I got a plan."

"What is it?"

Bosco told me about a legal proceeding called a Clayton hearing, which, if granted, meant that the judge throws out an entire case in the interest of justice. A Clayton motion could only be filed before sentencing. Bosco said he knew a guy upstate who beat his drug case by claiming he was anally raped while he was in Rikers Island awaiting sentencing. The truth was that he jammed a toothbrush up his ass. His attorney submitted the motion, supporting it with a medical description confirming his rape. The judge was so angry at the lack of security that he granted the motion.

"Man, that's some story. Where's the guy today?" I asked.

"Unfortunately, he's upstate serving time for the crime."

"I thought he got the conviction overturned."

"He did! But then the idiot told another prisoner how he got off and the guy turned him in to the DA to cut a deal for himself. It's how the system works," he shrugged. "But if you keep your mouth shut ..."

"I'll think about it, thanks."

ANTHONY PAPA

My cell was ready and I went in. Concrete floor, metal-framed bed, toilet in the corner. Bars. My mind was still in a fog as I sat on my bed and stared at my toothbrush.

During my time at Valhalla, I ran into a couple of prisoners who had serious plans for freedom. Freedom was on every prisoners' mind, I guess, and mine, too, but in the beginning I was more concerned with holding onto my family. I could feel them slipping away. How could I blame them? How could I be a father and a husband when I was a full-time prisoner? The calls to Marylou became shorter and shorter; the letters and visits less frequent. She was my lifeline to the world, and without her I felt lost. I became depressed and contemplated suicide. I considered hanging myself, but remembered the time I saw a prisoner swinging by his neck and realized I didn't have the guts to go out like that. Too much preparation. I needed a simpler method, one that would kill me instantaneously. The idea of electrocuting myself came to me. I could stick my hand in the light bulb socket overhead. I went through the motions several times, stepping up on my bed and touching the burning bulb, unscrewing it and tracing my finger around the socket's edge.

Like most jails, Valhalla had a high rate of suicide, and even higher rate of suicide attempts. Suicide, I learned, is more likely to happen in jail than prison because jail is where a person begins his sentence. Jail is where the reality of everything crashes down on you and you realize you're not going home. For some new jacks, prison-speak for new inmates, the trauma was too much; for the regulars, it was a familiar phase of doing time.

What helped me through was the love of my mother, Lucy. She became my life support and gave me the courage to go on. She sent me religious cards, a Saint Anthony medallion to wear and spent hours praying for me. What little discretionary money she had, she spent on religious paraphernalia—white candles she'd light and place all around the house and at her church. "When the light is shining," she'd tell me on the phone, "that means you're gonna come home. Don't you worry, Tony. You're gonna come home."

"Is the light shining, Ma?" I'd ask.

"It sure is."

She even bought horseshoes and hung them in the house for luck. She had a friend who was into Santeria—a kind of witchcraft—and the two of them would have séances and prayer sessions in my honor. She figured that by mixing her Catholic saints with those of Santeria, she'd get the benefit of both. "If the Catholic ones don't work," she wrote, "the others will. So don't you worry."

As much as she prayed for me, she said that the greatest consequences would come from my own prayers. "Pray, Tony," she told me when she came to visit. "Pray so you'll come back home."

Right before sentencing, that's exactly what I did. I prayed. I got down on my knees on the concrete floor of the holding cell and prayed to God, the Son, the Holy Spirit, Saint Anthony and anyone else who'd listen. I was praying out loud when the guard came for me. His weary expression said he'd seen it before.

In the courtroom, my lawyer was waiting for me. I hadn't seen George since the trial. When he saw me, his eyes bulged. "Oh my God, Tony," he said. "What happened?"

I knew I looked like hell. I'd stopped shaving and could feel the heavy bags under my eyes from not sleeping. To make matters worse, my arm was in a sling. The week before, I'd caught my hand in the sliding steel mechanism of the cellblock door, leaving me with a sprained hand and a thumb with no nail.

"You're deteriorating!" he said. "Are you okay?"

"I'm in prison," I snapped. "What did you expect?"

When it was our turn to see the judge, George launched into a sympathy speech. "Give him mercy, your honor," he said. "Just look at him, Judge. His physical condition is rapidly deteriorating. Mr. Papa is a first-time nonviolent offender who made a mistake." When he finished, the judge folded his hands and lowered his head. "You've committed a serious crime, Mr. Papa."

I nodded.

"But ..."

I looked up. Would he give me a break?

"I won't give you too much time, son."

My prayers were answered! Mom was right. Saint Anthony heard me! I couldn't believe it. The judge continued:

"For the sale of a controlled substance in the first degree, I sentence you to fifteen years to life."

My left knee—then my right—buckled. I grabbed George's arm so I wouldn't fall.

"Excuse me, your honor," the prosecuting attorney interjected.

"Yes?"

"I presume you are referring only to the first charge. As you recall, we dropped the lower counts of the indictment, but there are still two criminal charges pending." He held up two fingers.

The judge looked down at his papers. "Oh yes, you're right." He lifted his head and glared at me. "I also sentence you to fifteen years to life for the possession of a controlled substance in the first degree." My right knee jerked; again, I almost fell. George started to argue, but the judge held up his hand.

"However, since you are a first-time offender, I'm going to run your sentences concurrently. You will only have to serve one sentence, Mr. Papa. You are hereby sentenced to fifteen years to life in a state prison." He banged his gavel. The echo sounded like a gunshot. My next words horrified me. "Thank you, your honor," I replied. I guess I was in a state of shock.

Seconds later, it hit me: an overpowering feeling of despair. My body felt as if it had been pummeled with the judge's gavel. This is for real, I thought. This is for real. You're finished.

George gave me the same sorry face he'd worn during trial. "Don't worry, Tony. I promise you, we'll win this on appeal."

Before I was sent upstate, Marylou came to visit me. The visiting room at Valhalla was a small room with several long wooden tables. Visitors sat on one side; prisoners on the other. You couldn't embrace, only hold hands. I took Marylou's hand and told her the news. "Fifteen years to life," I said. She started to cry. Within seconds, I was crying, too. As she sobbed, I told

her she would be better off to forget about me and go on with her life. It would be best for our daughter as well. I didn't want Stephanie visiting me in a maximum-security prison and growing up with an image of her father behind bars. It wasn't right, I told her, though the decision devastated me. After all, the main reason I went to trial was so I wouldn't have to leave my family. Now, here I was telling her it was over. Fortunately, she didn't put up much resistance or make me any false promises.

A few days later, I was officially transferred out of county jail and into custody of the state prison system, the New York State Department of Correctional Services. The first stop was the maximum-security reception and classification unit, Downstate Correctional Facility in Fishkill, New York, about ninety miles north of Manhattan. It was nothing like county jail; it was more like a military base. Every year, about 20,000 prisoners enter Downstate, where they are screened for medical and psychological conditions, given an intelligence test, assessed for alcohol and drug use, and issued a security classification. All the data the administrators collected on a prisoner was then punched into a computer and the newly admitted inmate was matched with the appropriate "correctional facility."

The guards marched us off the bus and through a massive steel door in the center of a lethal electric fence surrounding the compound. Coils of razor wire wrapped and looped through the top of the fence, banishing even the thought of escape. We were led through a series of gates and checkpoints and into a building, where we were packed into a room for processing. Ten prison guards sat behind gray iron desks and summoned us individually to approach. Each prisoner was told to place his bag of belongings on the desk. The guard dumped out the contents and examined them. Just about everything was tossed into garbage bins. One guy complained when a guard chucked his love letters into the trash; when he didn't let up, the correction officer, or "CO" as they're called, pulled a pin on his radio and sat back in his chair while the inmate continued to complain.

"You got no right," the prisoner said. "Those are from my wife, man! You can't just throw them out. " He shut up when he saw what

was coming through the double-doors: a dozen COs in helmets and body armor, wielding clubs. "Fuckin' goon squad," whispered the guy behind me. "Racist bastards," said another.

The complaining prisoner held up his hands in surrender but it was too late. The goon squad went right for him, tackling him to the floor. They beat him down and dragged him away. The CO who'd summoned the goon squad smirked and paused to look at the rest of us before he called, "Next!"

The line began to move again. After that, nobody had the nerve or stupidity to bitch about losing his possessions. We approached the desk obediently when told, making sure to stand well behind the dotted yellow line in front of the desk. When instructed, we handed over our bags. I ended up losing most of my belongings. No food was allowed if it wasn't hermetically sealed in a store-bought container. All street clothing, books and magazines were confiscated. It was as if they didn't just want our possessions, but our self-esteem. Taking our personal belongings was just the beginning of a long and painful ritual to show us that we were powerless.

Next, they ran us through a line of barbers who shaved our heads military-style. All the while, the guards glared at us from the sidelines, daring us to challenge their commands. After they took our hair, they told us to strip and place our clothes in a pile. An inmate porter gathered the heap and dumped it in a garbage bin.

The demoralization process continued as one by one we underwent the dreaded body-cavity search. We stood before them like slaves on an auction block while they barked out a series of orders: "Open your mouth. Say, 'Aaaghhh.' Lift your nut sack. Turn around. Bend over. Spread your cheeks." We had to remain in a bent-over position with our cheeks spread until a guard wearing plastic gloves leaned forward and checked our rectums. "I should've run," I kept thinking. "I should have run when I had the chance."

It made me sick. I was beginning to understand the violation that rape victims must feel. Next, I was told to rise and prepare for "delousing." The COs lined us against a wall while a guard with a garden

hose sprayed us down with chemicals. A guy in the group before mine refused. "This stuff is gonna kill me," he kept saying. "No way ... fuck that poison hose!" The goon squad made a second appearance; when they were through, he was silent and subdued as they dragged him away.

By the time they called my name, I was so rattled I jumped. I kept thinking they'd target me for something and make an example out of me. Cowed and shaking, I walked to the wall and took the spray of chemicals. My skin burned and water streamed from my eyes, though I'd shut them as tight as I could.

After the de-lousing, the guards corralled us into the shower room and then rewarded us with clothing: state-issued "prison greens." With the uniform came our identification cards. A guard photographed each prisoner in his uniform, holding his freshly minted prison ID card. Somewhere between the strip search, the de-lousing and the shower, I'd lost my identity. I was no longer Anthony Papa. I was New York State prisoner number 85A2837.

Reception is hard because that's where the prison brass shows you who's in charge. "This isn't Rikers Island," they'd say, as if Rikers were a walk in the park. The guards went out of their way to show us they were our keepers. They'd stand around slapping their batons in their hands, scowling at us like we were vermin. They took every opportunity to instill fear in us and let us know we were unwelcome guests in their sanctified house of corrections. When speaking to a guard, it was "Yes, sir." When walking the halls, we had to march silently in lines of two. If you stepped out of line or mouthed off at an officer, if you were found with contraband or violated any one of their hundreds of rules, you were thrown into solitary confinement or paid a visit by the every-ready goon squad.

I was assigned to a cell in one of the many housing units scattered throughout the complex. Each cell had a metal desk, chair and bed anchored to the floor and wall. Nothing was detachable or destructible. I unpacked my belongings, which had been neatly stowed in a state-issued potato sack. Relieved at the thought of finally settling in, I was

moved the very next morning to a different housing unit. The day after that, I was moved again. This pattern continued for the next several weeks until I gave up unpacking my belongings. The constant transfers reinforced the notion that the prison was an institution of total control. It supplied all of our basic necessities: food, clothes, soap, blankets. It made us dependent on our keepers and created a feeling of infantilism. Experienced convicts warned me to fight this feeling. "Don't fall prey to it," an old con said. "You'll become institutionalized."

Looking back, I can see the genius behind their strategy: behavior modification through institutional dependency. The prison system systematically strips away your individuality and replaces free will with rules and regulations, which are outlined in a booklet issued to every prisoner. The booklet told us what we could and could not do. It was the bible of the system and we were told to regard it is such. Any deviation would result in a "misbehavior report."

Misbehavior reports were something like parking tickets. There were three levels of offenses: Tier I, Tier II and Tier III. Each level carried a more serious punishment, ranging from a verbal warning to solitary confinement. It didn't take long to discover that Downstate went by the book.

I learned this one morning before chow. Normally, the guards would announce "chow," and our cell doors would open automatically. That morning, mine stayed shut. "Excuse me," I called out to an officer making his rounds. "My door is locked. I want to go to breakfast." The officer kept on walking. A prisoner in the next cell told me I was "keeplocked." It wasn't a mechanical problem.

"For what?" I asked.

"How should I know?" he said. "Someone will come around and issue you a ticket." An hour passed before a guard came by and told me "to sign" for a misbehavior report. I read the piece of paper he passed through a slot in the door and saw I'd been given a Tier I ticket, the lowest offense level, for hanging my underwear out of my window. I turned to the window and saw that my two pairs of state-issued drawers were gone.

For this infraction, I was locked in my cell for the next twenty-four hours. They fed me by passing a food tray through the "feed-up" slot in the door. The next day, an officer said I would have to appear before the "adjustment committee." I had three choices, he said. I could plead not guilty, guilty, or guilty with an explanation.

"Officer, I didn't know that hanging underwear out of the window was against the rules."

"Tell that to the committee."

The next day, I was escorted to a different part of the compound and placed in a holding cell for six hours before I appeared before the committee. The holding cell was full of other deviants. I listened to them talking about what brought them there. Two guys had stabbed another prisoner over drugs; several others had assaulted a guard. I didn't bother telling them why I was there.

When I stood before the committee, three correction officers and a lieutenant, they read my charge: tampering with state property. The lieutenant asked I how I pled. I said I was guilty with an explanation and told him I didn't know I'd violated a regulation. The lieutenant sentenced me to seven days of keeplock.

"I want you to understand that rules must be obeyed," he stated. The austerity in his voice was laughable.

"Yes, sir. It'll never happen again."

"See that it doesn't."

"Sir? Can I get my underwear back?" I asked. The supplicating tone in my voice sickened me, but I had no underwear other than the pair I was wearing.

"When you finish your sentence," he said. I never did get my underwear back.

Shortly before I left Downstate, I was moved to a housing unit where the walls were covered with patriotic murals depicting military war scenes: battleships, fighter planes and uniformed men in lifelike poses. The officer in charge of the unit was an ex-Marine with a fondness for military paintings. The paintings captivated me, not because of

their subject matter but because of the way they seemed to jump off the walls and transform the entire unit from a prison into a scene from a battle. I remember wondering what it would be like to have that kind of talent, to be able to make shapes and detail come out of a paintbrush, to have power like that.

I inquired about the artist who'd painted the mural. His name was Ron and he was the porter. The ex-Marine had treated him well and let him paint to his heart's desire until he used his talent to try to escape. Now he wasn't let near a paintbrush.

Rumor had it that Ron's young son had suddenly died in some kind of freak accident. Ron was devastated and requested to attend the funeral. He was denied. Apparently, armed robbery was too serious a crime to warrant any favors from the administration. When he started writing complaint letters to politicians, the administration decided to pack him up and ship him off to another prison, a classic case of diesel therapy. Ron decided to get even. He sculpted a handgun from a bar of soap and painted it black with shoe polish. During the transfer, he pulled his makeshift weapon on the guards in the transport bus. Afraid that the mad artist had a loaded weapon, they did as he said. They threw their guns out of the window and unlocked his handcuffs. Ron put the gun to the driver's head and told him to drive to New York City. The plan was foiled when two inmates who were in the transport bus jumped Ron, no doubt trying to secure freedom for themselves.

I spent nearly six weeks at Downstate before my orientation period was over. Once again, I found myself back in the processing building with everyone else who'd arrived with me weeks ago. Once again, our property was searched and much was destroyed. This time, I lost my Saint Anthony medal and some prayer beads my mother had sent through the mail. The guard explained that they were contraband and could be used as weapons. I was dumbfounded by this and asked him how a religious medal the size of a dime could be used as a weapon. The guard became indignant. "Look—you don't question my authority. Rules are rules." It became apparent, then and over the following years, that not all guards interpreted the rules the same. One guard, for example, might

see my religious medal for what it was, just as the guard who let it pass though the mail security did. Another guard, like the one pointing his finger in my face, would call it a dangerous weapon. After the CO decided what I could and couldn't keep, he told me I'd get my sack back later and directed me to the waiting room.

There I sat for hours, along with dozens of other prisoners waiting for transfer. This was it, the other guys told me. I would now be shipped to my "home" facility. None of us knew where we were going until our property bag was returned with the attached dreaded yellow tag. The tag would be stamped with our new destination.

I was anxious to get out of Downstate but scared where I'd end up. I'd heard too many horror stories already and prayed I wouldn't see CLINTON or ATTICA boldly stamped on my yellow tag. These prisons were as far upstate as you could get. Some hugged the Canadian border so closely you could hear French on the local radio station. Distance would shorten phone calls and visits from loved ones. And the more isolated you were, the fewer people you had looking out for you, the more dangerous the prison environment became. There was no one to witness your condition. "Guards know which prisoners get visits and which don't," an old-timer said. "They're less likely to fuck with prisoners who have ties to the free world." Many of the guards in these prisons came from generations of correction officers. Rural communities where prisons like Attica, Clinton and dozens of other New York correctional facilities are located depend on the prisons to boost the local economy. In fact, local politicians were known to fight over who'd get the next prison. It was big business, and prisoners like myself were fuel for the carceral machinery.

Because most of the state's prisoners are blacks and Hispanics from New York City, and the guards are predominantly white, racism, tension and harassment were constant. Guards would lock you in "the Box" and keep you in roach-infested solitary confinement for days or months at a time for minor infractions, or because they didn't like the way you looked at them. "They're all rednecks," one black guy said. "If you're a city boy, nigger or spic, you'll have a problem."

Prison gangs were out of control, too. Word was that if you don't join a gang, you were easy prey. Plus, there were horrible rape stories. "Don't sleep too soundly in Attica," one guy warned. He went on to describe predatory "booty-bandits" who'd sneak into your cell, hide under your bed and wait for the right moment to attack.

Stories of guards killing prisoners were common. The hacks would blame the incident on other prisoners. "You go upstate," a seasoned con said, "you might as well disappear from the planet." There were stories of prisoners buried under the bleachers and baseball fields; stories about farmers with shotguns who hunted prisoners on the run for sport. "Don't go upstate, man," was what everyone said, especially those who'd already been there.

Of New York's dozen or so maximum-security prisons, the best place to go was Sing Sing, even though it had its share of crazy violence. Those with SING SING stamped on their tags were lucky because the prison was only forty minutes from New York City.

As I sat and waited, I once again turned to God, Christ and Saint Anthony. This time, they pulled through for me. When my sack was returned, the yellow tag was boldly stamped with the name of my home prison: "SING SING," it read.

CHAPTER 6

Swing Swing

THE EXPRESSION "SENT UP THE RIVER" finds its roots in New York penal history. From the early 1800s on, convicted felons from New York City were literally "sent up the river" to the gloomy penitentiary perched above the banks of the Hudson River. Opened in 1828, the fortress-style prison, originally known as Mount Pleasant, was nestled along the east bank of the Hudson, thirty-three miles north of Manhattan. Only ten feet above the river's high-water mark, the prison's nearness to the water gave a sense of serenity that belied the suffering behind its granite walls. Under the brutal regime of Elam Lynds, a warden who favored flogging, backbreaking labor and uninterrupted silence, convicts from Auburn prison were transported to Sing Sing to build New York's third prison. At the time, it was the largest prison in the United States. Running north and south along the river was a five-story cellblock, 480 feet long, and only forty-four feet wide, containing 1,000 separate cells.

I arrived on July 17, 1985. When the transport bus stopped in front of the prison gates, I was struck by the awesome view of the river, which spread out from the prison like a smooth, still carpet. The contrast of the natural beauty of the surroundings and the daunting façade of Sing Sing was mind-boggling.

The bus ride from Downstate had been short but painful. My hands were cuffed and my legs were shackled in leg irons. A chain was

then roped around my waist and connected to the cuffs to restrict movement. Through an iron-cage partition, three armed guards watched the two dozen convicts on the bus with me, similarly shackled. As the bus inched past the giant concrete wall that enclosed the prison, I looked up and saw gun towers with armed guards inside. Seagulls circled high above the guard towers, giving the prison the look of a medieval castle.

Sing Sing has always had a notorious reputation. Until 1971, it housed the state's electric chair; 614 men and women have been electrocuted within its walls. I later learned that the 531st prisoner to be executed was a twenty-seven-year-old man by the name of Anthony Papa. He was executed on July 1, 1948, almost thirty-seven years to the date that I stepped foot on Sing Sing soil.

In 1983, a riot erupted in the prison's cavernous B Block. Although no one was killed, the inmates held seventeen guards hostage for fifty-three hours to protest poor conditions and dangerous overcrowding. Despite the incident, the prison continued to run at 120% capacity, with 2,300 maximum-security inmates. It was where I would spend the next twelve years of my life.

When the huge steel door of Post 18 opened, the bus pulled in and stopped in a small courtyard. The door clanged shut behind us. Several clipboard-carrying correction officers boarded the bus and matched our faces to our photo ID's and paperwork. Then a second door opened and the bus drove into the heart of the prison complex. We traveled down a long winding road that led to the back of a building. This was the state shop, where new jacks were processed. We were then taken off the bus and steered like cattle into a holding pen. Our cuffs and chains were removed. One by one, we were called to another room, where we were reunited with our property and given our cell assignments.

I was assigned to B Block; with some 660 prisoners, Sing Sing's B Block is reputed to be the world's largest cellblock. To get there, we had to travel past the Special Housing Unit (or "SHU," pronounced "shoe"), where prisoners were sent for assaulting other inmates or guards

or caught with weapons or drugs. Known by prisoners as the "hole" or the "box," the dreary cellblock contained the prison's most violent men. They were locked in their cells twenty-four hours a day save for an hour of court-mandated "recreation" in an outdoor cage.

Long, concrete corridors and tunnels connected Sing Sing's many buildings, most of which were in horrendous condition. Slabs of peeling paint hung from the ceilings. A thin film of moisture, residue from the nearby river, covered the battleship-gray walls. The smell of mildew, disinfectant and body odor from 2,300 men made me nauseated.

At several checkpoints along the way, we stopped while guards known as "turnkeys" opened the steel gates that were strategically placed throughout the facility. Prisoners couldn't travel beyond these checkpoints without an escort officer or an authorized movement pass. About 300 yards and countless steel gates later, a door swung opened and I took my first steps into B Block.

The noise hit me like a freight train. Rap music from radios hanging on cell bars blasted throughout the tiers. Prisoners shouted at one another from across the rows of cages stacked one on top of another, four stories high. The voices of hundreds of convicts ricocheted off the steel bars, creating a thunderous din. The block resembled a giant airplane hangar full of human cargo.

While I stood there, stunned, another set of gates opened. A guard led us to a cell that had been converted into an office for the officer-in-charge ("OIC"). The OIC ran the daily activities of the block and attended to the custodial upkeep of the 660 prisoners who lived there. I was astonished by the enormity of his task. I gazed out over the tiers and saw prisoners running buck wild up and down the corridors, hanging out in each other's cells, shouting to men on the other side. It was mass chaos, the complete opposite of Downstate. Whereas Downstate was clean and orderly, Sing Sing was filthy, raucous and crowded. It was crazy.

The first cell I was assigned to was a windowless, fifty-four-square-foot solid metal cube, number W-429. It contained a small bed with steel springs and a torn, piss-stained mattress. A toilet with an old, porcelain bowl squatted in the corner, next to a small metal locker. A portable lamp

with a built-in electrical outlet was clamped over the bed. Graffiti covered the walls. I threw my property sack on the floor and sat on the bed, which was more like a cot. I held my head in my hands to drown out the noise.

Shortly after, a guard cracked the cell gates, signaling it was time for lunch. I followed a group of prisoners to the mess hall and took my place in line. The mess hall was as loud and confusing as the cellblock. Hundreds of prisoners, some eating, some leaving, some standing on line, filled the massive, high-ceilinged room. At one point, I made the mistake of reaching over another con's food tray for some bread. "Hey, motherfucker!" He screamed in my face. "What's wrong with you? Don't ever reach over my food again or I'll kill you."

I backed away and apologized. I learned quickly that this gesture, like so many others in prison, was a sign of disrespect. The subculture of prison carried its own set of rules, known as the "convict code," which prisoners lived and died by. The best that a new jack could do was to learn the code as quickly as possible and pray that in the meantime, his rookie mistakes wouldn't get him murdered.

My first few months were tough. My wife and daughter had all but disappeared from my life, which devastated me in a way that I'd never felt before. The loneliness and pain started to close in on me. There were times, especially at night, when I thought I might not make it to the next day. Thoughts of suicide entered my mind. The only way to neutralize the pain was to shut out my life as a free person, to pretend it never existed.

It helped when I got a job, mindless as it was. I worked in the yard giving out sports equipment to prisoners. I tried to spend as little time as possible in my cell, where the loneliness caved in on me and I was alone with my thoughts. Years later, after I'd adjusted to prison life and accepted the fact that I wouldn't be home for a long time, I came to realize that there was something spiritual about spending time alone in a six-by-nine-foot cell. It put me in touch with myself. In this sense, prison was the most existential environment I had ever experienced.

One of the worst parts about life as a new jack was being checked out by all the other prisoners. Not having a crew was dangerous. The

prison was infested with predators and scam artists searching for men who hadn't hooked up with a gang for protection. B Block was more dangerous than the other blocks because it was a transit-housing unit. Prisoners were constantly coming and going. Prisoners in transit status knew that they would be moving out so they lived for the moment, not caring about anything or anyone.

The way for a new jack to protect himself was to join a crew and find safety in numbers. Some inmates joined racial gangs for protection, but you could find just about any kind of group to hang with to show that you weren't doing time solo. You'd start by playing basketball or handball with someone, then meeting his friends. If they liked you, you became "one of the crew."

I found a crew by pumping iron with two older Puerto Ricans. After we'd worked out together a couple of times, Roberto, who was doing twenty-five years for murder, took me under his wing and showed me the ropes. He told me that it was important to always have a weapon handy in case something went down. I said I wasn't looking for trouble. "It doesn't matter," he said. "Trouble has a way of finding you whether you want it or not." Later that day, we were hanging out in my cell when Roberto opened his green army jacket. From the inside pocket he removed a shank—a six-inch sharpened piece of metal with the end wrapped in black electrical tape. He offered it to me.

"No, Roberto, I don't want that," I said.

"Don't be stupid, Tony. You gotta have something." He looked at my locker and reached for a small box full of batteries. He snatched my laundry bag and pulled out a sweat sock. "Perfect," he said, loading the sock with a handful of batteries and knotting the end. I told him about my experience with the sock at Valhalla. "Yeah, you can use socks for a lot of different things," he said, "from brewing coffee to smashing someone's skull." He placed a boot on my bed and demonstrated, raising the lethal sock over his shoulder and smashing it down on the boot. "One good crack and that motherfucker is finished!" he said. "I broke many heads like this, and cracked many nuts, too," he laughed.

"Nuts?"

"Not the kind you eat. The kind you get when you're backed up."

"Backed up?" His explanations were starting to confuse me.

"Yeah, backed up because you got no pussy." He reached for the jar of Vaseline in my locker. Instinctively, my fists clenched and I looked around for a guard. Roberto grabbed another sock from my bag and filled the inside with a scoop of Vaseline. "Here," he said, handing me the sock. "When you get lonely, all you got to do is stick your dick inside and you'll be all right."

I looked at the sock and tried to imagine fucking it. "I don't think so," I said shaking my head in disbelief.

"Look," he said angrily. "You'll do a lot of things you'd never thought you would. I've been down for a decade and have fifteen more to go!" He was yelling now; the veins in his neck bulged. "I did shit even I couldn't believe but I had to in order to survive. Doing time will change you—face it." He calmed down when he saw the look on my face. He could tell his sermon rattled me. "Just keep an open mind, Tony. It's the only way to beat all this time you gotta do."

I'd never thought about time and its consequences. In the street, "time" was a relative concept, flowing in and out like the tide. Sometimes you had more, sometimes less. Here, it controlled you, grabbed you by the throat and made you hyper-aware of your existence. Roberto spent many hours educating me about doing time. His lessons probably saved my life.

One day, he asked me if I'd do his laundry for him. "Sure," I said.

"Wrong answer." He waved a finger in my face. "You never do nobody's laundry." Doing someone's laundry was the first step toward becoming his punk, he said.

I remained on good terms with Roberto and his Latino crew and started hanging out with a different crew.

One day I was sitting on my bed when a con tapped on the cell bars. "Hey, you got any soda cans?" he said. It was Benny the can collector. Benny roamed up and down the gallery all day long looking for soda cans to return for refund in the commissary. Benny claimed he was

a big-time drug dealer out in the world; he was always bragging about the cars and money he had stashed away, yet here he was collecting soda cans for nickels. A lot of cons did this; their stories were all they had.

Benny told me about a prisoner he knew, Frankie Cheeze, who was from the same neighborhood I was from. I doubted him, but it turned out that Frankie Cheeze used to hang out at the same bar I drank at, and we knew a lot of the same people. After a while, I started associating with Frankie and his crew. They were some real characters ...

Frankie was doing a ten-to-twenty for murder. The way he explained it, he was trying to "clean up the community" when he killed the neighborhood crack dealer. Apparently, he'd shot him execution style. Frank's best friend was Bruno, also from the Bronx. Bruno was serving a sentence of forty-four years for a string of robberies. Witnesses identified him by his extraordinarily long nose. With such a heavy sentence hanging over his head, it was never a surprise to see Bruno strung out on junk. Six years after I'd met him, he died of AIDS in prison. I watched his 220-pound frame dwindle to scarecrow-size the year before he died.

There was also Old Man Charlie, known as the biggest storyteller in the joint. His favorite story was about the time he was playing football in Fort Leavenworth, a federal prison in Kansas. When the ball was handed off to him, Charlie ran up the middle, pile-driving through the opposition to make a stupendous touchdown. When he crossed into the end zone, a teammate pointed to the back of his head. Unbeknownst to Charlie, he'd been stabbed during the play. An opposing team member had driven a shank into his skull.

Lenny was a cheesecake gangster from Brooklyn, a wannabe tough guy always looking for ways to boost his reputation. One day, he decided to make a hit on a guy from upstate and waited for him with a pipe in his jacket. He stood on a small platform above the yard that dropped eight feet down to a concrete landing. When the guy appeared, Lenny swung at him, and his victim ducked. He managed to simultaneously evade Lenny's swing and throw Lenny off the platform. Lenny fell smack on his head and was out cold.

I'd been watching the fight and rushed to help when another convict grabbed my arm and told me to stay away. "If he's dead," he said, "they'll pin the body on you," he warned.

There was one black guy in our crew named Rasta. As his name implied, he was a Rastafarian who was rarely seen without a book in his hand. He was always striving to educate himself; he was easygoing and levelheaded, a good guy to know and spend time with. Despite having a crew, danger still existed. Much of the danger was brought on by drugs. Sing Sing was awash in drugs, and where there's drugs, there's violence. Different crews would fight each other over distribution turf. I tried to keep a low profile but learned that what Roberto had said was true: Trouble has a way of finding you in prison, whether you're looking for it or not. To survive in this environment, I had to become comfortable with violence. I wasn't a violent person on the outside, but I learned that violence was deeply imbedded in the prison culture, where the strong preyed on the weak. Either you defended yourself or you were victimized, plain and simple. It could start innocently, like the time I was walking the yard when a young blond-headed guy complimented me on my sunglasses. I made the mistake of letting him try them on. A week later I was walking through the block when I ran into the same guy. He was leaning against the steam pipes with two other prisoners.

Casually, he walked over and stepped in front of me, blocking my path. He took a broken, rusty razor blade out of his pocket and waved it in front of my face. "I want those sunglasses, motherfucker," he said. Because I'd let him try on my sunglasses, he figured I was easy prey and now he was testing me.

My friend Roberto had taught me to look at the size of the weapon before reacting. As a rule of thumb, if the weapon wasn't deadly, you should fight back at all costs. If you didn't, word spread that you were a coward, which meant that your ass would be on the line with others. If the weapon was too big, though, it was okay to run but always return with an equal-sized weapon.

I looked at the razor blade. It was less than an inch long. It couldn't kill me, I figured. I made my choice and looked square into the guy's

face. I was ready to fight because I knew that my survival at Sing Sing depended on it. If I let him take my glasses, I'd be pegged a pussy. The predators would find out and make my life more hellish than it already was. "Use that," I growled, "and I'll kill you." I stared him down with pure hatred in my eyes, thinking about how I'd fucked up my entire life, lost my family, and now I'd be spending my best fifteen years in this rat hole for passing a fucking envelope. The piece-of-crap con must have seen the fire in my eyes and everything that was behind it. He quickly put away the blade and tried to make a joke out of it. I walked away; the incident was over.

I came to learn that I could get out of most situations simply by feigning toughness, or "fronting," as prisoners say, putting on a certain face or using certain words and speaking with absolute conviction. There were times, however, when violence was unavoidable. Often, it boiled down to being at the wrong place at the wrong time.

One day I was walking the flats, the ground-level area of the block, when I saw this guy Nicky whom I knew from the weight room. At 6' 2" and 240 pounds of solid muscle, Nicky was a monster. The week before, he'd noticed my sneakers and asked me what size they were. "Ten," I said. Funny, he wore the same size, too. Since I'd once seen Nicky whack a guy over the head with a forty-pound dumbbell just for looking at him the wrong way, I figured it'd be a good idea to get on his good side. I told him I'd give him my sneakers when I got a new pair. He'd nodded and thanked me.

The next day, Nicky spotted me at the rear of the cellblock and motioned me over to him. As I got closer, I noticed that his face wore a strange expression and his eyes were bloodshot. From his breath, I could tell he was drunk on jailhouse wine. "Give me your sneakers," he demanded.

"I didn't get my new ones yet," I said.

"You think I give a shit?" Before I could answer, he unleashed a powerful upper cut that caught me square under my chin. I sailed backwards to the floor—and my sneakers came off! He hit me so hard, I literally flew out of my sneakers. To this day, I don't know whether

they'd been untied and flew off from the impact, or if he'd knocked me unconscious long enough to yank them off my feet. Whatever the case, shortly after hitting the floor, I popped back up and ran for my life.

Friends told me to forget about it. No one wanted to start trouble with a guy like Nicky. Besides, people said he went crazy every so often, usually when he was high or drunk. If I left it alone, Nicky would be fine with me, they said. It was good prison politics.

Sure enough, the advice was sound. The next day in the weight room, Nicky acted like nothing had happened. "Hey Tony, what's going on?" he said, slapping me on the back and flashing a smile. "Thanks for the sneakers," he said. I noticed that he was wearing them.

"Hey, all right," I replied. "They fit okay?"

"Sure do, man, thanks again."

It was good to have guys like Nicky on your side.

About six months into my stay in B Block, I noticed that inmates were disappearing from the unit at a faster rate than normal. I learned that Sing Sing was rapidly turning over its population as a way to curb the violence. After a spate of multiple stabbing assaults, the prison would change the composition of the population by swapping dozens of prisoners in Sing Sing with prisoners from facilities upstate. I wanted to stay at Sing Sing, and asked one of the porters on the block what my chances were.

"If you wanna stay here," he said, "you gotta make a move now. You have to get general population status and then you'll be transferred to A Block." A Block was the main housing area for Sing Sing's maximum-security general population inmates. Most of the prisoners in the system earned their way there after serving years in upstate facilities. I was told not to get my hopes up.

I felt like I deserved a lucky break and started to ask around. One guy told me to see a prisoner who taught in the paralegal studies program in the law library named Paolucci. He was one of two teachers in the paralegal program. Paolucci could see that I was desperate and a new jack. He told me he could arrange things.

When I asked him how, he said he had a contact who worked in the movement and control unit in the Correction Department's Central Office in Albany. His contact could easily assign me to Sing Sing permanently, he said, and the Administration would never question it. "It's done all the time," he said.

"What will it cost me?"

"For you? Two-hundred-and-fifty dollars," he said, implying he was giving me some kind of break.

I'd heard that inmate clerks had a lot of power in the prison. Chances were better than average that Paolucci was telling the truth. I told him I'd have my uncle deposit a check in his account. He said he wanted cash or the deal was off. If I wanted to stay, I'd have to get him the money the old-fashioned way. It was a risk I was willing to take.

When my sister came up for a visit that weekend, I had her pass me the money: five fifty-dollar bills. Now all I needed to do was find a prisoner by the name of Whitey. Guys from the block said Whitey was a long-timer with a bad drug habit. His wife lived nearby, so he was always in the visiting room. Whitey was the prison drug mule. Dealers or desperados such as myself would pay him to "slam" the drugs and transport them back to the blocks. Slammers stuck things up their rectum.

I spotted Whitey and approached him. I asked if he'd slam the money. "Twenty bucks," he said.

"Deal."

"You got any Vaseline?"

I didn't.

"Then get me some cellophane from a cigarette wrapper."

I passed some cellophane and the folded-up bills to Whitey. He went to the bathroom. When the visiting time was over, we left the area together. I was curious to know how the hell Whitey would get through security. I certainly didn't have the nerve to stick something up my ass and risk time in the box, or worse, another conviction. You had to be a special kind of guy to do this, someone with nothing to lose, I figured. Like a guy I knew named Jackie who was doing life for murder. He was

transferred out of Sing Sing to Clinton prison. Not wanting to take a chance catching something with a dirty needle, he shoved his works up his ass bearing the pain of a ten-hour bus ride. I wasn't at that point yet.

We walked toward the booths where prisoners were strip-searched. They were the size of bathroom stalls and didn't have doors or curtains. I entered the booth; Whitey entered one next to mine. I stood there and waited. A guard approached and stared me in the eyes. I was used to this from county jail. The gesture was meant to detect any signs of nervousness. As I started stripping off my clothes, I heard Whitey arguing with the CO. Another cop ran into the booth to assist with the search. The guard watching me told me to get dressed. He didn't even bother to search me. As I walked by Whitey, three guards were standing around him. He was naked and I thought for sure he was busted.

When I got to the housing area, I cursed my luck. Chances were strong that Whitey had been busted and ratted me out to the guards to lessen his punishment. This was all I needed. A few hours later he appeared outside my cell. "Here you go, pal," he said, handing me five wet fifty-dollar bills.

"Jesus, Whitey, I thought you got busted." He explained that the guard searching him was a wise-ass who'd hassled him before. "He was just trying to bust my chops," he said. Before he left, he told me to hang the bills to let them dry. "Might wanna wash them again, too," he said. "Jailhouse money smells like shit." He was right.

The next day I gave Paolucci the cash. He told me to sit tight, he'd take care of things. A couple of weeks went by and nothing happened. I was afraid I'd get shipped upstate any day.

"Don't worry about it," Paolucci said. "Just give me a little more time."

Sure enough, I found out that Paolucci had spent the money on drugs and taken me for a ride. When I told my friend John, he was mad I hadn't asked him about Paolucci before giving him the money. "The man's a known scam artist," he said. John hated Paolucci, not because Paolucci had scammed him but because he'd flunked John in the paralegal class.

"It's disrespectful to flunk a fellow prisoner," he said. "Not to mention embarrassing."

Because I was his friend, John said, and because he'd been waiting for the proper excuse for payback, he promised to take care of Paolucci for me. I probably wouldn't get the money back, he said, but at least I'd get vengeance.

When the moment presented itself, John attacked Paolucci with a pipe, almost murdering him.

Payback was fine, but I was still going to be shipped upstate. It could happen anytime, without warning, I'd been told. I had to find a way into general population.

I tried to get a job as an electrician in the prison. Getting assigned to certain jobs could guarantee general population status if a prisoner had a skill the facility needed. Prisons saved thousands of dollars by employing convicts instead of civilian contractors. Convicts with plumbing, electrical and carpentry skills were highly valued. Even though most prisoners welcomed the work, the pay stunk—a buck fifty was the most you'd earn in a day. It was state exploitation at its finest. Convict labor was outlawed in the early 1900s, and government regulations prohibit state correction departments from selling convict-made products on the open market for the obvious reason that private businesses can't compete with the low cost of prison labor. Despite these restrictions, New York's Department of Correctional Services makes $24 million annually through its inmate-run CORCRAFT factories that operate in most of the state's maximum-security prisons. Over 2,500 prisoners manufacture products such as uniforms, cleaning supplies, license plates and furniture. The Corrections Department then sells them to other state agencies and local governments. Prisoners are paid wages ranging from sixteen to forty-five cents an hour.

I went to the chapel where the administration had set up a committee to assign qualified prisoners to work assignments. I approached a counselor and said I'd like to work as an electrician. I said I had skills to offer Sing Sing and that I wanted to spend my time doing something constructive, something that could get me a job in the real world once I got out.

"Look everyone," the counselor called out. "This man wants to be rehabilitated!" He doubled over in laughter.

I looked at his pudgy face, red with glee, and I thought of everything I'd gone through to get to this sorry place, how I was standing there like a fool, begging for a job that paid pennies. This time, I didn't *want* to contain my anger.

"And what about it?" I shot back, not bothering to disguise the hostility in my voice. "I know lots of guys in here who want to improve themselves." A few heads turned. The room grew quiet.

"Rehabilitation does not exist," the counselor said flatly, glowering at me.

"Really," I continued, "You mean to tell me that your job amounts to nothing more than locking people up? You don't believe in giving prisoners a chance to do something constructive with their time?"

He didn't respond. I knew I should've kept my mouth shut, but I was sick of the crap. All the prison was good for was warehousing men, infantilizing them and then churning them out like so many widgets on the day of their release. I stepped closer to read his nametag. "Mr. Cody," it said. He was a civilian employee, not a cop. Fuck it, I thought, feeling empowered for the first time in months. "You know, Mr. Cody," I said, enunciating both syllables in his name. "With that kind of attitude maybe you shouldn't be a counselor."

He stared at me hard and tapped his pen nervously on the desk. I decided to back down. "Look, man, I'm sorry. I got a family to support. I could really use a job."

"I don't have a job for you," he said, his voice rising. "Now get out!"

As I left, a counselor sitting in the rear of the chapel got up and walked out with me. He introduced himself as Dennis Manwaring, the Special Subjects Supervisor. "I heard what you said about your family," he said. "Why don't you come by my office tomorrow morning and we'll see what we can do." I looked in his eyes and I trusted him.

The next day, after a brief interview, Dennis signed the necessary paperwork and got me general population status. Just like that, I was staying at Sing Sing.

As soon as I moved into A Block, I called my attorney. "Don't worry," George said, "I'll get you out of this." He'd been making that promise from the moment he'd met me to the day that the jury pronounced me guilty. "You got a good case for appeal," he'd said. "A really good case …"

George had a way with people. Your gut could be shouting "He's lying!" but somehow he'd pull you in. I reminded him he'd made the same promise before the trial.

"It's a whole different ball game now," he explained. "Appellate Court judges look at laws and facts, not circumstances and hearsay like trial courts. My God, Tony, there are such obvious constitutional violations in your case! It's a travesty of justice! I'm *positive* I can reverse your conviction." My life was in George's hands. Despite what my gut was telling me, I wanted to believe him. I had no other choice.

Shortly after I blew trial, my Uncle Frank hired George to work on my appeal. He didn't tell me, which wasn't surprising. Frank loved me like a son and was generous to a fault. Golden-tongue George told Frank that he'd given him a break by charging him only five thousand dollars instead of his regular appellate fee of ten grand. Of course, Uncle Frank didn't have that kind of money and had to go on a payment plan. Now George was saying that he couldn't proceed with the appeal until we got the trial transcripts from the court. Without them, he said, he couldn't draft an effective appeal and the court charged $3,500 to produce the transcripts. I told George I didn't have the money and to file a poor person's motion to request the transcripts free of charge. The motion was denied, but George promised to resubmit the request. He said he was doing his best to get me out of prison and I needed to be patient. "It's going to take some time," he said. I told him I'd wait.

Meanwhile, I tried to settle into my new environment. A Block looked just like B Block: tier upon tier of cells stacked one on top of the other in sterile, institutional monotony. I was assigned cell P-685, located on the third tier of the cellblock's northern side facing the Hudson River. Of course, "facing" the Hudson didn't mean a picturesque

view. If you craned your neck just so and squinted hard, you could catch a glimpse of the river beyond the dirty windowpane, steel bars and coils of razor wire.

I remember unpacking my belongings. For the first time since I arrived at Sing Sing, a feeling of calm settled over me. It was quiet and the galleries weren't jammed with prisoners. I resisted the urge to arrange my belongings too tidily or decorate my cell. I wasn't going to pretend that this six-by-nine-foot cell was my home.

You could tell a lot about a prisoner simply by the look of his cell. Some men decorated their cells with matching towels, covering the walls and sometimes even the toilet bowls in same-colored towels to create the appearance of an accessorized bathroom. Some prisoners displayed their toiletries in neat rows: bars of soap, hair grease and other products neatly arranged to show they had money and were doing "good time." On the opposite end of the spectrum, other prisoners lived in barren cells devoid of any personal effects—no pictures, posters, anything—except for a couple of rolls of state-issued toilet paper. These prisoners were the equivalent of homeless people on the outside.

It didn't take long for my neighbors to check me out. As I finished unpacking, two men from the cells on either side of me came by to introduce themselves. George and Max were both serving life sentences for murder. George was a distinguished-looking white man, quiet and serious. Max was Puerto Rican, lean from years of heroin use. They described themselves as "old-timers," guys who'd spent most of their adult years in prison. They were in their sixties and had been pals for a long time.

"How long you in for?" Max asked.

"Fifteen to life."

"Drug charge?" George asked.

"Yeah."

"First time?" asked Max.

"Yeah, I just came over from B Block."

"It's different here in A Block," Max said.

"It's definitely quieter," I admitted.

George laughed. "Wait 'til the afternoon."

They said they hoped we'd all get along. They didn't want any problems; they just wanted to do their time as peacefully as possible. "Don't worry," I assured them. "I'm not looking for trouble."

"Gotta look out for them new bucks," George warned. "Young kids coming in from the city jails."

"They don't know nothing about doing hard time," said Max.

"It's a crazy block, A Block is," said George. "But you'll do all right. Just stay away from the drugs." He gave a sideways look at Max.

"And the punks, too," added Max, shaking his head. "Too many of them here."

"And try to tune out the noise, come afternoon ..."

They weren't kidding. A Block's din started around 3:30 when prisoners came back from their work assignments. They packed the galleries and roamed about, shouting, laughing, catcalling, and roughhousing. It was in those first few minutes that I got my first good look at what hard time was all about—a prison on the edge, spinning on the head of a needle waiting to crash. Although the noise level was just as bad as in B Block, there was one big difference: You could *smell* the tension in the air. You could *feel* the life sentences many of the men were serving. Some prisoners shuffled ghost-like along the tiers with a vacant look in their eyes. Cons called it the "dead man's stare," common among lifers who knew they'd never go home. Over the years I met countless men who knew they would die inside the walls. I also met some very dangerous individuals, who would murder you in a heartbeat.

Later that afternoon, I went to the yard to survey my new surroundings. On the outskirts of the baseball field, I found a place where I could lean against the fence and see the Hudson River unobstructed by barbed wire and the hulking mass of the prison. With the sun on my face, I watched sailboats drift slowly down the river. Seagulls swooped down then settled on the shore. I leaned my head back and drew in a deep breath. It was so peaceful I almost forgot where I was.

A piercing scream shook me from my reverie. I looked up to see three figures running across the baseball field. The man being chased

was running for his life. The guy behind him was cursing and swinging what looked like a huge kitchen knife. A baton-wielding guard pursued the two men while yelling into his radio for backup. When the guard got close, he charged the prisoner with the knife and smacked him with his baton. The prisoner became enraged. Incredulously, instead of stopping, the prisoner turned and chased the guard in a circle around the field, completely forgetting about the original man he was chasing.

Backup finally arrived. A group of guards cornered the knife-wielding prisoner in the handball court. They surrounded him and ordered him to drop the knife, but he continued to swear at them in Spanish, charging them with the blade raised high in the air. The guards would back down, and he'd charge them again. It was insane. The dance continued until an old Puerto Rican, angry that his bocce ball game had been interrupted, hurled a ball at the convict, hitting him square in the back. The prisoner cringed in pain and fell to the ground. The guards descended upon him like angry hornets. They wrestled the weapon from his hand and beat him into submission with their baton.

A Block had the fitting moniker of "labyrinth." Looked down from the uppermost tier, the block resembled a perfectly square maze encased in steel. From certain angles, it looked like something out of an M.C. Escher nightmare. Each tier contained three-foot-high railings topped with fencing to prevent prisoners from throwing each other over. The fencing was basically worthless because every ten feet or so, someone had cut a hole large enough to dump a body over.

According to George and Max, the term "labyrinth" was fitting because prisoners got lost in Sing Sing. "Not literally," George said, "figuratively." George was deep; I liked listening to him. "People get lost in that they lose their identity, they *become* the number assigned to them by the state." The wisdom of their decades in prison emerged in this simple conversation. I listen intently.

"They lose themselves in the system they've become part of," explained George. "For men with limited resources, it's their only way to cope."

"They get institutionalized," added Max. It sounded as if they'd gone through this routine before, schooling new jacks in the perils of prison

life. "Be careful," warned George. "Take my word for it. You're new here. The predators will try to run some game on you any day now."

George told me to be especially careful in "Times Square," the name for the flats behind the gym. Times Square was the Sodom and Gomorrah of Sing Sing. There was always some kind of action going on there, some deal going down. The guards knew what went on, but most of them, like the prisoners they watched over, were old-timers who knew how the system worked. They were more interested in doing their shift and going home in one piece than playing super-cop. They avoided confrontation at all costs.

New guards were different, and Sing Sing had a lot of them. It was where most of the guards straight from the training academy were sent for their three weeks of on-the-job training before they officially became New York State correction officers.

At best, the relationship between prisoner and guard is a union in survival. Prisoners do not trust guards and guards certainly do not trust prisoners. In the vacuum that's created, suspicion and hostility fester.

Female guards were seldom assigned to Times Square. Those who did work there suffered. The prisoners got a kick out of giving them a hard time. A favorite way of finding out if a female cop was "soft" was to see her reaction when a guy stuck his penis through the bars at count time. "Count this head!" the con would yell.

Some officers made their jobs more difficult by playing hardball, going strictly by the rulebook. In dealing with prisoners, a black-and-white approach is not always smart, particularly when it comes to petty violations. Most prisoners walk around with a massive chip on their shoulder—they're pissed off *before* you've threatened to write them up for something. I witnessed more than a few occasions where a simple violation turned into a serious altercation all because the guard didn't know how to operate in the gray. I saw many new jacks get beaten and even stabbed by prisoners because they didn't know the system. Sooner or later, the new cop would learn the ropes and life would go back to normal.

You could get anything you wanted in Times Square: goods, services, entertainment, you name it. There was even a casino in the back with an ongoing poker game. To get into the game, you needed a carton of cigarettes for the moneyman holding the kitty. He would exchange the cigarettes for pieces of old playing cards, known as jailhouse poker chips. Most of the time, the game was civilized, but occasionally a fight would break out and a prisoner would end up in the clinic.

The cells around Times Square were like booths in an outdoor market. From behind their curtain-draped cells, convict-craftsmen sold materials such as handbags, leatherwork and belts. Artistically inclined prisoners sold greeting cards and poems in frames made of intricately folded cigarette boxes. Some men provided tailoring and ironing services, similar to a dry cleaner's on the outside. Several prisoners had candy stores with cookies and chips, and cold cans of soda in buckets of ice, a rare commodity in the joint.

Other cons actually operated restaurants out of their cells, giving that section of the block the look of Manhattan's famed Restaurant Row. The Puerto Ricans cooked up pots of rice and beans; the Italians offered spaghetti and meatballs; the African-Americans made their chitlings and yams. There was even a Chinese take-out cell and a McDonald's, where you could buy hamburgers and French fries.

You could also purchase services. For a few packs of cigarettes a week, you could have dinner delivered to your cell. In Times Square, you could find a prisoner to slam dope for you, throw someone a beating, or do your laundry. Sex was available, too, although you'd have to worry about AIDS and other diseases since condoms were considered contraband. Correction officials don't permit them, they say, because doing so would imply that they condone sexual activity among prisoners, which is against the rules. I thought this was odd. Everyone knows that prisoners have sex, consensually or otherwise. In fact, experts say that the New York State prison system is the largest AIDS clinic in the world. About 10% of state prisoners are HIV+, yet the governor continues to block bills permitting condoms, even though they are permitted in New York City jails.

A jailhouse remedy was to cut off the fingers of plastic gloves discarded by the guards. If you wanted sex and had the money, there was a gang of queens that ran a sex-for-pay service. These were some of the most dangerous prisoners at Sing Sing because they had a great deal of power and were a highly sought-after commodity. With their make-up, nail polish and fake breasts, their resemblance to women was so strong that if you passed a group of them in the corridor, you'd think the prison had suddenly gone co-ed.

While prison rape was not as common as depicted in the movies, it happened. And you could count on it happening if you were weak and didn't have a crew to protect you. I knew dozens of prisoners who had a hard time surviving and got turned out, either because they couldn't defend themselves from predatory convicts or because they couldn't handle the sexual deprivation. They'd buy blowjobs from men and then get visits with their wives on the weekends.

To say it was wild in A Block was an understatement. It was out of control. The source of the problem was out-of-touch administration. When the prison brass came through for an inspection, which was rare, their presence was forewarned by guards in the office, who told the guards in the block. They straighten things out temporarily, but the minute the white shirts left, it was business as usual.

My first night there, I was awakened by the screeching cries of a cat. It sounded like it was being murdered. Yelling and curses erupted and echoed throughout the block. "Puta!" "Maricona!" they yelled in their native tongues. I washed my face and moved toward the front of my cell. I stuck my mirror between the bars and looked for the source of the noise. Max was doing the same thing. "That's Chief, fucking a cat," he said.

"What the hell?"

"Yeah, you heard me right. He's one sick motherfucker. He locks down on W gallery with the mess hall workers. The guy has a thing for cats. He buys them from prisoners who catch 'em in the yard. There's a lot of crazy things going on here. You'll see."

I found out that the prison had more than a few sadistic psychopaths like Chief, who was serving a life sentence for murdering a

couple of kids. Just knowing what people were capable of fueled the level of violence in the prison, that and the thriving prison drug trade. Whether you were a recreational user seeking a respite from prison life, or a hard-core addict who needed a daily fix, you could find your drug of choice at Sing Sing. There was heroin, weed, coke, crack, speed and pills. Heroin was the most popular drug. The six-hour high could wipe an entire day from the calendar.

Drugs were smuggled in various ways. Some were hidden in packages sent from the outside. Peanut butter, for example, was excellent for smuggling drugs. The peanut butter would be melted in a microwave and scooped out to make room for the drugs. It would then be replaced and the jar would be heat-sealed in the microwave. Some people would actually have the container professionally shrink-wrapped before mailing it to give it a store-bought look.

Prisoners' visitors also brought drugs into the prison. They'd transport them in a body cavity—I once knew a guy who smuggled drugs in his baby's diaper—extract them in the visiting room bathroom, and then pass them on to a prison mule, who'd slam the drugs up his ass and clear security with ease.

Corrupt guards and civilians who worked in the prison also brought in drugs. Drug dealing was a lucrative way to supplement their state salaries, and since they weren't subject to intrusive searches like prisoners, they could smuggle in much greater quantities. They didn't have to rely on body cavities to conceal the drugs. They'd simply bring them in their handbags or briefcases.

For the right price, you could get virtually any type of contraband you wanted, from drugs to steak to street knives to television sets. A lot of the stuff was stolen from the Sing Sing warehouse. With an operating budget of about forty million dollars a year, everyone was getting a piece of the pie. Word of mouth advertised who had what. The price of drugs varied, but the rule of thumb was four times the drug's street value. A ten-dollar bag of heroin on the street would cost forty dollars cash or the equivalent in cigarettes. If you didn't have cash or smokes, you could make payments through "send-outs," essentially street-to-

street transactions. Send-outs were the safest way to go because they were difficult for administration to trace. The person who sold you the drugs would give you the name and address of a contact on the outside. You'd have a friend send the contact the money, who would then deposit it in the prisoner's commissary account.

If you got hooked on drugs, you could count on paying with more than smuggled currency or cigarettes. Some guys got in so deep they even sold their bodies to get a fix. Whether or not you used drugs on the outside, it was easy to get hooked on the inside. It was said that if you didn't have a habit when you came to Sing Sing, you could easily leave with one. It made me realize, too, that if the drug trade couldn't be controlled in a maximum-security prison, where security and cops abound, it could never be controlled in the outside world.

On Saturdays, at the top tier on P gallery, there'd be a line a mile long in front of Conno's cell. Conno had four bodies and was serving eighty-years-to-life for murder. He had a gang of prisoners who'd watch out for the guards and a curtain draped over the front of his cell. Customers would enter his cell, lay the cash on his bed and buy whatever drugs they wanted.

Some prisoners sold drugs to support their families. These were the men who saw their homes repossessed or their families evicted when they were shipped off to prison. They'd been their family's primary breadwinners; now, the most they could do was cover the cost of Pampers with their meager prison wages.

Guys who wanted to sell drugs on their own as independent operators always had trouble. After the hard work of smuggling the drugs into the prison, drug crews would extort them almost immediately. I remember one guy, Fat Ralphie, a pudgy Latino who started selling dope to feed his kids. Ralphie saw no harm in making money off the bundle or two of heroin that his wife smuggled in every Saturday. Pretty soon, Ralphie had built up enough clientele to attract the attention of the drug crew that controlled the cellblock. One day after a visit from his wife, they paid Ralphie a visit. They forced him to sit on the toilet and shit out the balloons of heroin he'd slammed and threatened to cut

his throat if he didn't. Fat Ralphie didn't have much pull in the joint, so he was forced to continue smuggling for the drug crew. Every Saturday, after a visit with his wife, he'd receive a visit from the drug gang. After he smuggled for them a few times, it was too late to pull out. Every week, they threatened to kill him if he didn't produce. Eventually, Ralphie had to check into PC—Protective Custody.

Jailhouse wine was even easier to get than drugs because it didn't have to be smuggled. It was made in the prison from easily obtainable ingredients: oranges, apples and potatoes. Prisoners would ferment the stuff in buckets they'd stash in the ceilings, toilets, sinks, anywhere they could hide them. The way Sing Sing was built, there was no shortage of hiding places. The best was when one prisoner actually hid a bucket of hooch underneath the ceiling panel above a guard's desk.

I was learning the ropes and settling into the general population at Sing Sing. I had no other choice but to adjust to the environment. It was the only way to survive. Meanwhile, my connection to the outside world was slipping away. My weekly phone calls to my lawyer became monthly ones. George's cheerfulness faded by the phone call. Finally he told me, squeezing out the words, "Listen, pal, you're going to have to do some time. Get it into your head."

I hung up on him. At that point, I realized I'd become part of the labyrinth, like it or not.

Discovery of Art

DEPRESSED AND LONELY, thinking my life was over, I began searching for a way to deal with my imprisonment. I had been effectively cut off from the real world. To compensate for the loneliness I subscribed to every piece of junk mail I could. A single piece of mail confirmed that I hadn't been forgotten. This was the worst part of being in prison, realizing how alone you were. I had no direction in my life and knew I needed a way to transcend the situation, something to give meaning to my life. Something to get out of bed for in the morning.

One day, while walking to my cell, I smelled the sharp odor of paint wafting through the tier. I followed it to a cell about twenty yards away. I peered inside and saw a prisoner painting a portrait. His back was toward me. For several minutes, I watched him in awe, transfixed by the gentle motions of his brush and his intense concentration. With every stroke of his brush, the painting came closer to life. He looked like he was in another world.

His trance was broken when he stopped to pick up a tube of paint. He turned to me. "You keep looking in my cell. You got a problem?" One of the unwritten rules in prison is that you never look directly into another man's cell. It was a sign of disrespect, an intrusion.

"It's nothing," I said. "I was kind of mesmerized watching you paint. I admire your talent."

He nodded and pushed out his chest, apparently flattered by my remark. "You ever try it before?"

"Nah, just some drawing when I was a kid."

"You never painted?"

"Nope."

"You want to try?"

"Why not?"

His introduced himself as Angelo Surean, but everyone called him Indio, he said. His close friends called him Indio-Love. He was known as the best portrait artist in Sing Sing. Indio also loved to chase the bag; he supported his habit through his art. For a bundle of dope (ten bags of heroin), he'd paint the most magnificent Rembrandt-style portraits and sell them to prisoners and guards alike. Before I left, Indio gave me a brush, some watercolors and a sheet of paper. "Give it a shot," he said. "If nothing else, it'll take you away from here for a few hours."

That evening, I played around with the watercolors. Something about the process energized me. I stayed up all night trying to paint a landscape of the Hudson. The finished piece looked terrible; I thought it was the worst painting I'd ever seen. The sharks I added to the river didn't help.

The next morning, I showed Indio. "Wow, not bad," he said to my amazement.

"Huh?"

"You wanna learn how to paint?"

"Yeah ... how?"

He told me to go to the hobby shop the next day. He'd worked there for the past six years. "I have a corner, near the ceramics area, where I do my painting," he said. "I'll teach you the basics to get you going."

"Sounds great, man. Thanks."

"Are you assigned right now?" Being assigned meant having a prison job. I told him I was unemployed. "How would you like a cushy porter job in the hobby shop? The prison will pay you ninety cents a day and you can learn how to paint."

Apparently, Indio had some influence in the hobby shop. Not only had he worked there for a half a dozen years, he was a favorite of the female instructor, Flo. He said he'd see what he could work out.

Two days later, I was assigned the job. From that moment on, painting became an essential part of my life.

The hobby shop was located in the basement of the school building. Like the law library, one floor up, the area had a steady flow of traffic and was a prime spot for illegal activity. The more bodies, the easier it was to pass things off. Another reason the basement was a crime zone was because the officer assigned to the area played it smart. He knew that people were dealing drugs but he looked the other way; it was the safest—and easiest—thing to do. With seventeen years on the job and eight more to go until retirement, Harry was biding his time. "He's a prisoner just like the rest of us," the guys said. "Knocking out his twenty-five-year bid."

Harry often nodded off at his desk, looking like he'd just done a good bag of dope. He never reported anybody for anything—too much paperwork involved—and regularly drank on the job. In fact, Harry let prisoners store gallons of hooch in the ceiling above his desk as long as they'd give him a jug when it fermented. He actually liked the stuff.

Along with a crew of inmate porters, there were two civilian teachers who worked in the hobby shop. One of them, Pete, taught woodworking and leather crafts. Flo taught ceramics. Pete tried to go by the book but was too afraid of the convicts to do so. More often than not, he looked the other way when something was going down. Like the time when Ace, one of the workers, almost caused a riot when he sold a dummy bag of heroin to another prisoner. Instead of dope, the bag contained ceramic dust.

The poor instructors had their hands full because the workers ran the hobby shop like a Wal-Mart. They made fast money selling ceramics and other goods to prisoners, especially around the holidays when cons needed gifts for their loved ones. The administration restricted inmates to making two pieces a month, but it was more like two pieces a day around the holidays. Customers would pay with cash, drugs, services or cigarettes.

The other instructor, Flo, was a 45-year-old flower child still clinging to the ideals of peace and free love. She had a nice little shape on her from her days as a figure skater, but Flo could've been the ugliest woman in the world and we all would have found her beautiful. That's how it was in prison, although she did have a seductive way of bending over the kiln. Flo's bending and the easy money were the main reasons behind the six-month waiting list to get into the class. Flo got off on the attention, but she kept her hands off the prisoners.

Some students eventually got dismissed for lewd behavior, but only when it got out of control. She once caught a student jerking off behind the ceramic molds of Michelangelo's Pieta. I was surprised when she didn't kick him out. Instead, she treated us to a short lecture on human behavior, saying that masturbation was a natural response to loneliness and deprivation. But soon after, the same student was caught masturbating on her sweater in the back office. Flo screamed when she saw him and kicked him out. Another guy got busted trying to look under Flo's dress with a pocket-sized mirror that he glued to his shoe.

No one came close, however, to the school building porter who developed a lucrative business when he turned Flo's private bathroom into a peepshow. He carved a hole in the wall of the utility closet that was connected to the bathroom and charged a pack of cigarettes to any prisoner who wanted to watch Flo relieve herself. It went on for months before she found out. This time, she told the administration. Though she was a love child at heart, Flo did have her limits.

I focused on painting and learned everything I could from Indio. At first, he taught me how to paint in watercolor. According to Indio, watercolor was one of the most difficult mediums to master. Most students quit after a few weeks. For me, it was different. Not that it came easy. I struggled but the challenge invigorated me. I fell in love with the explosive process, watching the colors bleed onto the surface of the canvas and waiting for the piece to come together. I did my painting on a small table in the corner facing the Hudson River. Despite the coils of razor wire obstructing the view, the expansiveness of the river was awesome. If the light fell a certain way or the water was especially still, I

could get lost in its eerie stillness, the majestic beauty of the river juxtaposed against the granite walls of the prison.

Every year, the New York State Department of Correctional Services, in conjunction with the state senate, hosted the Corrections on Canvas art show. The contest was open to all 70,000 prisoners throughout the state and was a major motivation for prisoner artists. Indio entered the contest every year and usually came away with several ribbons.

I'd only been painting for a few months when I learned about the contest. I told the guys in the shop that I was going to enter and win a prize. Most of them laughed; some of the guys had been painting for years and hadn't won a ribbon.

Not surprisingly, I didn't either, but Indio did, along with another artist from our group. The guys in class heckled me with I-told-you-so's. "Try painting-by-numbers," one of them joked. To cheer me up, Indio presented me with a mock award: a framed document with a silver seal made from a cigarette box wrapper and a small pink ribbon. Printed were the words, "Artist Indeed!" Some of the guys signed it with upbeat messages: "Keep on trying!" and "Better luck next time."

I told myself that I'd win a ribbon the next year. I visualized the ribbon I'd receive and day and night, I worked on my painting. I studied drawings and techniques from books and watched Indio when he'd let me. Painting became my obsession.

When it came time to prepare for the contest, the painting I decided on was titled *View over Manhattan*. It was a painting of the city I missed and loved, the city that had disappeared from my life which I needed to paint to keep alive. I won my first ribbon that year.

Indio was impressed and decided it was time to teach me how to paint in acrylics. Through this medium, I discovered the true power of a brush on canvas. The raw energy it produced was amazing. I started painting pictures from art magazines that Flo brought in for me. She picked out pictures she thought I could handle and showed me how to approach them. I was very happy with myself, painting beach scenes

and girls in frilly white dresses in the Impressionism style. Even though my pieces were copies, Indio said that just copying the great Impressionists would improve my skills. Monet and Renoir were my favorites.

Through Indio's mentorship, my artistic skills flourished and I began to see myself as an artist. He had taken me under his wing and we became close friends. Only once did we have a problem.

It happened the day that Indio was released from solitary confinement. He'd been locked up for a month for dirty urine, meaning that he'd tested positive for drugs. Indio was usually careful when it came to his drug use, but sometimes there was nothing you could do. If a guard smelled marijuana but couldn't trace it to a specific cell, he'd test every prisoner in the vicinity.

When Indio came back from solitary, he didn't look right. I didn't expect him to actually look cheerful after a month in the hole, but his expression wore a hostility I'd never seen on him before. I was showing Flo an art book I'd just gotten in the mail when Indio walked in. He sat at a table, not bothering to say hello. When Flo left to go to the bathroom, Indio approached me. "What you think you're doing?" he said.

I looked up. "What do you mean?"

"You're sitting in my chair," he said.

"What about it?" Indio's eyes bulged. He looked paranoid, like he was seeing an illusion. "What's wrong with you, man?" I said.

"I don't like this," he shot back.

"Indio, what's the matter? Are you okay?"

"Listen, man, I don't like this," he said again. He squinted at me with an evil look in his eye. His jaws tightened.

"Like what?" I asked, not caring for his attitude. "Do what you have to do, man," I told him. I turned away from him and continued reading. Suddenly, from the corner of my eye, I saw him move. Instinctively, I raised my arm, just in time to deflect a ceramic mug he was swinging at my head. It smashed against my wrist and shattered on the floor.

"What the hell?" I shouted, holding my wrist. A shard of ceramic had cut through to the bone. Blood streamed down my arm in a thick, warm flow. Indio stood over me, shaking with rage while I grimaced in

pain. Flo returned and ran toward us. "What happened?" she yelled.

"He went crazy! He hit me with a cup!"

Flo paused and looked at Indio. Then she turned to me and said flatly, "No, you tripped over a stool."

"*What?*"

One of the students must have gone for help because moments later a female cop came rushing in. "Why are you bleeding?" she demanded, surveying the broken mug on the floor. "What happened?"

"I tripped over a stool," I mumbled. "I was carrying the mug and I tripped."

"I'm calling the sergeant," she said, radioing for her superior.

They took me to the prison infirmary. Most of the time, there were no doctors on duty; if you were lucky, a physician's assistant was around. That was fine if all you needed was an aspirin or your temperature taken. If you needed sewing up or anything else more serious, you were in trouble. Stitches and surgery meant going to a hospital on the outside. Before that could happen, the Watch Commander would have to dig up your prison mug shot to verify that you were who you said you were, check your record for escape attempts, and basically complete a bunch of paperwork. Meanwhile, you could be bleeding to death or dying of a heart attack.

After the paperwork was completed, you then had to remove any personal clothing you were wearing and change into your official prison greens and state-issued work boots. I guess this was so you wouldn't be mistaken for a regular citizen in the hospital. Finally, you were shackled in leg irons and handcuffs and tossed into a transport van for the twenty-minute ride to the emergency room.

The transportation officers didn't help the situation. They were paranoid about escapes. When they tried to handcuff me, I put up a fight. "Are you out of your minds?" I yelled at them, showing them the bleeding, eight-inch gash, open to the bone.

"Security reasons," they said, holding out the cuffs. Most escapes were attempted during hospital runs. Several months before, a prisoner had grabbed the escorting officer's gun in the hospital elevator. He then

pistol-whipped the officer and fled. Although he was captured within days, the administration fired the officer and tightened up security.

"I'm not going," I said. "I'll bleed to death before you put cuffs on my wrist." The guards talked it over and struck a compromise. They agreed to leave my bleeding wrist uncuffed, but they handcuffed my good arm to a chain around my waist. Nearly three hours had passed from when Indio threw the mug at me and I arrived at the hospital.

When the officers escorted me through the doors, the emergency room went quiet. Everyone turned and gaped at me; mothers scooped up their children. Shuffling through the room in leg irons, cuffs and a waist chain, I felt like a wild animal. People looked at me with disdain. I felt ashamed and hung my head. This feeling of disapproval, part of the prisoner stigma, gets stamped into your soul. Even when you're free, it stays.

I was given ten stitches on my wrist. Afterwards, there was an interrogation with the cops, who demanded to know what had happened.

"Mr. Papa," the sergeant said in a threatening tone, "It is in your best interests, and the security interests of this facility, to tell us exactly what happened." When I didn't respond, he added, "If you are concerned about reprisal, we can protect you ... immediately if need be." Right—if I told him what really happened, they would transfer me to protective custody and I'd be forever labeled a snitch. Next to being a child molester, "snitch" was the worst "prison jacket" you could have in the joint.

"No one attacked me, sir," I explained. "I just tripped over a stool while carrying a mug. That's all there is to it, I swear."

He let me go.

The next day, I saw Indio in the yard. He was tending one of the little gardens behind the school that the administration permitted in designated areas. He was bent over a flowering bush, examining some newly opened buds. I approached him warily, afraid that he might flip out on me again. "Hey ..." I started.

Before I could ask him what happened, he apologized. "I'm sorry, Tony," he said. "I'm really sorry ..." He tried to hug me. "I didn't mean that."

I shirked his hugs. "You almost killed me, man."

"Yeah. I did that to my brother once, too."

"What do you mean?" I knew that Indio was in for armed robbery and that he robbed to support his drug habit. In my mind, he wasn't a stone-cold criminal. He was an addict who did what he had to do. Addiction demands criminality. But violence? I never imagined he'd turn on me.

"Sometimes I just bug out, man. I guess I thought you were dissing me, sitting in my chair and all. I know you didn't mean anything by it. I'm sorry, Tony, really."

I learned that there was another side to Indio. Apparently, he had a history of violent outbursts. Once, while playing paddleball in the gym, he almost murdered another prisoner. Indio was in the middle of a serious game when some other guys started playing basketball in the same court. When they didn't stop when Indio asked them to, he beat one of the guy's faces to a bloody pulp with his paddle.

I assured Indio I didn't mean to disrespect him. "You're my mentor, how could I replace you?" I said. Luckily, the incident in the hobby shop was the last violent encounter we'd have. He spread his arms, gave me a hug and that was that.

From then on, Indio looked out for me and proved to be a valuable friend. On more than a few occasions, he protected me from harm. Because of his reputation, having Indio as a friend prevented others from trying me out. In the meantime, I decided to join a newly formed art class.

Due to pressure from the small but vocal group of prisoners with an interest in painting, the administration agreed to offer an art class in the school building. They hired an art teacher named Ed Klaber. Ed was a no-nonsense instructor who taught classes in a strict academic setting. His class was nothing like the informal sessions in the hobby shop. Ed established firm rules that he insisted be followed or he'd terminate you. The class was a privilege, he said. He could teach if he had only one student. There was no loud talking or playing music. No using black paint on your palette. And God forbid if you gave up on a

drawing and wasted a sheet of paper. Although it was like being in a prison within prison, it was in Ed's class that my skills as an artist emerged.

Under his tutelage, I embarked on a serious course of artistic study. I read about the masters, the French Impressionists in particular, and continued painting copies of Monet, Manet and Renoir. This time, however, my drawing skills really took off. Ed noticed and even paid me a few compliments.

Around this time, I met a local writer named Vicky Boutis through an exhibit at the Ossining Community Center. Occasionally Flo would hold art shows there featuring paintings by the Sing Sing artists. A portion of the sales were donated to the community. Vicky was a left-leaning intellectual. After one of the shows, she wrote me a letter telling me that she thought I was talented and liked my work. I responded and we became pen pals. To show my appreciation for her encouragement, I gave Vicky a painting of a pretty woman standing on a beach. Vicky wrote back, thanking me for the painting. As time went by, I sent Vicky another piece in the same genre, an impressionistic seascape. This time, Vicky wrote back and said that there was more to art than women in white dresses on exotic beaches. She told me of the Mexican mural painters and how they used their art as political weapons. This concept intrigued me. I began reading about Diego Rivera and other political artists whose paintings gave expression to the plight of the oppressed. It became clear to me that this was the direction I wanted to pursue as an artist. I wanted to use my art as a tool to raise awareness, not simply to provide enjoyment. This realization marked the birth of my political awareness and the start of creating original works that captured the essence of imprisonment.

The year was 1988. I was in the third year of my incarceration when one night, while sitting in my cell, I picked up a mirror. The image in the reflection startled me. The despair that I felt in my bones—the hopelessness that I'd learned to live with only by denying its existence—managed to seep out nonetheless. I could see it in my face. In the mirror was the face of a man who was to spend the most produc-

tive years of his life in a cage. Had I not had my art, I would have screamed.

Instead, I grabbed an 18" x 24" canvas from under my bed and started to draw. A strange feeling came over me: Instead of despair, I felt the energy of rage. I was desperate to capture the moment and to recreate on canvas the haunting vision of myself. I drew with a focused detachment—a kind of existential awareness I'd never before experienced. Five hours later, the painting that emerged depicted the frontal view of my head half immersed in darkness. Only one eye was visible. I'd made my incarceration palpable. I titled the painting *15 Years to Life—Self-Portrait*. When I showed it to Ed, he was quiet. For the first time, he didn't suggest improvements.

That year, I completed several political paintings, including two of my best, *Corporate Asset* and *Nightmare of Justice*. The latter was a 38" x 50" work on canvas portraying in vivid detail the deterioration of my spirit. I felt that no photograph could capture my emotions as well. The painting featured a towering figure floating in space gripping two bars of a prison cell, trying to break free. Below my torso, I imbedded the scales of justice in my rib cage.

Corporate Asset illustrated the prison industrial complex before the term became part of the political discourse on imprisonment. It represented the financial gains of the prison machinery at the cost of human misery. Inset scenes depicted the systematic dehumanization of the incarcerated: a prisoner atop the revolving doors of justice becoming a nameless statistic; Lady Liberty turning the giant gears that crushed bones into dust.

I entered these works in the Corrections on Canvas art show. I considered them my most powerful artistic expressions. The judges did not share my enthusiasm. Instead, I won first place for a watercolor painting titled "Pink Bathroom Sink." It was a piece from my collection of "diabetic art," a term I used to describe paintings that were appealing to the eye but devoid of substance. Although most of my paintings were political pieces, I continued to paint the eye-pleasing scenes that won ribbons at art shows. I wore two hats, painting for myself and painting for others.

The prison authorities didn't make it easy for me to ply my trade. Ninety percent of the products in a standard art catalogue were considered contraband. Metal, wood, glass and flammable liquids were banned. So were oil paints and turpentine, which I needed to mix paint. In the past, the authorities allowed oil paint until the prisoners began using it to start fires and make bombs. In prison, "security" overrides everything. It's easier to just ban things outright than have to worry about controlling limited usage. Much of the security was overkill, and any violation gave the officials the justification they needed to ban whatever they wanted.

Nonetheless, there were ways to skirt the rules. You could buy some supplies on the black market in Times Square or bribe a guard to smuggle in what you needed. In exchange for a portrait now and then, Indio had an "understanding" with a few of the officers. After a while, I did, too.

Prisoners would often ask me to paint their portraits. I did a few but gave up after a while. It wasn't worth the litany of complaints about the nose being too big, the eyes too close or far apart. Complaints of this nature could be a problem if you were commissioned by a convict who threatened to pipe you if your depiction of him didn't match his own grandiose perception. I preferred doing portraits for the officers. They tended to be more appreciative and they'd bring me supplies in exchange for my work. If it weren't for the corroboration and support of the correction officers, my artistic skills would not have advanced.

Despite the rigid rules in Klaber's art class, supplies were available and I thought it would be safer to paint there than in the hobby shop. At least, that's what I thought until the escape.

It was about seven o'clock on a Wednesday night. The class was held five nights a week, from six to eight-thirty. I was at my easel painting when a Puerto Rican kid who sat next to me stumbled into the room. He nearly tripped over my easel before he slumped in his chair. When I turned to look at him, I saw that his face was flushed and he was panting. His face bore a red mark shaped like a hand and his glasses were missing.

"What's up José? What happened to your glasses?"

"I … I was in the bathroom," he said, then looked around to see if anyone was watching. "Something's going down, man," he said. José had been on the toilet when three prisoners entered the bathroom. He heard them making noise, he said, like they were tearing at something. When José got up, he saw one of the guys with a wire cutter in his hand, clipping the chicken wire that covered the windows. The second guy spotted José and charged him. He grabbed him by the collar and pinned him against the wall. The third guy pulled out a shank and stuck it to his throat. "Get the fuck outta here and keep your mouth shut," he spat.

José said he was so scared that he froze. The guy pinning him against the wall slapped him, sending his glasses flying. "Get out!" he yelled.

"I didn't need to be told a third time," José said. "I ran out quick."

"Come on," I said. "Let's go check it out. We'll get your glasses back." I stepped out of the classroom and turned left toward the bathroom but stopped when I saw the smoke pouring out into the hallway. I heard the clanging of keys and loud footsteps coming from around the corner. The cop on duty was a new jack. He turned the corner and ran toward the bathroom but couldn't get near it because of the smoke. "Fire!" he bellowed. "Everybody out of the building! Move it!" He ran toward the fire alarms in the hallway and activated them with a key. The doors from the classrooms swung open and prisoners filed into the hallway. Officers in riot gear appeared in the corridors. In two minutes, the entire building was evacuated. They pushed us out like cattle, all the while yelling at us to maintain order and walk in a straight line.

Outside, we trudged up the hill overlooking the prison. Spotlights from the guard towers beamed down on the railroad tracks that snaked through the grounds. We knew something was up, and it wasn't just a fire. Then we heard the gunshots, and next the magic word: "Escape!"

"MOVE IT, INMATES, MOVE!" a cop shouted through a megaphone. They marched us into the block and straight to our cells. "CODE BLUE, PEOPLE! INTO YOUR CELLS!" The sergeant on duty instructed his officers to keep us on lockdown until further notice. The cell doors

closed behind us; we were in for the night. Mirrors snapped from bars, creating a series of rapid flashes throughout the block.

"Hey George, what's up?" I asked.

"Must be an escape, why else a Code Blue? Word is, Julio was gonna make a move."

"Julio from the law library?"

"Yeah …"

There was no telling how long we'd be on lockdown. After an hour or so, the excitement was replaced by dread. The guards turned off the power and water in the blocks. They said it was for "security reasons," but we all knew they did it to punish us. A fellow convict had escaped, and it made the administration look stupid. Conditions in the cellblock were unhealthy enough. Without running water, they were horrendous. We couldn't flush our toilets or wash our hands. The accumulating sweat and body odor of hundreds of prisoners made the poor ventilation worse. Luckily, it was early summer and the temperature was mild. By July, the block would be scorching hot, rising to over a hundred degrees. I remember once pressing my face against the cell bars hoping to catch a breeze from the wings of a pigeon that flew by my cell.

I sat on my bed contemplating the possibility of what could be days locked in my cell. It was a good thing I'd purchased half a dozen sodas that morning. They were still somewhat cold, as I'd stored them in my toilet bowl.

During lockdown, we were given meal trays three times a day and the meals were always cold. The civilian employees, having no classes to teach or prisoners to attend to, were pressed into duty distributing meals. The service wasn't exactly friendly. The officers were none too pleased as well, being that they had to attend to their captives' every need and deflect our countless questions and requests we asked of them.

As the evening turned to night, prisoners tuned in to their contraband radios for word of the escape. We only had access to AM radios. FM was considered contraband because the administration believed that FM radios could be made into receiving transmitters, giving prisoners access to their two-way radios. However, like everything else the

administration called contraband, we had FM radios. Some of them were bootleg contraptions passed on over the years from departing prisoners. Others were modern radios smuggled in by cops or civilians. I once bought a radio in half a dozen pieces, essentially a circuit board connected to dials by paper clips and rubber bands. For antennae, we'd attach copper wire to a magnet and snake the wire through the bars and over the metal railing on the tier.

By morning, the rumor was confirmed. When the report came over the radio, the cellblock erupted in cheers and catcalls. I'm sure I wasn't the only one wishing I were in the escapee's shoes. Escape was a constant but distant fantasy. When you walked through the yards, it was hard not to look at the walls and think, "They're not that high ... maybe I could make it."

Lockdown did nothing to stop the prisoner's information network. News traveled cell to cell, tier to tier. Guys would yell messages across the tiers; other guys listened in and passed on the news. Later that night, we learned the escapees' identities. Two of the guys were from my art class: Tommy Linz and Darius Gittern. The other guy, Julio Giano, worked in the law library. Both Tommy and Julio were doing time for murder. The authorities should have kept a closer watch on Julio. He had "rabbit fever" even before he entered prison. During his murder trial, he'd somehow managed to slip a hand from his cuffs in an elevator en route to the courtroom. He grabbed the gun of the escorting cop and pointed it at him. The standoff ended when Julio's partner, who was still handcuffed to Julio, was shot in the head by a cop. Julio gave up and seven years were added to his thirty-three-years-to-life sentence. He spent the first five years in solitary.

Darius was doing time for burglary and would've been up for parole in three years had he not tried to escape. Most interesting to me was Tommy Linz. By everyone's measure, Tommy was the most talented of the twelve students in our art class. For months before the escape, he had been working on a still-life painting of fish, done in pastels. Although it was a copy of a 17th century Dutch master, it was gorgeous, so close a replica of the original that it was hard to tell the

difference. Ed declared it "a masterpiece." Ironically, the very moment that Tommy was in the bathroom clipping through the chicken wire, we were standing around his easel admiring the painting he'd finished just minutes before. Utterly mesmerized, we didn't even notice that he'd slipped from the room.

Word spread like wildfire about how they pulled off the escape. The day before, they sawed off the bars in the bathroom window. They applied wax to the bars to keep them in place. To avoid suspicion, they returned the saw to the woodworking shop as soon as they finished with it. They disconnected the light fixtures in the bathroom and sprayed the floor with wax squeezed from a mayo bottle so that anyone entering after their getaway would slip. The wax had been unnecessary; their homemade smoke bombs worked damn well. I'd witnessed their power firsthand. The smoke they emitted prevented anyone from even getting to the door.

Once they opened the window, which was on the second floor of the school building, they dropped a thirty-foot ladder made of shoelaces and climbed down the wall. They used a pair of wire cutters they bought for fifty dollars from a guy who worked in the electric shop to snip the fencing that ran along the railroad tracks. That was one of the oddest things about Sing Sing. Railroad tracks for Amtrak-Metro North trains ran smack through the grounds of the prison. After the escapees got through the fence, they ran along the tracks and made their way to freedom.

Their success was short-lived. Word was, they would have made it if they had been able to secure outside help. The escape from the prison had been flawless, but their plans collapsed on the outside. They split up to improve their chances but within three days, each of them was captured. Darius was caught just several hours after the escape, less than half a mile from the prison. He was waiting in the Amtrak-Metro North station for a train. Linz was discovered hiding under an overturned boat along the Hudson. Julio was found without his trousers in the backseat of a parked car. That was the strangest. Given Julio's history, we figured he'd stage some kind of heroics before he went down, like taking a hostage or

leaping from a moving car. "Reminds me of T.S. Eliot," George commented. "He went out with a whimper, not a bang."

The entire prison was locked down for the three days it took to capture them. It was the first time since I'd been at Sing Sing that I'd been confined in my cell for this amount of time. The uninterrupted hours brought me closer to my painting. Luckily, I had enough supplies in my cell to stay busy. On the third day, I lined up the watercolors along the wall. I was stunned: ten finished pieces stood before me. At first, I thought it was an illusion. Maybe my eyes were playing tricks on me, I thought. I'd barely slept in 72 hours. It was as if I'd been in another world.

One piece in particular stood out. I had titled it *Freedom*. It depicted a man running through a maze being chased by guards. At the end of the maze, a bright light illuminated the passageway out, bathing it in yellow light. Something about the light transfixed me; I couldn't stop staring at it. Suddenly, an idea sparked. Looking deep into the light, I realized that it held the answer I was seeking. My art would set me free. I knew it. Through my art, I could generate public interest in my case. All I needed was a plan.

After lockdown, my senses were sharper than ever. The hours of sensory deprivation had heightened my awareness. Thoughts that wouldn't have occurred to me before now overwhelmed me. My connection to the physical universe wasn't only a perception, it felt real. I noticed everyday things as if for the first time: blue sky and green grass, the breeze on my skin, the whiteness of the clouds high above the guard towers. The majestic Hudson and distant sailboats literally brought tears to my eyes. All around the yard, convicts were picking flowers, spreading their arms and breathing the fresh summer air. It was a sight to behold.

After the lockdown, all I wanted to do was paint. Not only had my art moved to another level, it created a fire within me that my legal battles couldn't match. I had to force myself to go to the law library instead of the hobby shop. Painting became an obsession; I knew that somehow it would help me get out.

After the luxury of painting uninterrupted in my cell during lockdown, the bullshit in the hobby shop started to annoy me. I was sick of

the drug dealing, the shanks passing hand-to-hand, the false bravado of the prisoners, and the daily threat or occurrence of violence. After one guy attacked me with a pair of scissors, I knew I needed a break. I needed a place where I could get away from the muck and mire of prison life, someplace where I didn't have to be constantly on guard. I found the solitude of my cell the best place to paint and started spending more and more time there. Immersed in a painting, I could effectively tune out the noise and mayhem on the cellblock. Sometimes I'd ask the officer on duty to actually lock the door of my cell. To achieve total privacy, I hung sheets across the bars, which must have looked pretty weird from the outside. Imagine well-worn bed sheets, splattered with paint, hanging over a clothesline fashioned from shoelaces stretching across the front of my cell. It was a simple but effective method for keeping away intruders. Although hanging anything on the bars was against prison rules, the steady officers usually looked the other way, except when the prison brass were touring the blocks. Behind my curtain, I felt freer to paint. The isolation afforded me complete focus. I kept up this routine for months.

Chuck Culhane, a poet and painter I knew from the hobby shop, came to see me one day. He invited me to a poetry workshop hosted by an outside volunteer. Chuck was serving twenty-five years for his supposed involvement in the shooting of a Westchester County deputy sheriff in 1968. He and another prisoner, Gary McGivern, were being transported to a prison upstate. McGivern, who was handcuffed to Chuck, decided to attempt an escape. From the back seat of the car, McGivern tried to grab the sheriff's gun. The struggle ended with the sheriff shot dead. Chuck was charged with murder, even though he never touched the gun. Chuck and McGivern were sentenced to death. Chuck spent four years on death row until New York abolished the death penalty in 1985. (Ten years later, Governor Pataki reinstated the death penalty upon entering office.)

Chuck wanted to know why I wasn't hanging out in the hobby shop anymore.

"I feel better painting here," I told him.

"What about your job there?"

I laughed. "No one checks attendance." I was still receiving 90 cents a day for doing nothing.

Chuck looked around my dark cluttered cell. "Lighting's terrible in here. How can you paint in the dark?"

I pointed out how the shadows danced around the room from the single thirty-watt light bulb hanging from the wall. It was my only source of light. I didn't have a window in my cell and the row of dirty windows across the tier were always closed.

"You're gonna go blind in here," he said.

I tried to think of something to say that would justify why I was spending hours on end painting in a darkened cell, but nothing came to mind.

"I guess I just feel more comfortable working alone."

"What are you going to do? Hide in your cell for the next decade?"

I thought about it. "Maybe you're right. Maybe I need a break."

"See the darkness as a metaphor," he said.

"Huh?"

"A metaphor. For what this prison system is all about—the dual constructs of narrowness and lightness, perpetuated by fear and ignorance."

I started to grasp what he was saying. His poetic words struck a chord.

"Get back into the light and create, Tony," he continued. "You may not change the system, but you can change yourself, how you see things … Recreate the people and world around you."

Chuck was right. I realized I'd have to face my demons sooner or later. I hadn't noticed the darkness of my cell before. Or had I become too insecure to paint in the light?

"See you in the shop tomorrow?" he asked.

"Yeah."

He turned to go.

"Hey Chuck …"

He stopped, raised his eyebrows.

"Thanks."

Deep Fried and
Hermetically Sealed

I COULDN'T SHAKE THE FEELING that my lawyer wasn't doing anything to help me. I started asking around for someone who could give me legal advice. The prison was full of prisoners who offered legal expertise, for a fee of course. These "jailhouse lawyers," as they're known, aren't actually lawyers but they know the law inside and out, particularly criminal appellate law. Many would offer their services as a way to make money to support their families on the outside or their drug habit on the inside. The first guy I spoke with was Leo Mulero, a jailhouse lawyer who worked in the law library.

"Don't wait around for your lawyer like I did," Leo said. Both Leo and his wife were serving twenty-year-to-life sentences for drug convictions. They'd exhausted their appeals years ago; the attorney they'd hired failed to raise significant issues on appeal that could have set them free. Leo didn't trust lawyers.

"No one's gonna represent you the way you would represent yourself," he said. "All the lawyers want is your money. They know you're desperate."

"How can I handle my own case when I'm not a lawyer?" I asked, still clinging to the fantasy that George must be doing something for all the money we'd paid him. "Learn," Leo said. "Go to the library and start studying your case." I told him I'd picked up a little knowledge of the law in a paralegal class offered by the prison. Essentially, the prison-

sponsored class taught the basics of legal research: case review, filing motions, the appeal process and Constitutional issues. I agreed with Leo and decided to go back to the library to study my case, determined to find that magic legal loophole that every prisoner dreams of.

One day in the law library, I got to talking with one of the inmate law clerks, a young black kid from Buffalo who went by name "Love." He asked me what I was in for. When I told him, he nodded his head sympathetically.

"So you got burned under the Rockefeller drug laws too, huh? Damn, Tony, those are tough laws." He told me about his experience. For an amount of cocaine that would fit in a small plastic baggie, he had been sentenced to twenty years to life under these very laws. So far, he'd done a decade.

After talking with him, I began to research the history of the Rockefeller drug laws. I found out that in 1973, then-Governor Nelson Rockefeller successfully pressured the New York State Legislature into enacting harsh drug laws as part of his get-tough-on-crime platform. At the time, the Republican governor was angling for a spot on the presidential ticket. Rockefeller didn't get the ticket, but he got his drug laws. They were the strictest drug laws in the country and applied to even low-level, nonviolent offenders.

Essentially, the laws require that judges impose a *minimum* sentence of fifteen years to life for anyone convicted of selling two ounces or possessing four ounces of a controlled substance. Because the sentences are mandatory, judges cannot take into account the role or background of the defendant. Whether the defendant is a kingpin or a first-time offender is irrelevant.

Rockefeller's intent was to curb the drug trade by making laws that were so harsh that they would serve as deterrents. Obviously, that didn't work; drugs today are more available, purer and cheaper than they were thirty years ago. Rockefeller considered the lengthy sentences appropriately harsh for drug kingpins, but it wasn't kingpins who were getting caught because kingpins aren't usually on the street selling drugs. They hire people for that. In fact, most of the prisoners I knew who were

doing time for drug offenses were low-level offenders, most of whom were drug *addicts*, not kingpins.

New York's stiff drug laws prompted other states as well as the federal government to follow suit. The trend across the country was gradual, but by 1983, forty of fifty states had passed similar mandatory drug laws. In 1978, Michigan passed its extraordinary "650 Lifer Law." Anyone charged with the sale or possession of 650 grams or more of a controlled substance was mandated to *life imprisonment.* Although the laws were (fully) repealed in 2003, they sent hundreds of drug offenders to prison for life before the state legislature realized it was too costly.

In most cases, politics drove the enactment of harsh drug laws. The nation's war on crime had become a more clearly focused war on drugs. Declaring oneself "tough on drugs" was an easy way for politicians to curry favor with voters. What many citizens didn't realize, however, was the extent to which mandatory sentences undermine a cornerstone of our adversarial system: the heralded right to due process. Under mandatory sentences, judges are stripped of all sentencing discretion, leaving prosecutors to control the outcome of a case.

Another consequence of the drug laws in New York and the country at large was the massive build-up of the prison system. In 1973, when the laws were enacted, New York's total inmate population was 12,500; just twenty years later, it had more than quadrupled to 64,500.

One morning, my cell door swung open. I jumped up from my sleep.
"Yo bro, take it easy. It's me, Leo. I thought you were awake."
"Well, I wasn't."
"Your eyes were open."
"That's how I sleep now."
Leo laughed. "I hear you." He sat down on the chair across from my bed. "I've been thinking about your case."
"What about it?"
"Something's not right."
"Like what?"

"It's obvious—your lawyer is not doing his job." Despite George's occasional claims that my appeal was progressing, I was beginning to think that Leo was right. For four years now I had been hoping that George Bloomstein would get me out of prison, but it certainly wasn't looking that way. Leo said we should spend the morning going over my legal paperwork. I told him I didn't have any paperwork.

"What do you mean you don't have any paperwork?"

When I told him that George hadn't even gotten the transcripts of the trial from the court, Leo had a fit. Three times, George had filed motions and three times, he'd been denied.

"What should I do?"

"File a motion on your own," Leo suggested. "Without the transcripts, you aren't leaving prison. File your own motion, and this time, request copies of the past denials."

I did as he said and two months later, I got a letter stating that I had, yet again, been denied. There were copies of the three previous rejections, too. They all cited the same reason why I'd been denied: I was not "adhering to the court's request to reveal the source of money to pay for a private attorney and for bail." In other words, if I'd been able to pay lawyer fees, how could I be indigent?

"But I told them why!" I said to Leo. In my motion, I'd sent an affidavit from my Uncle Frank, who stated that he'd paid my attorney fees and bail with his life's savings.

Leo was shaking his head. "Look at the affidavit," he said. "They aren't going to recognize that affidavit."

"Why not?"

"Because it's not notarized. The court will not recognize a submitted document that is not notarized. Your lawyer should've known that."

"How could he have overlooked that? I mean, it's so obvious. He must have had an underlying reason."

"I don't know … Have you paid him in full yet?"

I told him that my uncle was still making payments. "Then your attorney did it on purpose. To buy time. So he could get paid in full before he did any work for you."

I was beginning to believe Leo. I filed a fifth time, this time getting my uncle's affidavit notarized.

I came to find out that George Bloomstein wasn't unknown to other prisoners. In fact, he was considered a shyster. This guy Ray, whom George represented on his appeal, had only bad things to say about him. "You know he drives a Rolls Royce?" he asked. "Brand new Royce, and you know who paid for that car? We did, with our blood." He bit his hand to illustrate. "The bastard ripped us off and bought himself a Rolls Royce while we rot in prison."

For most prisoners, lawyers are their last hope, but it's all too easy for unscrupulous attorneys to take advantage of them. Most prisoners lack even a high school diploma, have no legal knowledge, and few financial resources. And even if they can afford private counsel, as long as the lawyers continue to get paid all is well. But when the money runs out, the client is still in prison. He's no longer a priority and his case gets put on the back burner.

Culiata, or "Pork Chops," as we called him, was an old guy everyone knew from the yard where he'd spend hours walking zombie-like in circles. He'd been down seventeen years when an attorney promised to get him out of prison. Culiata was in high spirits ... until he lost the motion. Culiata wasn't the brightest of men, a fact that his lawyer used to line his own pockets. Unknowingly, Culiata had signed his house over to the lawyer in return for his work on the appeal. Even worse, the attorney was evicting Culiata's eighty-year-old mother to get his $25,000 fee. This was only one of the many horror stories I heard.

Two months later, I received a letter from the Appellate Second Division. I ripped open the envelope and scanned through the paragraphs. I was granted the poor person's motion ... and assigned new counsel. I did it! I rushed to find Leo.

"This is it, Leo. I'll finally be able to get this appeal going."

Always the pessimist, Leo told me to take it easy. "Don't start packing just yet."

I told him that I'd been assigned a new attorney.

"What's his name?" he asked.

"John Dixon."

He gave me a weird look. "You're kidding, right?"

"No, why?"

Leo shook his head. "Out of the frying pan, into the fire."

Apparently, Dixon was known throughout the prison as the Appellate Division's hatchet man. Although he was an experienced attorney, Dixon was known to take on over fifty cases at a time, which he'd ram through the courts at a rapid-fire rate using boilerplate appeals.

"They don't care," Leo spat, meaning the courts. "They give all these cases to guys like Dixon knowing damn well that the representation will be minimal. Sure, you got a statutory right to an appeal—but it doesn't mean it has to be good. And the more cases these court-assigned attorneys take, the more money they make."

"How can I get out of this?" I asked Leo.

"At this point, getting another lawyer will be very tough," he said.

Leo suggested I first try to make the best of it by writing a letter to Dixon. "Establish a relationship with him. Introduce yourself. Tell him you want to help him out. Get your transcripts. You have to get your own copy of them at the appellate stage, so you can do your own research. If you don't get them now, it will be almost impossible to ever get them."

Even though the Court had qualified me as a "poor person," my minutes would not go directly to me. Instead, the Court would lend them to my attorney, for 180 days to perfect the appeal, then they would have to be returned. I was going to have to go through my attorney to get them.

I did what Leo said. I wrote Dixon a letter, but got no reply. I phoned his office, but was told that he did not accept phone calls from prisoners. I realized that potentially I was in worse trouble than I'd been in with Bloomstein. I wrote additional letters, stating to Dixon that I did not want him to submit anything on my behalf without my permission. Still, no replies. My own lawyer did not want to communicate to me, and my life was in his hands! I started freaking out.

I wrote again, asking him how he planned to argue my case, but again, he didn't reply. I requested a copy of the minutes; I begged him to

let me help him! Finally, I got a reply containing one statement: "I have received your letters and I will take them under consideration."

Desperate, I begged my aunt to intervene. Aunt Connie was married to a retired narcotics officer in New Hyde Park, near Dixon's office. She tracked him down and begged him to give me a copy of the transcripts. At first he gave her a hard time, but because of her persistence, he agreed to make a Xerox of the transcripts for $125 in copying fees. The day I received them, I began searching for issues to raise on appeal and researching related case law.

The very next day, however, I received in the mail the appeal that Dixon had filed without my permission. It was an eight-page boilerplate brief that argued my case ineffectively. When I showed it to experienced jailhouse lawyers in the library, they said it was garbage—a typically generic brief that shoddy lawyers save on their computers and change a few words around to fit the facts. Even worse, Dixon had waived the oral argument to the Court. This was an opportunity to appear before the Court and have an open dialogue with the judges and answer any questions they might have.

I wrote Dixon another letter asking him to include an additional legal point that he'd overlooked. I considered it my strongest issue. Again, no response. I then requested permission from the Courts to file a brief *pro se*. I was especially eager to file the motion because a relevant and potentially helpful case had just been decided. The case, *People v. Percisco*, contained some of the very same issues as my case. In *Percisco*, an undercover officer testified on the witness stand that an informant had told him about Percisco's drug dealing. It was second-hand, out-of-court hearsay evidence. At my trial, the same thing happened when the judge allowed Polinski's tape-recorded statements to be used as evidence against me. The Court found that admitting the testimony violated of the defendant's Sixth Amendment Right to Confrontation because the informant was never brought to court to stand the test of cross-examination. The ruling in *Percisco* was published on the front page of the *New York Law Journal*, attesting to its importance.

If I could just get this point of law in, I thought, I could win the appeal. Luckily, the Court gave me permission to file the brief *pro se*.

I asked around and was directed to see Jimmy Seelant, a jailhouse lawyer with a good reputation. Seelant said he personally knew the lawyer who'd handled Percisco's case, and would try to get me a copy of the brief.

Within a week, I had the brief in my hands. Leo and I got to work, using the *Percisco* brief as a guide. We spent the next several weeks in the law library crafting the argument, and submitted to the court a thirty-page brief showing how I'd been denied my right of confrontation. It was a fantastic argument. I was convinced that I was going to win the appeal and went so far as to start going through my things, thinking about what I might want to give away when I left. Leo came by and saw me putting clothes in my travel bag, an old potato sack the administration had given me upon entering the system.

"Hope you're not packing," he said.

"Why?"

"I've seen guys hang themselves over their appeals," he said, shaking his head. "They swore they were gonna win. You think like that, Tony, you'll flip out if you lose. Trust me, don't get your hopes up." Leo said that the chances of reversing a criminal conviction in a state appellate court were less than three percent.

"Remember what had happened to Taxi," he warned. Taxi was doing seventeen years to life for possession of two ounces of cocaine, enough to fill about half a plastic baggie. The cops found him asleep behind the wheel of his taxicab with a bag of cocaine on his lap. When he lost his appeal, he attempted suicide and ended up in the prison psych ward. Like Culiata, he walks around like a zombie, high on psychotropic drugs.

Leo was right. Three months later, I got the bad news: denied. I was devastated. To make matters worse, I wouldn't have Leo around to help me. He had just been shipped off to Southport, New York's high-tech, ultra-secure, maxi-max prison. Inmates called it "the end of the line." Over 750 men were locked down twenty-four hours a day in disciplinary confinement. All movement was monitored by video surveillance and assisted by electronic door systems. Special alarms, cameras and security

devices were everywhere. The isolation, I'd heard, was crushing: Inmates couldn't participate in programs, make phone calls or have any contact with other men. Their meals were delivered through "feed-up" slots in the door. When the prisoners left their cells for medical call-outs or their one hour of rec, they were mechanically restrained with handcuffs attached to waist chains and leg irons. They even remained shackled during rec, although recreation consisted of standing alone in an empty, outdoor cage.

Leo got sent to Southport because he fell prey to a scam artist named Blondie. One day Blondie came to the law library and asked Leo to give him some legal advice. A few days later, Leo approached me in the block. He opened his brief case and pulled out a letter. It was an authentic-looking document from a law firm saying that Blondie was worth over one million dollars and should consider setting up a trust fund. Blondie asked Leo to set up the fund and offered to pay him $1,000 for his services. Leo was thrilled.

A week later, Leo went to Blondie's cell to have him sign some papers. Blondie then asked Leo to do him a favor and take a package over to B Block for him. Leo had a special law library pass that allowed him to travel almost anywhere in the prison. Blondie said that the small package wrapped in tissue paper contained a ring that he wanted to give to someone. Leo agreed. Just as he was leaving A Block, two guards threw him against the wall and searched his briefcase. A snitch had tipped them off. Inside the package were a dozen single-edged razor blades that had been smuggled in by a civilian. Blondie was selling them for a carton of cigarettes apiece to the gang-bangers over in B Block.

Because prisoners are prohibited from corresponding with other inmates, I lost all contact with Leo. I was now on my own. I realized that I needed all the help I could get and decided to enroll in a two-year paralegal program at the prison sponsored by Bronx Community College. It was an excellent program, and I felt that it would give me the skills I needed to research and write a solid, persuasive appeal. Like everything in prison, though, getting in wasn't easy. I had to fight my way in.

My pursuit of a college education actually began during my first year in prison. I wanted to earn the undergraduate degree I wasn't able to

finish on the outside. Mercy College offered classes at Sing Sing subsidized by state and federal funding. I enrolled in the bachelor's degree program but a week later I was expelled. Apparently, a college loan I'd defaulted on ten years back made me ineligible to receive tuition assistance from the government. I did some research in the law library and learned that I could set up a loan repayment plan. After one year of payments, I would be able to re-enroll. I wrote to the Department of Education and told them that I was incarcerated and desperately wanted an education. "I only make 90 cents a day," I said, "but I am willing to sacrifice this money for the chance to receive an education." I was approved with the stipulation that I pay $20 a month.

After one year of payments, I tried again and was approved for financial aid. Since I needed the legal skills to work on my appeal, I decided to enroll in a two-year paralegal program first. Started in 1982 by its former director, Dr. Allen Wolk, the paralegal program was sponsored by Bronx Community College which offered critical legal skills to incarcerated individuals. Initially, politicians opposed the program but high-powered directors from the college lobbied hard for its establishment. They had to fight the public perception that educating prisoners was "coddling crooks." The reality was that less than one percent of the 2,300 prisoners at Sing Sing went to college, and the majority of prisoners at Sing Sing read at the third- or fourth-grade level.

After I completed the paralegal program, I decided to re-apply to Mercy College to finish my undergraduate degree. The college denied me again, this time saying that I owed them $2,200 for the semester that I'd enrolled in during my first year in prison. For some reason, they had charged me the full $2,200 annual tuition, even though I'd only attended classes for a week before I was terminated. I wrote the college and told them of the mistake they made. I pleaded with them to let me go to college and change my life for the better. They refused to listen. I had no alternative but to file a lawsuit in Westchester County Court. I litigated for a year to straighten out the error. In the end, to avoid opening the door to similar lawsuits if I prevailed, the college agreed to a $100 settlement and I enrolled.

Attending college in prison wasn't easy. Trying to study in my cell was virtually impossible. Radios played constantly. Prisoners would yell to each other from their cells, sometimes just for the hell of it. Conversations that started between two men soon included ten or more. It wasn't only the noise that made studying difficult; the prison's restrictions on basic academic materials added to the struggle. For example, before leaving the school, the guards would search our folders and books to make sure we weren't concealing contraband smuggled in by teachers. In the eyes of the administration, "contraband" could include anything from drugs to reading assignments that the officials considered inappropriate. One semester, the guards confiscated my spiral-bound notebooks that were filled with notes I'd taken and needed for an upcoming exam. The wire, they said, could be fashioned into a weapon. Fair enough, but so could a zillion other things in the prison. I stayed in the program and studied as best I could, often late into the night when the cellblock was quiet.

In addition to college, I got a job in the law library as an inmate clerk and was able to use my legal skills to help other men on their cases. My victory against Mercy College bolstered my reputation as a solid jailhouse lawyer and other prisoners turned to me for help. After a while, I landed a coveted prison paralegal job. There were ten paralegal positions at Sing Sing, not due to any beneficence on the part of the administration but because a Supreme Court ruling years before stated that the "fundamental constitutional right of access to the courts requires prison authorities to assist by making adequate law libraries and legal assistance from persons trained in the law."

I handled many cases, both civil and criminal. Many of the cases were drug-related. Some were serious; others were frivolous. One case concerned a convict charged with starting a fire in New York hotel that killed twenty-three people. In another, I helped a serial killer on his appeal. The wildest case I handled belonged to "Old Man Charlie."

Charlie was a real character, a grizzled old-timer who'd spent half his life behind bars. From reform school to the toughest max joints, Charlie had seen it all. He approached me one day in the law library.

"Hey Tony, I need your help on a very important matter."

"Is it about your appeal?" I asked.

"No, it's more important then my freedom... I need to eat!" he stammered. He smiled and revealed a gummy grin. "Look at these," he said, reaching into his shirt pocket and pulling out a set of uppers. When he put them in his mouth, he looked like Mr. Ed, the talking horse.

"These bastards won't fix 'em," he said. "They say there's nothing wrong with 'em, but I can barely chew my food."

I helped Charlie file a lawsuit against the prison, citing the landmark case, *Estelle v. Gamble*, which established inmates' constitutional right to adequate medical services, including dental care. Unfortunately, we lost. At the deposition, Charlie stupidly told the attorney general that he had the money to buy his own dentures, but he felt that it was a matter of principal that the prison abide by the law and provide him adequate dental care.

As I expected, the judge ruled against him, stating that while the prison dentures mightn't be to his liking, they met the standard of "adequate" care. But Charlie still needed teeth that he could actually chew with, so I filed a state action in Westchester County Court and wrote a letter to the chief medical officer of the state prison system in Albany. I informed the medical director that Charlie was ill—he had TB and was rapidly losing weight. Not being able to chew his food compounded the problem. "Mr. Charlie Scotti will surely die," I wrote, "if he does not receive proper medical attention soon. His death will be on the State's conscience."

A week later, Charlie was examined by Dr. Johnson, the prison dentist who'd given him the ill-fitting dentures. Dr. Johnson didn't appreciate the old man's blowing the whistle on him, but he agreed to fix the teeth and told Charlie to leave them with him for repair. Charlie was ecstatic.

The next day I got word that Charlie had been "keeplocked," confined to his cell for punishment. I went to see him and he showed me the misbehavior report that had been issued against him. It was written by Dr. Johnson, who charged Charlie with destroying state property and lying. The dentist alleged that Charlie had filed down the teeth with an "unauthorized tool" and that he had lied to the chief medical officer. Rather than fix the teeth, he'd decided to get even with Charlie.

I agreed to be a witness at Charlie's disciplinary hearing. Prisoners are allowed to call other prisoners or staff as witnesses. At the hearing, I told the captain that I'd written the letter and filed the lawsuit on Charlie's behalf. I stated that the charges were false and he could see that the dentist had lied simply by looking at the dentures. The hearing officer said the dentures were not in his possession.

"You never saw the dentures, sir?" I asked. He said he hadn't. "Then how can you verify any of this?"

The officer turned red with anger. He flicked off the tape recorder. "I know about you hotshot jailhouse lawyers," he said. "Overruled! Now get out of my office." So much for a fair hearing.

To our surprise, several days later some officials from Albany came to the prison to examine Charlie. Apparently, my letter had arrived at exactly the right time. A series of newspaper articles had just been published about the soaring rate of TB in the state's prison system. It was reaching epidemic proportions due to inadequate screening in the city jails. Within a week, Charlie got his teeth. In fact, it was Dr. Johnson who had to reexamine Charlie and fit him for a proper set of uppers.

Not everyone benefited from my advocating skills in the law library. Carl the Pervert was such a man. I was sitting at my desk in the paralegal room one day when a clerk came in and showed me a New York Supplement 2nd edition. The index had been ripped out along with several pages. Ripping pages out of law books is a mortal sin in prison. Law books are prisoners' link to freedom and they're worth their weight in gold. Any prisoner caught ripping out pages would get the "B&B" treatment. First, a crew of library workers would drag the guy into the backroom and give him a beating. Then they would ban him from using law books. The clerk's room had an additional set of the Supplements, so I pulled the book off the shelf and discovered that the exact pages were missing!

When a case was missing from two law books, it usually meant that the prisoner didn't want the case to be seen. I wrote to the New York State Library and requested the missing pages. In about two weeks, I received the materials. I scanned the name of the case and discovered it belonged to Carl, one of the clerks.

Ironically, Carl's job was to repair damaged books in the library. He was a strange guy, quiet, middle-aged and pony-tailed. His legal specialty was litigating Court of Claim actions; he'd filed many successful motions for prisoners. Carl was also obsessed with green towels. In fact, he decorated his cell with them.

I read the missing case and was appalled. Carl had been found guilty of molesting several young children and was busted shortly after having sex with a six-year-old girl and a ten-year-old boy. The molested kids identified Carl when they described a green towel he had used to wipe himself off after his acts. What really freaked me out was that Carl always carried a green washcloth in his back pocket—the same one he offered to people if they needed to wipe something. Carl's case was photocopied and passed around the law library. It was all over for Carl when Panama, a law clerk who'd recently borrowed Carl's towel to wipe his face, cornered him in the book room. He almost beat him to death with a typewriter. After that, Carl went to PC—Protective Custody—and was eventually shipped to another prison.

After the Appellate Court denied my appeal, I filed a post-conviction motion with the original Court, challenging my conviction based on a constitutional violation. My situation was further complicated because the original judge had suffered a heart attack and retired. When this happened, my case was thrown into a pool of judges. The case was assigned to a Judge John Carey whose claim to fame was being the presiding justice of Westchester's "Fatal Attraction" murder case. It was a high-profile case that was made into a movie about an attractive schoolteacher who murdered her lover's wife. The first case ended in a hung jury, but the second trial resulted in the woman receiving twenty-five years to life. I followed the case and was impressed with Judge Carey's legal analysis and writing skills. He blended quotes from Shakespeare and the Bible into the opinion.

I began the long process of filing my Criminal Procedure Law section 440 Post-Remedy motion. At the same time, I submitted a request under Freedom of Information Act to the Westchester DA for the thirty-minute tape that the people had used against me in my trial. The request was

denied, forcing me to file an additional civil action under CPLR Article 78. This was an all-purpose legal tool that challenged final administration decisions. This case was also assigned to Judge Carey. My life was in his hands, and I prayed that he would give me a break.

No such luck. Nine months later, I was denied both motions. In my 440 motion, the Judge complimented me on my "scholarly brief," but stated that he no choice but to deny my appeal on a technicality: He was "procedurally barred from addressing the issue because it was already addressed by an appellate court." In other words, the damage done by Dixon when he raised my confrontation issue on appeal—in one sentence—could not be repaired.

Judge Carey also went on to say that "given the complexity of the legal reasoning required to reach such a conclusion to the constitutional question asked, as indicated by the scholarly memoranda herein of both the District Attorney and defendant *pro se*, clarification of New York constitutional law in the area would seem to be desirable." After the decision, I decided to try once more. I had another avenue of relief in the state courts before I went to the federal courts. I filed an Ineffective Assistance of Counsel claim to the Appellate Division Second Department. My argument was simple. According to Judge Carey, my appellate lawyer had argued the strongest issue I had in a single sentence. I argued that this action met the ineffective assistance of counsel standard in that it prevented the Court from looking at the totality of supporting law. I bolstered this argument with strong case law and again prayed for the best.

Forty-five days later, the Court rejected my claim. I was heartbroken. I was exhausting my legal remedies at a rapid pace, which friends had warned me about given the psychological toll that it takes. Prisoners were known to suffer mental breakdowns when they exhausted all of their legal remedies while still facing long sentences. I was starting to understand the importance of pacing myself and decided to take a break from the courts. With my hopes for freedom fading, every day was a struggle to hold myself together.

CHAPTER 9

The Zoo

LIKE ALL PRISONERS serving long sentences, I eventually learned what doing time was all about. It wasn't just about marking X's on your calendar, it was about learning to live in the present, no matter how bleak the present was. Dwelling on the past and hoping for the future were as painful as they were futile. I had to forget about life on the outside in order to maintain my sanity on the inside. I had to let go of the rope in order to survive.

My existence had been reduced to daily routines and calculations. Every other Wednesday I was allowed to go to the commissary and purchase fourteen dollars worth of goods. Every third day I could take a shower. On Fridays, a movie was shown in the chapel. The walk from my cell to the mess hall was 1,338 steps. It took five minutes to consume a meal before we were ordered to leave. If I smuggled out three slices of bread every Tuesday after lunch, I could skip the evening meal of cooked liver and make it until morning without hunger pangs.

I thought about time only in reference to the day at hand and the functions associated with it—the headcounts and bells and other mechanisms by which the prison maintained order and security. Even death had become a routine part of prison life.

One afternoon after the four o'clock headcount, Chino the porter came by my cell. "Hey man, hurry, check this out," he said. I followed Chino down the gallery to the last group of cells near the back. "Look

at this," he said. I peered into the cell and saw a middle-aged black man in his bed. A white sheet covered his body from the neck down. His right elbow was cocked on the bed frame; his index finger pointed at the ceiling as if he were in mid-conversation. The cell was barren except for a roll of state-issued toilet paper sitting on top of his locker.

"So what?" I said. "The guy's sleeping."

"Bullshit," Chino shot back. "He's dead." We opened his cell door and walked in. We stared at his body and could tell he wasn't breathing. Chino tugged on his arm. This was a mistake. Immediately, a burst of intestinal gas shot out from the corpse, filling the air with a rotten stench. We held our noses and ran. We yelled for the officer-in-charge, screaming at the top of our lungs, "Dead man in cell P690!" Within seconds, the entire gallery of prisoners erupted in chants: "Dead man on the gallery! Dead man on the gallery!" Nobody could find the guard. Finally, after ten minutes, the guard appeared with a panicked look on his face. He ran into the cell and radioed for assistance. Dying alone in prison—that was the worst fate of all.

After seven years in prison, my life beyond the walls had shrunk to a fraction of its former existence. Nearly all of the people I'd known before prison had faded from my life. In 1990, my wife and I divorced. She couldn't handle the sentence, and I couldn't blame her. We'd struggled from the beginning of our relationship anyway. I loved her, she loved me, but our relationship was too fragile to handle a problem of this magnitude. It didn't help that Sing Sing didn't have a family reunion program like most of the other maximum-security prisons in the state. Family reunion programs allowed prisoners to spend occasional weekends with their families in trailers similar to mobile homes on the prison grounds. For forty-eight hours, you could almost feel normal again. You could cook your own meals and take your time eating. You could sit on a sofa, watch TV and put your arm around your child. You could sleep in a bed instead of a cot with your wife and feel a warm body next to you at night. But because Sing Sing was only an hour from New York City, officials said a family reunion program was unnecessary. The truth was, the program was politically risky to begin

with. There was little public support for programs that helped prisoners' families stay intact.

As a result, sex was rampant in the visiting room. Despite the rules, couples had sex whenever the opportunity arose and often right under the guards' noses. There were times when my Uncle Frank would visit on a Saturday, the most popular visiting day, and we could hardly hold a conversation because of all the sex-related chaos that went on when couples tried to get intimate and the guards barked at them to stop. The administration issued various directives to control the situation. It was a back and forth contest between the administration and us. Once, they even tried to ban couples from kissing, which of course didn't last long. No matter how strict the rules or steep the consequences they threatened us with, little if anything could be done to prevent people from responding to their basic needs for sex and affection.

Prisoners developed various ways to have sex in the visiting room. Some were low-key; others were outrageous. A common method was when the prisoner cut a hole in the pocket of his pants, through which his girlfriend would slip her hand and masturbate him. Once the guards caught on, they actually placed a large sign in the entrance to the visiting room that stated: "NO HOLES IN INMATES' POCKETS ALLOWED!"

Other couples were bolder, sometimes fucking right in the chair with the woman sitting on the prisoner's lap. Some guys would wait for the right moment to duck into the female bathroom to have sex with their girlfriend in a stall. If you got caught, your visiting privileges would be suspended for several months to a year.

The closest I got to having sex in prison was on a visit with a woman I met through an art show. She had admired my paintings and written me a warm letter. After several months of corresponding, we had developed an easy rapport. We talked about life, art, politics and relationships. When we finally met face-to-face, the attraction was instant and overwhelming. The bond we developed felt mystical.

Though we tried to control it at first, after three visits we couldn't keep our hands off each other. It started after the second visit when we

said goodbye. As much as I wanted to kiss her, I decided to let her make the first move because I didn't want to ruin anything. When the officer announced that visiting hours were over, I feared that nothing physical would transpire between us. But just before she turned to leave, she stepped closer and kissed me deeply. I put my hand on her ass and pulled her toward me. "Break it up, folks," the guard bellowed. We could hardly pull ourselves apart. She promised she'd come back the next weekend.

As I'd hoped, the weather was sunny and warm, and the outside pavilion was open. It was easier to have a sexual encounter in the pavilion than in the main visiting room because only two guards stood watch, as opposed to the dozen or so inside. A female guard placed us at a table about fifteen feet away from her station. My friend and I sat down and started talking. Within minutes, we were holding hands.

My friend's back was toward the officer. As we talked, we our lips grew closer. Finally, we kissed. An explosive situation developed. The sexual energy we experienced was like nothing I had felt in my seven years in prison. I wanted her; she wanted me. When her legs drifted apart, I arched my knee into the crevice and rubbed in small, circular motions. The next minute, she was squirming against me and breathing faster while we continued to kiss. I moved my knee to her rhythm and felt her entire body start to tremble. Just then, the female officer called out, "Anthony Papa! Report to the officer in charge!"

Immediately, my friend jerked back and flipped down the sunglasses on her head to cover her eyes. I approached the officer.

"How dare you," the female cop said.

"How dare I what?" I responded.

"You know what you were doing," she said. "I should write you up right now and terminate your visit. How dare you carry on like that. It's a disgrace."

"Listen, officer, I'm sorry, but I haven't had sex for seven years." Part of me wanted to laugh.

"I don't care about that!" she snapped. "Do you understand? You have embarrassed not only the staff but also every visitor here." As she spoke,

I noticed a nearby couple dry humping each other. It was a joke. The entire pavilion was full of men and women responding to their primal urges. There was nothing the guards could do to stop it. "Now go back to your table and conduct yourself in a respectable manner," she said.

I returned to the table and told my friend what happened. We watched the officer as she stared at another couple engaging in similar fashion. She let them continue, and then just at the moment of climax, she broke up the action as she'd done with us. My friend and I held hands and started kissing again. When things got hot, we walked to the far end of the pavilion hoping that the officer wouldn't notice us. We stopped near the children's play area and hid under a slide for cover. I wrapped my arms around the exquisitely soft and shapely body of my friend and kissed her openly on the mouth. She relaxed and responded in kind.

"Stop what you are doing right now!" a voice from an overhead speaker announced. Every head turned toward in our direction. I looked around to see where the voice was coming from. "You two— behind the slide. Return to your assigned seats. This is a direct order!" It was Big Brother at its best. From an overhead video camera on the perimeter of the pavilion, guards in a security booth monitored our every move. There was nowhere to run and nowhere to hide. We were in our keepers' ultimate control, where even the simple act of kissing was regulated and destroyed.

I learned to adapt to my situation but adaptation came at a cost. I became desensitized to the violence and corruption that surrounded me. A stabbing had come to seem as common as a bowel movement. Crooked guards no longer surprised me. One thing you learn on the inside is how easily the ugliness of prison life seeps into your skin, souring the lives of everyone there, including the civilians, guards and administrators. Drugs, sex and gambling were part of the fabric of life at Sing Sing, sanctioned and fueled by a crew of rogue guards. If you had the money, you could buy the drug of your choice or even sex from female guards who hustled their bodies to testosterone-charged cons.

Few of us were surprised when the news hit that a female guard known as "Green Eyes" was caught having sex with a prisoner in his

cell. For months, Green Eyes had been smuggling drugs and prostitut-ing herself to a con we called "Fox." The operation was busted when Green Eyes decided to raise the price tag on her sexual services. Fox became enraged, grabbed her and dragged her in his cell. She started screaming and the goon squad arrived within minutes. To avoid a rape charge, Fox testified against Green Eyes and confessed everything that he knew about the goings-on at Sing Sing. When the story hit the papers, a clever journalist dubbed the prison "Swing Swing," a name that stuck for years. A state investigation ensued and confirmed the existence of rampant drug smuggling and a sex ring, and even fingered several guards who'd sold their off-duty weapons for a quick buck. There was nowhere to escape the chaos in Swing Swing. Even the sanc-tuary of the chapel was destroyed when it became a prime spot for drug trafficking and violence.

A partial respite came when I was approved for a transfer to Honor Block. For almost three years, I had been on a waiting list. Only pris-oners with excellent disciplinary records could get into Honor Block, located in 7 Building about twenty yards from A Block. Honor Block was cleaner, quieter and more orderly than the other housing blocks. For me, the best part of Honor Block was that the cells had windows. I had forgotten how invigorating it felt to simply open a window and breathe fresh air. In my cell in A Block, I had compensated by painting a window on the cell wall.

The first cell I was assigned to was known as the "rain cell." Locat-ed on the top tier in the back of the building, it was where new prisoners were sent until a better cell became available. When it rained, the ceil-ing leaked so badly that you had to pitch a tent of garbage bags to stay dry. Despite the leaks, no one complained because the perks were worth the wait. The basement contained two washing machines, two dryers and a small gym. There was a kitchen with two stoves and an ice machine. For entertainment, we had four TVs: one in the middle of the block, one outside in the yard, and two in the basement. There was con-siderably less tension because Honor Block contained only seventy men as opposed to the 650 prisoners I lived with in A Block.

From the outside, Honor Block looked like an orderly housing area in which reform-minded prisoners complied with the rules and regulations of the facility. The truth was, the same crap that went on in the other housing blocks occurred in Honor Block as well. The cons were just quieter about it, but no less vicious. Shortly after I arrived, I went down to the basement to wash my clothes. There in the washing machine was the pet kitten that belonged to Willie the Pusher, spinning and banging against the sides. Thump, thump, thump. Someone had gotten even with Willie for selling him a beat bag of dope. The cat was stiff as a board. Gone was the little silver collar that Willie had placed on her neck to show ownership. Some junkie had probably ripped it off to cop a bag of heroin.

Upstairs, the kitchen was empty due to a raid we'd had the day before. Fat Daddy had smuggled in some steaks from the mess hall where he worked as a butcher. The meat sold quickly and was eaten faster. Three packs of cigarettes got you two porterhouse steaks. Soon enough, the hacks caught on and raided the supply. Someone had tipped them off. Like every housing area, Honor Block had its resident snitches, prisoners who curried favor with the guards by keeping them informed of illegal activities. Four officers searched the two refrigerators and found two cows worth of meat stored in mesh bags with combination locks.

Devine was a three-time loser doing twenty years for stealing a truckload of television sets. He had a thing for TV, even in prison. All night long, he'd sit in front of the TV in the basement like he owned it. He threatened anyone who dared to change the channel. His favorite program was the Howard Stern Show. One night, a young buck named Juice got sick of it and popped Devine in the mouth with a metal mop bucket, breaking one of his dentures.

Two guards were assigned to the block, CO William Vega and CO John Martinelli. Vega, the day officer, was a no-nonsense hack who ran the block with an iron fist. He was always hounding someone for something. Every Saturday, for example, he would awaken us early to remind us that Saturday was cell clean-up day. One of the rules in Honor Block was keeping a clean cell; prisoners could actually be given misbehavior reports if they didn't pass inspection. In the afternoon, Vega would stop

by our cells and administer his notorious "dust test." He would reach up on the top of the cell door and wipe it with a white cloth. After a while, the only thing I cleaned was the top of the cell door.

Vega was an easy guy to hate. He had a chip on his shoulder and a cruel streak that made us look like angels. When he found cats in the yard, he'd kick them to their deaths. He did that to stick it to the cat-loving cons in the block. His counterpart on the 3 p.m.-to-11 p.m. shift, Martinelli, was a decent guy who laid low and didn't give us any trouble. Apparently, Martinelli mellowed considerably after someone tried to set him up by placing drugs in his locker. He almost lost his job over it.

Honor Block had its own yard facing the Hudson River. It was there that I painted many scenes of the beautiful landscape, although I'd been warned on several occasions to stop. The administration thought I was drawing diagrams of the prison for an escape plan. There were flowering gardens and vegetable gardens split into sections. Some prisoners planted vegetables like tomatoes and peppers. Under the foliage other prisoners planted more lucrative crops of weapons and drugs.

The Honor Block yard abutted another housing area, 5 Building, and it was at this juncture that food and other contraband entered the distribution chain into the major housing areas of the prison. A prisoner from 5 Building would drop a bag from a window into the yard for pick-up. A prisoner would retrieve the bag and bring it into Honor Block, from which it could be distributed to A Block and then B Block. It was wild to see bags full of raw meat and chicken stolen from the mess hall dropping from the windows into the yard. I knew more than a few guys who got caught and were immediately sent back to the trenches of general population.

I escaped much of the madness through my art, spending hours in the yard painting scenes of the Hudson when the weather permitted. I was learning to use the creative process to transcend the poisonous environment. In addition to art, I discovered that writing was a powerful tool to express the feelings that prison life compelled me to bury. I joined a creative writing class taught by the poet and writer Fielding Dawson. Dawson was a maverick instructor who had taught writing

workshops in state prisons for over a decade. He was a crusty old guy who loved poetry and the pathos that emerged from the hardened cons in his class. Ed Klaber, the art teacher, introduced me to Fielding one night in the school. "There's someone who wants to meet you," he said. "He's a writer from the city looking for some prison artwork. Go up to the third floor. He's teaching a workshop there right now."

In the evenings, the school building hummed with activity. Prisoners filled the classrooms and participated in a variety of academic and vocational programs that were eliminated in the mid-1990s as "no frills" prison bills swept through the country. I walked by a classroom where a dozen or so men sat in small metal chairs with notebooks opened on their desks. Peering through the window, I saw a middle-aged man in front of the chalkboard. His shock of silver-gray hair, neatly parted and combed, caught my eye. I waited for a few minutes until the men lowered their heads and began writing. I knocked on the door, and Fielding waved me in.

I liked him immediately. The expression on his face was warm and expectant, not suspicious and scowling like most teachers' demeanors. "Excuse me for interrupting," I said. "My name is Anthony Papa. Ed Klaber said you wanted to see me."

"Oh, yes, yes, Anthony, good to see you. Eddie told me all about you." We stepped outside of the classroom. "I'm looking for some drawings of different parts of the prison to use with my writing. Do you think you could do a few for me on typewriter-size paper?" he asked. I told him I would and the next week gave him six pen-and-ink drawings.

I told Fielding to be careful with them. If an overzealous guard found them in his possession, he could be accused of fueling an escape plan. I had been warned on several occasions not to paint landscapes which included the buildings and roads on the prison grounds and actually had to destroy several paintings as a result. Once, I was ordered to get rid of my painting, *Metamorphosis*, the largest work I did in Sing Sing. It measured 48" by 50" and was painted on a bed sheet with acrylic and state-issued toilet paper. It was stretched on a wooden frame and hung on a nail over my sink. A lieutenant stopped by my cell one day and took a

long look at the painting. I thought he was admiring it. I was wrong. He told me that the painting could cover up a hole in the wall and be used for an escape attempt. I told him that behind the wall was my neighbor's cell. If I wanted to enter it, I'd just walk through the door, not make a hole in the wall. The lieutenant became furious and ordered me to mail it home or throw it out immediately.

Fielding and I became friends, even though it was against policy to do so. The administration had strict rules against civilian teachers having personal relationships with prisoners. They weren't allowed to accept phone calls from prisoners or even correspond with them, but Fielding didn't care about that. He saw us as human beings, not the monsters the prison folks portrayed us to be. He became a true friend, even smuggling me in a fountain pen and an inkwell for my drawings. He helped me with my writing and my artwork. He encouraged me to write poetry to capture the emotional responses to my incarceration, the same way I did when I painted. One poem in particular had merit, he said.

Sometimes They Surface

Sometimes they surface, those images of awe
Like waves in the hurricane that is my existence
They live in the corner of my mind
Other times they sleep, waiting
To be awakened by emotions like shoes on feet.
My moods hang on whispers like a pair of earrings
Telling stories of my life from the deepest part of my soul
Sprinkling my roots with imagination
Growing into monsters that haunt my memories
With abstract visions of persecutions that sometimes surface.

I enjoyed the dynamic tension between the brush and the pen. I began keeping a journal and often wondered which was the more powerful medium. Ed said it was the brush. To Fielding, it was the pen.

Morale in the school plummeted when our beloved art teacher died of a heart attack at age forty-seven. Ed's death not only marked the

passing of a gifted instructor and friend but the closing of the art class. We hoped that the administration would fill his position, but after a year it was still vacant. Art wasn't high on the administration's list of priorities. I decided to try and do something about it.

I wrote to then-Governor Mario Cuomo and several state senators requesting their assistance. I told them of the importance of art programs in prison and how for me, art had become a guiding light in an environment of total darkness. I told them how art was a therapeutic tool and how restorative programs nurture latent talent and ease tension behind bars. I got two responses. The first was from the Correction Department's Deputy Commissioner of Programs on behalf of Governor Cuomo; the other was from Senator Joseph Galiber of the 33rd District. The letter from the Department spoke the party line:

> The fiscal crisis in state government caused cutbacks of some programs and the elimination of others. Nevertheless, many inmates like you have been able to continue with their artwork as a leisure time activity. Some facilities have been fortunate enough to find talented inmates to assist others to paint or sketch…

Blah, blah, blah. Senator Galiber told me that the severe budget shortfall in 1991 resulted in the elimination of sixty-two art and music positions in the state's correctional facilities, for a savings of 2.1 million dollars. I reread the letter from the Department: "Some facilities have been fortunate enough to find talented inmates to assist others…" and decided to write a proposal to the Superintendent requesting that I teach the art class at Sing Sing. The proposal pointed out that the closing of the prison's art class had left a tremendous void. The art class, I stated, helped enhance prisoners' self-esteem, aided in their rehabilitation and helped to manage an increasing idle population. To my surprise, the Superintendent agreed and allowed me to re-open the art class. We called ourselves "The Hudson Valley School of Art" and dedicated it to Ed Klaber.

The class was held two nights a week and was a unique arrangement because we were unsupervised. No guard or civilian employee was

assigned to us. I could basically run the class myself, although running an art class in a maximum-security prison was not easy. First, most art supplies were considered contraband. No metal, glass or flammable materials were allowed. To cut mat board, we used blades from disposable razors. If anyone had gotten caught, he would've been charged with weapons possession and sent to the box. When anything went wrong in the school, we were the first to blame. All of my students were searched, whether the incident happened in the library or the GED class.

The room was full of wooden easels made in the woodshop. Half of them were missing the three-inch screws that held them together. Prisoners stole them to make weapons. The art supplies were locked in two big metal cabinets. This caused a problem because prisoners are not allowed to possess keys. A civilian who worked in the recreation department would have to escort me to class and open the cabinets. In the beginning, the hardest part of running the class was distributing the supplies and getting them back. Ed used to position himself in front of the cabinet to guard the art supplies. To receive a particular item, a prisoner had to give his identification card to Ed for security. When you returned your supplies, your card was returned. I couldn't do that because I was a prisoner, not a civilian or a guard. I didn't want any problems with prisoners accusing me of acting like a cop. I knew of convict-teachers who got piped simply for doing their jobs. I told everyone we were responsible for the class and everything that happened in it and created an honor system for the supplies. The cabinet that Ed had guarded with his life was now open for everyone to help themselves. At first, some guys stole a tube of paint or a paintbrush, probably in Ed's memory, but soon that stopped and the system worked fine.

What I tried to instill in the class was the value of art, how it could help them survive imprisonment and keep the life force alive. At first, I tried an academic approach but soon abandoned it because the students wanted to dive in headfirst. Some men used the canvas cathartically, as a vehicle to channel their energy, negative or positive. I was amazed to see how quickly art changed the attitudes of some of my students. I remember a twenty-two-year-old kid named Youngblood, the leader of a violent

gang in B Block. Within a few months, he discovered the transformative power of art. The very same prisoners he once fought became the subjects of his paintings. There was another twenty-two-year-old, Lorenzo, who had the talent of a young Picasso. Like Youngblood, he was a gang member. The life he described to me growing up in the South Bronx sounded like a tour in Vietnam. Shoot-outs, drive-bys, and murder were as common to him as Boy Scouts and campfires were to kids in the suburbs. I counseled him about art and talked to him like a son. He was in the class for a year before he was released, and during that time his painting took off. His plan was to enroll in art school once he got out, after he'd found a job and a place to live. Two weeks after his release, however, he was shot dead in the street for his cell phone.

All in all, I had about a dozen regular students in the class who bonded as artists. Some writers and poets from Fielding's class joined, and together we formed a creative subculture within the prison. But like all things in the joint, or everywhere I guess, the bad is mixed in with the good. It took considerable effort to keep the few knuckleheads from destroying it for the rest of us. After a couple of months, word got out to the prisoners that the class I taught was unsupervised. This meant trouble. Big Don from the law library started coming to the class. Don was a tough guy serving a twenty-year sentence for murder. He was also a businessman, or a hustler, depending on which way you looked at it. The prison teemed with men like him, guys looking to make a fast buck any way they could. Don was the man you went to for things. His main gigs were selling drugs and making greeting cards, an unlikely combination although there were big markets for both.

One day, Big Don told me that he needed a corner of the classroom to manufacture his greeting cards. I agreed, thinking it might be good to have a guy like Don in the class because of the influence he had over other prisoners. Soon after, he recruited a crew of Asian workers from B Block. They sat at a long table, forming a sort of assembly line, and mass-produced hundreds of greeting cards a month. It was amazing. One guy would draw the illustration for the card; another would add color with a magic marker. Another guy would write the text while the next man made

the back cover. Piece by piece, the card traveled down the line and came together. The final step was covering the card in a clear plastic. The men even crafted custom-designed envelopes. The final product looked like a Hallmark card. Big Don and his crew distributed them in the housing blocks and sold them for two packs of cigarettes a piece. The cigarettes were then changed into cash, which funded Don's lucrative drug trade. This was done by going to one of the prison's moneychangers, cons who played the role of banker. For twelve packs of smokes, you received a ten dollar bill. I had to put him in check on many occasions, like when he tried to expand his empire by setting up a tattoo parlor in the classroom.

For the most part, though, the class ran smoothly because the guys wanted to learn. They craved constructive activity and needed an outlet to express themselves in a positive way. I often wondered what a freeworlder might think upon stepping into the classroom and seeing convicted felons painting as if their lives depended on it. We once did a group painting that showed the bond we developed as artists. I found a discarded bulletin board in the hall and dragged it into the classroom one night. We primed it with white acrylic paint I'd swiped from the utility room in the basement. My students and I transformed the five-by-ten-foot bulletin board into a spectacular painting we named *Genesis*, which used scenes from the Bible to illustrate the power of art to transcend the forces of oppression. The administrators were so impressed they hung it in the visiting room.

It was my eighth year of incarceration, and I decided to try my luck in the courts once again. At this point, I had exhausted all of my state legal remedies and had only the federal courts to turn to for relief. I knew that I had a valid legal issue to argue, but I also knew that if I continued to proceed without a lawyer my appeal would go nowhere. The courts frowned upon prisoners who acted as their own lawyers, which my experience as a *pro se* litigant proved. I reached out to a close friend for help, Andrea Miller.

Andrea lived in Ossining, and had become the keeper of my artwork. She had a friend who was an attorney and said she'd see if he'd help me on my appeal. I didn't think he would because I didn't have a dime to pay him. I told her it was a long shot, but to my surprise, he agreed. The

problem was, Danny didn't have experience in criminal law. But that didn't matter as long as I could trust him. I could write the appeal myself but I needed a lawyer to file it. Just having letterhead bearing the name of an attorney would make a difference. So, since I was familiar with criminal law and knew exactly what I wanted to argue, Danny agreed that I should write the legal argument for a habeas corpus motion and he would submit it to the Southern District of New York. I prayed that my case would be assigned a compassionate judge, someone like Judge Robert Sweet, a senior District Court Judge who publicly denounced mandatory-minimum sentencing schemes.

In my previous motion to overturn my case in the state proceedings, the courts did not address my most important issue: that my Sixth Amendment rights had been violated when I was denied the opportunity to confront the People's main witness against me. I desperately wanted an answer and decided to abandon my other legal issues and concentrate solely on this one. I spent weeks researching and developing my argument before Danny submitted it to the Court.

My habeas corpus petition was assigned to the Honorable District Court Judge Peter Leisure. I researched his background and decisions on various cases and learned that he was a conservative but fair judge. All I could do was hope for the best. Several weeks later, Danny informed me that Judge Leisure granted us an evidentiary hearing. I was elated, because evidentiary hearings are rarely granted. The judge referred the case to Magistrate Judge Barbara Lee for a report and recommendation. Several months passed before I heard from her; I tried not to get my hopes up in the meantime. Finally, I received her recommendation: denied. I filed an objection, forcing Judge Leisure to conduct a *de novo* hearing that confirmed the magistrate's opinion. Next, I filed for permission to appeal to the Second Circuit Court. Again, my hopes were dashed. All of my motions were denied.

By now it was 1993; I had been down for eight years and exhausted all of my legal remedies. I had nothing left to argue. My fate was sealed: fifteen years to life, whichever came first.

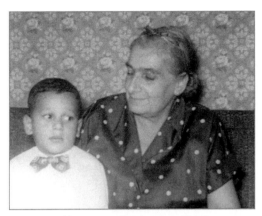

At age 5 with my grandmother Angelina Papa
Bronx, New York

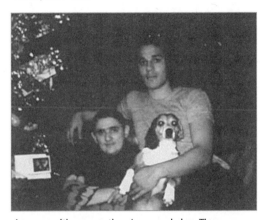

Age 17, with my mother Lucy and dog Tippy, 1972

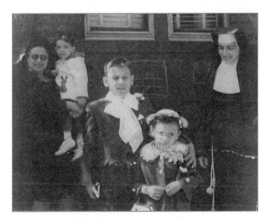

At 12 years old with my sister Angela, and Aunt
Ro-Ro holding cousin Donnie
Our Lady of Pity Church, Bronx, New York

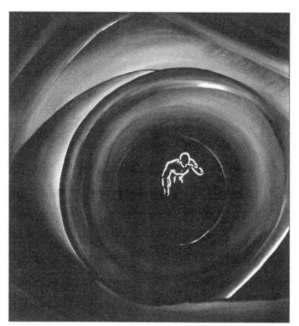

Life of Frank Papa, 1988

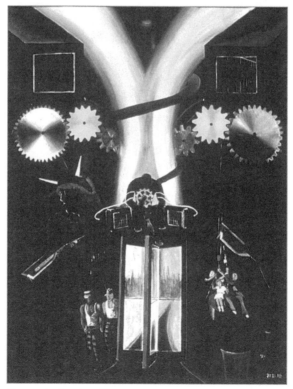

Corporate Asset, 1988

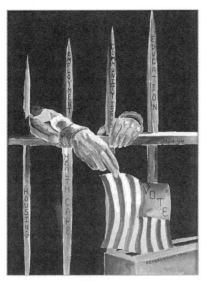

Vote, 1994

From an Associated Press shot of me behind bars, 1994

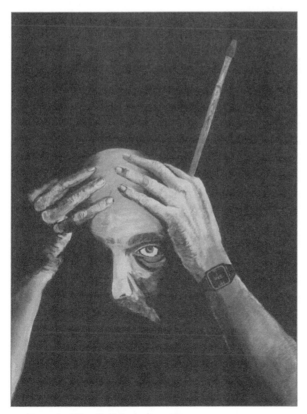

15 Years to Life—Self-Portrait, 1988

At Sing Sing Prison during a festival in the gym: holding my daughter Stephanie, with my mother Lucy and uncle Frank in the background

A family shot of me in Sing Sing with my uncle Frank, nephew Vinny, and daughter Stephanie, 1986

Nightmare of Justice, 1988

Metamorphosis, 1991

Fry Chicken Not People, 1988

After the Whitney, 1994

Delivering a fiery speech against the prison system at NYTS graduation in the Sing Sing visiting room, June 10, 1995. Left: Sister Marian Bohen, one of my instructors at NYTS

With Governor Pataki, June 12, 2002

My mother Lucy and wife Luciana, holding baby Anthony
Bronx, New York, 2002

With my wife Luciana, her father Joe, his wife Sandra, and
Anthony Jr. São Paulo, Brazil, August 3, 2004

Anthony Papa, Al "Grandpa" Lewis, Judge Jerome Marks, and Frank Serpico at City Hall rally against the Rockefeller Drug Laws, calling for repeal in 2000

Holding the sign at a 2001 protest in front of Governor Pataki's office with the Mothers of the New York Disappeared, and retired New York State Supreme Court Justice Jerome Marks at the mic

Argentine Madres travel to New York City to protest with Mothers of the New York Disappeared on the steps of City Hall, April 12, 2004

The Whitney Museum

SEPTEMBER 10, 1993 WAS A DAY that would permanently alter the course of my life. It was on that day that the administration received a letter from Elizabeth Sussman, the curator at the Whitney Museum of American Art. Sussman contacted Sing Sing to see if there was a convict-artist who could participate in an upcoming Whitney exhibit. She wrote:

> I am the curator for the Whitney Museum of American Art's upcoming Mike Kelley exhibition. Kelley has made a significant contribution to the performance and conceptual art of the past fifteen years, and we are very enthusiastic about mounting his first retrospective. One of the works in the exhibition, *Pay For Your Pleasure*, requires the appearance of a work of art by a convict. The piece has been shown in Chicago, Los Angeles, Berlin, London, Switzerland, and France with the cooperation of local authorities.
>
> I am writing to ask if your institution sponsors an art program and what are the possibilities for the loan of an artwork to the Mike Kelley exhibition. The show will be held at the Whitney Museum from November 4, 1993 through February 20, 1994.
>
> Thank you very much for any assistance you can offer.
>
> Best regards,
>
> Elisabeth Sussman, Curator

The request was channeled to Sing Sing's Supervisor of Special Subjects, Dennis Manwaring. Dennis was a decent guy who had worked at the prison for over twenty years. It was through his assistance years before that I was able to stay at Sing Sing when he transferred me into general population. Dennis oversaw the art program and stopped by my class one night with her letter.

When I read the letter, I knew that participating in the show was the break I had been waiting for. As I re-read the lines, they blurred into a single word: FREEDOM. I told Dennis that I wanted to participate in the exhibit and gave him a set of slides of my paintings that I'd smuggled into the prison several years before. My friend Vicky had made the slides when a curator from the Museum Del Barrio in Manhattan had come to the prison to see my work. The curator invited me to participate in a group show, but the show never got off the ground. Nevertheless, the experience reinforced my sense that my art held the keys to my freedom.

A week passed and I hadn't heard anything from Dennis. I was impatient because I knew how the system worked. Anything that involved the administration, whether a simple decision or task, would take weeks to address or end up disappearing in the sea of red tape. The chain of command and zillions of rules and regulations created total confusion.

Several days later, I ran into Baldy, Dennis' inmate clerk. I asked him what was going on with the show. "There's not going to be a show for you, Tony," he said.

"What do you mean?"

"You better go see Dennis."

I immediately requested a pass to Dennis' office. The door was open; he was busy doing paperwork at his desk. I popped my head in. "Hey Dennis, you got a minute?"

"Have a seat, Tony," he said, not looking up. Several minutes passed while my palms started sweating. Finally, he raised his head. His face looked weary. "We're not going to participate, Tony. I'm sorry."

That was Dennis—short and sweet and to the point. So short, in fact, that I felt like I'd been socked in the gut. I needed this break. It was the only one I had left. Some prison employees don't even give you a chance

to argue, but Dennis was different. He had a soft side. I decided to work it. "Dennis," I pleaded, "what are you saying?" I looked in his eyes and tried to understand what was going through his head.

"I refuse to let any of my prisoners become exploited," he said. I asked him to explain what he meant. He went on to say that he had received "a startling letter" from the Whitney that convinced him that barring my participation was the right thing to do. I asked to see the letter. He hesitated, but finally gave in. He handed me a folder containing two letters written by Elisabeth Sussman.

Dear Dennis:

Thank you so much for your willingness to cooperate with the Whitney Museum. What I did not make clear this morning is that the piece of art by a prisoner that is appropriate for Mike Kelley's work must be made by a prisoner who is a murderer. I hope that one of the people you identified this morning fits that description. If you have any questions, please call me. In the meantime, I am enclosing a loan form, which functions to identify the artwork and to serve as a contract. If you could possibly send this back to us at once, we can then go ahead and make arrangements to pick up the work in the next week or two.

Best wishes and thanks again.

I turned the page and scanned the second letter that was sent to Dennis, which was sent in response to a letter he'd written her stating that he wouldn't allow me to participate. It was dated October 12, 1993.

Dear Mr. Manwaring:

I regret having presented the matter of your inmate's inclusion in Mike Kelley's *Pay for Your Pleasure* piece without providing a context for the admittedly jarring stipulation that the inmate would be serving time for homicide. Kelley's work consists of a pantheon of images of great men from Western history accompanied by quotes celebrating artistic genius. At times the text seems to exempt artists from the civil constraints of law and common ethics, and Kelley's incorporation of a work of art by a convict emphasizes this idea by taking an extreme position. As part of *Pay for Your Pleasure*, visitors to the exhibit will be requested to make a donation to crime victims.

You should be informed that the description of *Pay for your Pleasure* in the checklist at the back of the exhibition catalogue does specify a work of art by a person convicted of homicide, though not necessarily by name. I appreciate your reluctance to identify the crime committed by the inmate whose slides you sent us (they're very good!). Please reconsider the matter and let us know if you are willing to proceed with the loan.

Like Dennis, I was taken aback by the museum's insistence on having a painting by a convicted murderer, but in the long run, who cared? What mattered was that my art would be shown at one of the most prestigious museums in the world. "Dennis, you have let me do this!" I said. "It could help me get my freedom back! I *know* it will!"

Dennis sat up straight in his chair and didn't say a word. He reached for the phone and called Father Kavanagh, the old priest who'd been at Sing Sing for over thirty years. He was Dennis' spiritual advisor. Whenever Dennis had a tough call to make, he turned to the Lord and Father Kavanagh.

"Father, is it ethical to release the crime of a prisoner to an outside source?" Dennis asked, nodding as he listened to the priest. He hung up and made the sign of the cross. "Well, Father said it was unethical, so I won't reveal your crime."

For a split second, I was elated, but then I realized Dennis didn't say he'd let me participate. "Dennis!" I pleaded, "You have to do this for me. Please!" I was practically shouting.

Dennis slammed his hand on the desk. "Are you a murderer?" he yelled. "Did you ever kill anybody?"

I shook my head.

"No? Then are you telling me to lie?" he asked, his voice shaking. "I'm not going to lie, Tony. And that's that!"

I had to think fast. "Okay," I said, regaining my composure. "I'm not asking you to lie, Dennis. I'm not asking you to do anything. *I'll* write the letter and if anything goes wrong, it's on me."

Without a word, he lowered his head and went back to his work. I took a pad from his desk and proceeded to write a letter.

Dear Miss Sussman:

In response to your inquiry about the crime I committed, I am respectfully submitting to you that I am indeed serving time for murder. In fact, I am currently serving two 15-to-life sentences for a double murder. I hope this satisfies your inquiry as to the status of my crime.

Sincerely,

Anthony Papa

I did I what I had to do and even threw in an extra murder just in case. A week later, I received a positive response from the Whitney.

Dear Mr. Papa:

Thank you very much for agreeing to lend one of your paintings to the Whitney Museum's Mike Kelley exhibition. Mr. Kelley has chosen to include *15 Years to Life—Self-Portrait* in his piece *Pay for Your Pleasure*. We now need a little bit more information. What is the date of the painting? Is the painting acrylic on canvas or some other surface? Should the credit line read "Collection of the artist"? This information will be used on the label located near the painting to identify the artist and work.

I will send your slides back to you this week. Is it okay if we keep the photograph of *15 Years to Life—Self-Portrait* for a while longer? It's helpful to us to have an image of any work that will appear in an exhibition here.

Thanks again (and congratulations!)

Sincerely,

Minou Roufail, Curatorial Assistant

The following week the Whitney sent a handler to the prison to pick up my self-portrait. My dream of having a painting exhibited in one of the most prestigious museums in America was coming true. Now all I needed to do was figure out how to parlay this stroke of luck into a way out of prison.

For the next month, I was on pins and needles waiting for something to go wrong. A decade in prison does that to you: it makes you expect the worst. But things were out of my hands. All I could do was pray that

everything would go as planned. Dennis was invited to the opening of the exhibit but he didn't want to go. He gave me the tickets instead, which I sent to my friend Andrea Miller and asked her to go in my place. On opening night, Andrea brought her husband Neal and my lawyer Danny Freeman and his wife to the Whitney. I will never forget that night. While they mingled with high society at the Whitney, I sat in a prison biology class staring at the clock and imagining what was taking place at the museum. I couldn't sleep that night. I tossed and turned and exhausted myself doing pushups until I fell asleep.

The next morning I called Andrea. "The show was great," she said. I asked her how people reacted to my self-portrait. She said that she and Neal had planted themselves near my painting to hear what people were saying. One couple wondered if it was a Rembrandt, she said.

"I don't get it. Couldn't they read the name tag?" Andrea told me that there was no nametag beside the piece. Not even in the exhibit catalogue, she said, did my name appear. She introduced herself to Mike Kelley, the artist who was having the show, and asked him if he could help me in some way. "What more can I do?" he replied. "His work is being shown at the Whitney. The rest is up to him."

When I read the reviews, my painting was discussed but my name was not mentioned. *The New York Times*' art critic Roberta Smith praised the painting as an "ode to art as a mystical, transgressive act that is both frightening and liberating, releasing uncontrollable emotions of all kinds." I was faced with a dilemma: how to use my art to secure my freedom when the Whitney Museum hadn't even mentioned my name.

I wrote to two organizations for advice: *Art News*, a magazine in which I'd once placed an ad offering a painting in return for legal services, and the Art Students League in New York City. Rosina A. Florio, Executive Director of the Art Students League, wrote back.

Dear Mr. Papa,

In reply to your letter, I should like to congratulate you on showing at the Whitney. However, if the exhibition concerns prison art, then you have been stigmatized. But memories are short and people rarely remember an artist showing in a group show.

May I suggest, however, when dealing with a gallery that might show your work, that you do not mention your imprisonment it is of no importance. An artist has no personal background. It is the work of art that is important.

There have been several exhibitions in the past 40 years that showed prison art but nothing happened. Getting into a gallery is tough. A gallery owner is in for the money. They really don't have altruistic reasons. I suggest that instead of sending slides from the prison, you ask your family to send them or have them take them to galleries with no mention of where you are.

As a painter, you learned honestly. Therefore, your work should be judged on its merits, not on your history. These, of course, are my sentiments. I don't like art to be exploited in any way. Although, so much of it is.

And it may be that you may gain some modicum of success if you pursue your art coupled with your imprisonment. But then you will never know how good an artist you are.

Perhaps the years in prison have not been so unfruitful. You are a student of psychology and sociology. You are studying and are painting pictures. Would you have been able to do all of these vocations on the outside? You would have to be employed, go to school and pay for it, find a studio, pay for that. You would need money for living expenses, art supplies, travel, etc.

Have I made the outside world a little less palatable? Consider the imprisonment a sickness that must be endured but it can be cured. Continue to paint and to create, because these are golden moments.

Imagine receiving a letter from a freeworlder telling you that your years behind bars were "golden moments." It made me sad when I realized how little society understood the prison experience. But I did appreciate her honesty. She convinced me that the Whitney had indeed exploited me, just as Dennis had warned, but maybe that was my recompense for lying about my charge. I guess we were even.

While pondering my next steps, I recalled an article in an art magazine that discussed how most artists neglect to capitalize on the momentum after showing in a major gallery. If you don't follow up, the

article warned, your moment in the sun will quickly fade. You had to get mileage as long as you could. I had an idea.

The week before I had met Rudy Cypser, a volunteer for an alternative to violence group at Sing Sing. He was affiliated with a major prisoners' rights organization, CURE, and told me that he'd heard about my work at the Whitney. He suggested a story be written for their monthly newsletter. I'd said I'd get back to him.

I wrote to Rudy, saying I'd like to take him up on his offer. He assigned Johnny Lee, a staff reporter in the prison, to do the story. Johnny was serving fifteen years to life for murdering a man who killed his brother in a gang-related shooting in Chinatown. I often thought about how Johnny and I were given the exact same sentence, me for passing drugs and him for committing homicide. Johnny and I had known each other for years; he locked in Honor Block with me. "Why don't you write the piece?" he said. "You know more about your life than I do." I agreed and wrote the interview—asking the questions and supplying the answers about how I'd discovered myself through art and education while in prison and how I made it into the Whitney. I typed it on the computer in the school and ran off dozens of copies. I then developed a "press list" of writers and editors from newspapers and magazines and sent them my article.

At first, no one responded, but in a couple of months I hit paydirt when Roberta Arminio, the Director of the Ossining Historical Society Museum, sent my interview to Ken Valenti, a staff reporter at the *Gannett Suburban Newspaper* in Westchester. I got to know Roberta when I'd donated a watercolor of the museum in celebration of the town of Ossining's 175th anniversary. Ken wrote and told me that he wanted to do a story on me. I was excited.

Getting Ken into the prison wasn't easy. Like all members of the media, he had to submit a request in writing to the Department's Public Information Office and establish that he was doing the piece for a legitimate publication. If the request was approved, the Public Information Office would then contact the prison, which would then set up the interview. To my surprise, the request was granted and a month later, I had my first real interview.

I was told that the interview would be conducted in Dennis Man-waring's office. I waited there with Baldy, praying that everything would come off as planned. Like most inmate clerks, Baldy ran things in Dennis' office. Some days he thought he was a civilian, which didn't sit too well with the convicts. I think that's why they set his mattress on fire. Usually, the administration would immediately send the victim to PC, since the act was considered a death threat, but Dennis must have intervened. The truth was, most convicts set prisoners' mattresses on fire just to get rid of guys they didn't like.

Ken and the photographer finally showed up. The photographer decided that I should sit behind Dennis' desk so that he could get some shots of me in front of the metal bars on the window. I pushed everything on the desk into an empty box, including pictures of Dennis' children. A civilian employee named John, who was assigned to escort Ken and the photographer, sat on the side while Ken started to ask me questions. Every time I raised my hand to make a point, the photographer shot a flurry of pictures. After a while, I just raised my hand to see the guy take my picture. It was comical. In the middle of the interview, Dennis walked in. "Hey Dennis," I shouted, raising my hand. "Smile for the camera!" He shook his head and left.

Ken asked to see my cell and Dennis approved the request. As we walked to the block, Ken said it was the first time he'd been inside the belly of the beast. He waited on the main floor of Honor Block with John while the photographer set up a tripod near the window of my cell. The cell was so small, just fifty-four square feet, that he had to put one tripod leg up on the bed. "Welcome to my home and gallery," I said. A nail I'd pounded in the wall above my sink served as a makeshift easel. My wooden palette doubled as a cover for my toilet bowl. "There's a toilet under that?" he said, snapping away.

"Yeah, and it has other uses as well," I said. "It makes for a good refrigerator, water's nice and cold. And I can clean my paintbrushes in it, too." After the photos, Ken joined us in my cell. He was like a kid in an amusement park, his eyes widening as he took in the surroundings. "I can't believe I'm sitting in a cell in a maximum-security prison," he said. "I can't

believe how small it is." He looked at the books on my desk and was interested in one in particular, B.F. Skinner's *Beyond Freedom and Dignity.* "Why do you read books like that?" he asked. "It's how I deal with my imprisonment," I said. Ken kept staring at my desk. It was an old, metal desk built by convicts in an upstate prison factory. I trusted Ken with a secret. I told him how I used the desk to hide contraband. I pried open the middle drawer and slipped small objects into the inch-wide space that was created underneath. I showed him the tiny FM radio, and the fountain pen and inkwell from Fielding. The interview lasted over three hours.

I held my breath waiting for the piece to be published, hoping that Ken would do a good job and the article would generate interest in my case. A few days later, a guard told me to report to Dennis Manwaring's office. He gave me a pass and I left, wondering what fresh hell awaited me.

"Hey, Dennis, what's up?" I said.

"Ken Valenti called. He wants to speak to you." Dennis called Ken and handed me the phone. "I have to run down the hall," he said. "I'll back in a few minutes." That was Dennis' way of covering himself. Employees could only allow prisoners to use their phones in case of emergencies. This wasn't an emergency, but Dennis knew it was important to me. He was cool that way.

I called Ken and asked him how the piece was going. "Fine," he said, "I just have a few follow-up questions." I answered his questions and clarified various points. Then he dropped a bomb. "So Tony," he started, "is it true that in order to exhibit your work at the Whitney you had to lie about being a convicted killer?" My heart sank. I maintained my composure and told Ken the truth. "Look—I'm serving a fifteen-year-to-life sentence for a nonviolent crime. I've been in prison for almost ten years for passing an envelope for five hundred bucks. Did I lie? Yes. Was it unethical? I'll ask you that question. Getting into the Whitney was my best shot at freedom. If you'd been in my shoes, what would you have done?" While I waited for his response, I imagined the headline: "Drug-Dealing Convict Dupes the Whitney." A short silence ensued; Ken didn't answer the question. "Okay, Tony, thanks for your time. The piece should come out in next Sunday's paper."

Sunday came and went. The story didn't appear. I asked a few guards and civilians to pick up the paper for me since I couldn't buy it in the prison. Three weekends passed and no article. I'd just about given up hope when the following week a guidance counselor stopped me in the hall. "Anthony, congratulations!" he said, handing me the June 7, 1994 Lifestyles section of the *Gannett Suburban Newspaper*. "Way to go!"

The article, titled "Mr. Papa's Paintings," spanned the entire front page of the section and featured a picture of me standing over my palette-covered toilet bow, paintbrush in hand. Next to me was a painting I'd called *After the Whitney*, an abstract piece that illustrated my dream of painting my way out of prison. The article captured the highlights of my case, my art and my struggle for freedom. Ken didn't write a negative word about me or mention how I'd got into the Whitney.

Soon after, I received another request for an interview. This one was from Richard Stratton, editor of *Prison Life*, a glossy national magazine for America's captive audience. Richard was an ex-con who'd done eight years in federal prison for drug smuggling. The judge had originally sentenced him to twenty-five years, not only for the drug charges but for refusing to cooperate with the government and identifying his customers. Stratton wrote a precedent-setting motion, arguing the blatant unfairness of penalizing a person for refusing to snitch, and his sentence was lowered. Because of his experiences, Richard had a vendetta against the government and to this day is a tireless advocate in drug law reform. He saw my article in the Westchester paper and sent a reporter from *Prison Life* up to interview me.

The reporter, a beautiful blonde, got permission to interview me in my cell. Like Ken, she sat on my bed. I sat next to her and joked that it had been a decade since I'd shared a bed with a woman. Luckily, my remark didn't scare her—I mean, there she was sitting inches away from a convicted felon in a tiny cell in a maximum-security prison. She laughed at my comment and listened sympathetically as I told her my story. She wrote an incredible article titled "Portrait of an Artist Behind Bars." The opening few paragraphs said it all:

If life throws you lemons, make lemonade. Anthony Papa would prob-
ably cringe at such a sickeningly cheerful cliché, but it's hard not to
recall it when you meet him. Think you've been thrown a few lemons?
Try a fifteen-year-to-life sentence for passing an envelope containing
four-and-a-half ounces of cocaine, losing ten grand to a scumbag attor-
ney who gave you the worst advice money could buy, being divorced by
your wife and watching the dealer who set you up get off scot-free while
you were sent up the river.

Tony Papa wasn't an accomplished artist before prison. He wasn't
even an amateur. He was a regular Joe from the Bronx with a family and
a business installing car alarms and radios until his arrest. The night-
mare was only beginning. When the prosecutor offered Papa a
three-year-to-life sentence, his lawyer, George Bloomstein, read the des-
peration in Papa's eyes as money in the bank. He advised Papa to go to
trial. "He got the cash and I got the time," says Papa.

The article meant a lot to me, not only because it captured my senti-
ments so accurately, but also because it afforded me an opportunity to tell
the world what had happened. The story held no punches and exposed
the shark of an attorney who had taken advantage of a desperate client. I
happily sent George a copy.

I also sent the article to other newspaper and magazine editors and
said that I was available for an interview. In February of 1995, I sent *The
New York Times* a letter-to-the-editor in response to an article about
Rockefeller drug law reform, and they published my letter.

A week later, a national columnist for *The New York Times*, the
Pulitzer Prize-winning Anthony Lewis, excerpted my letter in an editori-
al. Titled "Crime and Politics," Lewis talked about the recently enacted
national crime bill that gave states 10.5 billion dollars to build new
prisons. Lewis wrote:

Because there is a deep public fear of violent crime in this country,
every politician wants to look tough on crime. What better way than
building more prisons to house violent criminals for longer sentences.
But if you actually look at the facts, a huge prison-building program is
not a rational way to fight crime. Indeed, it will take us in the wrong

direction—lock us into the mistake for a long time. The rates of violent crimes that especially alarm us—murder, robbery, rape—are leveling off or going down. Then why are the prisons so crowded? Because they are full of nonviolent drug offenders. It's hardly a secret that severe drug laws, with long mandatory sentences for nonviolent offenses, are the reason for the enormous prison population growth in recent years ...

Under the Rockefeller drug laws, the number of prison inmates in New York has quintupled since 1973. There is a human element too, that gets lost in all the political rhetoric about toughness on crime. It was brought home to me the other day by a letter-to-the-editor of *The New York Times* by a prison inmate in New York State, Anthony Papa.

"I'm a first time offender in my 10th year of a 15-to-life sentence for passing an envelope containing four-and-one-half ounces of cocaine," Mr. Papa wrote. "Since incarceration, I have gotten two college degrees and am attending graduate school at New York Theological Seminary. I made a mistake when I was young. I needed a wake-up call, not to be thrown in a cage for fifteen years." New York prisons are full of men and women who are fully rehabilitated, Mr. Papa said. He urged that their sentences be shortened as part of the Pataki program. But his letter implicitly carried a larger message: that we should be moving away from such a waste of public resources and human life.

In March of 1995, for the tenth year in a row, I participated in the annual Corrections on Canvas art show in Albany. The show was held at (on the first floor of) the Legislative Office Building where members of the State Senate and Assembly had their offices. I always included political pieces opposing current criminal justice policies, hoping to influence one of the many politicians who passed by the exhibit on their way to work. Ironically, politics led to the closing of the annual art show in 2002.

For thirty-five years, prisoners in New York State had been allowed to exhibit their art in the Corrections on Canvas show. They donated fifty percent of their profits to the Crime Victims Board, an organization that provides services and financial compensation to crime victims. But controversy erupted when the public learned that paintings from a serial killer were on display. The media went into overdrive, and Governor

George Pataki folded under the pressure. To avoid looking soft on crime, he canceled the show altogether, thereby punishing thousands of prisoners for the act of one individual.

The piece I submitted in 1995 was titled *God Bless You*. It protested the Governor's 1994 ban on college programs for prisoners. The painting depicted a prisoner in a graduation robe in front of a cell. The tassel of his cap wrapped tightly around his eyes, mouth and throat, signifying the death of the educated prisoner. In the bottom corner, I painted a scroll with a Kairos document, which read:

> We the imprisoned people of New York State, 85% of whom are black and Latino, 75% of whom come from 26 assembly districts in 7 neighborhoods in New York City, to which 98% will someday return, possibly no better off than when we left, uneducated and lacking employable skills, declare this Kairos in response to the elimination of the prison college programs, GED and vocational training programs and education beyond the eighth-grade level. The elimination of prison education programs is part of Governor Pataki's proposed budget cuts. It amounts to less than one third of one percent of the total state budget, but it will cost taxpayers billions of dollars in the years to come.

I went on to state that many studies, even one conducted by the New York State Department of Correctional Services, have demonstrated empirically what people know intuitively: that prisoners who earn college degrees are far less likely to return to a life of crime upon release. According to research conducted by the Department, of the inmates who earned a college degree in 1986, 26% had returned to state prison, whereas 45% of inmates who did not earn a degree were returned to custody. For many prisoners, gaining an education signals an end to personal failure and a ladder out of poverty and crime. Without it, the governor may as well change the name "Department of Correctional Services" to "Department of Correctional Warehousing." As the former Chief Justice Warren Burger stated: "To confine offenders without trying to rehabilitate them is expensive folly."

I ended the scroll by asking concerned citizens of New York State to contact their legislators and demand that the present range of prison education programs continue to operate for the benefit of the entire state. "God Bless You."

I submitted another painting, a 28" x 36" mat board cut into the shape of a cross. I painted windows on the cross and placed excerpts from articles about my case inside. In one of the window panels, I placed a photograph of a nun holding a ruler with a caption that read: "Free Anthony Papa." My hope was that these works would somehow reach someone who could help me.

That March, I received a letter from a reporter with the Associated Press. She had seen the work on display in the Legislative Office Building and wanted to write a story. I agreed to the interview and she came to Sing Sing. Her article appeared in six different newspapers across the state.

The next month, the *Staten Island Advance* ran a story with the headline: "Inmate Finds Purpose, Voice Through Painting." It featured a picture of me standing behind my cell door. Through this, I met Ben Butler, a Staten Island businessman who commissioned me to paint the cell door depicted in the photograph. Ben became a good friend and would later help me in my quest for my freedom.

Shortly after these articles appeared, a counselor from the prison approached me. I didn't know him well but he'd always struck me as a fair-minded guy. He pulled me aside in the hallway. "I'm putting my job on the line by telling you this," he said, "but you need to know something. I think you're doing the right thing, but in the eyes of the administration, you're making them look bad. You have to 'self-regulate,'" he said. "If you don't, they'll make your life miserable."

The counselor was right. On July 7, 1995, I was ordered to pack up my property because I was being transferred to Tappan, a medium-security prison on the grounds of Sing Sing. It was located "down the hill," near the banks of Hudson River. Tappan comprised three buildings housing prisoners in a dormitory setting. When officials want to send a prisoner a message, they transfer him, usually to a facility in the farthest

corners of the state. I guess I was lucky that they only sent me down the hill, but I hated the thought of moving. For years, I'd lived in a single cell in Honor Block; now I would be living in a crowded dorm. I packed my property into seven garbage bags and dragged them to my new home.

The sergeant who greeted me said that I would be sleeping in a bunk bed. The boom in the prison population during the 1980s and '90s forced medium-security facilities to double their capacity. They did this not through new construction, but simply replacing single beds with bunk beds. Each of the state's twelve maximum-security prisons had to designate a company or two for double-celling, meaning that cells that were designed for one man would now hold two. Some of the cells in the old maxes such as Sing Sing measured fifty-four square feet.

It was awful, and the sergeant seemed apologetic when he pointed to my bunk bed. The correction officers' union had actually opposed the decision to double cell inmates, arguing that it was dangerous, inmate management at its worst. The sergeant added that I was only allowed to take three bags of property to my "cube." The other bags would be stored and I could have access to them once a week.

My first reaction was panic. I would have to share a cubicle with another prisoner and sleep in a bunk bed in a crowded dorm. I asked the sergeant what would happen if I didn't comply. He said I'd be sent to the hole.

When I located my new home, essentially a bed in a sea of bunk beds, the bottom bunk was occupied. The top bunks were the worst because you had absolutely no privacy. Whether sitting or reclining, you were in full view of everyone in the dorm. I heard the prisoner in the bottom bunk before I saw him. He had a serious medical problem; his labored breathing sounded like a lawnmower. An odor hung in the air around his bed. When I extended my hand to introduce myself, he spoke to me through a hole in his throat. A stream of liquid sprayed out and landed on my shirt. I fled.

I approached a guard and told him that I couldn't stay there. "That's your problem, pal," he said. I regained my composure and told myself that I'd overreacted, that things would get better. When I returned after

the count, it was worse. The cubicle was littered with the inmate's medical supplies. He'd left dirty gauzes and bloodstained towels all over the floor. When I tried to climb the ladder to the top bunk, I had to step over his dirty underwear and smelly sweat socks he'd left hanging from the rungs.

That night, I was in a deep sleep when all of a sudden the bed started shaking. At first, I thought the guy was jerking off, or maybe a train was passing on the tracks below the prison. I tried to fall back asleep, but then the shaking became violent. I peered down to see what was happening and saw the guy choking on his own mucus. I sat up and flung my legs over the side of the bunk to jump down, but when I placed my hands on the top of his locker for balance, they slid off the surface. It was covered with mucus.

I went straight to the officer and told him what happened. "I'm not going back," I said. "Put me in the hole. I don't care. Anything's better than this." The officer allowed me to sleep in an empty cubicle that had been cleared out that day. "Don't get too comfortable," he said. "We got two guys coming in on Monday." The next day, I filed a grievance and wrote to the administration, stating that they were creating a dangerous health crisis because they were not properly screening prisoners with infectious diseases. Two days later, my bunkmate was transferred to another unit and I was sent back. In his place came a prisoner with a broken leg. Incredibly, the prison had assigned him to the top bunk. Since there was no way he could climb the ladder, I told him about the empty unit. That way, we'd both have our privacy. I thought the problem was solved, but the best was yet to come.

When I awoke the next morning, a young black guy no more than twenty years old sauntered into the cube. "Hello, sir," he said in mock formality. "My name is JJ. I don't want to cause no problems, but I have to tell you, I'm a rocker!" I looked at the guy. He seemed normal. No holes in his throat, no broken limbs. "Yeah," I said, "No problem. I used to be a rocker myself, into Deep Purple, Led Zeppelin, the old stuff." He asked if he could use my radio while I was at work. "Sure," I said, "but keep it low or they'll confiscate it."

"You got it," he said.

About two hours later, when I returned to the unit, I heard the radio at full blast. "Asshole," I mumbled. When I turned the corner, a crowd of prisoners was peering into my cubicle, staring at JJ. He sat on the top bunk rocking back and forth like a hummingbird on speed. I figured he had some type of neurological disorder. All that day and night, he rocked in his bunk. He wouldn't stop. He'd stare at you with a loopy grin and just keep rocking back and forth, back and forth. The next morning I was sitting on my bunk when his big toe landed directly in my mouth when I opened it to yawn. That was the last straw.

I wrote four grievances to the administration outlining a litany of policy violations. I threatened to file a lawsuit against the prison. Finally, the next week a captain called me to his office and offered to move me to my own unit if I withdrew the complaints. I agreed and moved. Those few days almost broke me. They affected me more than all the years I had spent in the maximum-security part of Sing Sing.

The Art of Clemency

BEING IN PRISON all those years had drained me spiritually and emotionally. There were times when the only emotion I was aware of was a quiet, smoldering rage. Because of the barriers I'd built to survive, I'd become desensitized, and I knew it. There was still a part of me that could see myself from the outside in, and what I saw I didn't like: a callous, bitter individual consumed with the injustices of the world. I knew that I needed to heal if I ever wanted to interact normally with people upon release. I had some insight into human behavior because of the bachelor's degree in Behavioral Science I'd earned from Mercy College in 1993. The problem was, the program was over and I was still locked up. The walls of negativity were beginning to close in on me again when a friend told me about a unique program he'd recently joined known as the New York Theological Seminary, a one-year, forty-two-credit program that afforded a select group of Sing Sing prisoners the opportunity to earn a master's degree in theology. Opened in Sing Sing in 1983, the New York Theological Seminary was the only program of its kind in country, a graduate-level religious studies program that required a four-year degree from an accredited university to join. The program demanded intense academic scholarship and a commitment to personal growth. Each year, hundreds of prisoners applied but only fifteen were accepted. I was fortunate to be chosen by Dr. Bill Webber, the longstanding director of the program and to this day a fearless champion of prisoners' rights.

The core of the seminary teachings was based on liberation theology, rooted in "praxis," or action as an essential ingredient in all theological method. Its hermeneutical approach argues that we cannot begin to understand, criticize, or verify the meaning of scripture or tradition unless we are approaching it from the actual practice of liberation, from concrete involvement in trying to make the world better.[1] The program brought together men of diverse religious and ethnic backgrounds. A recurrent theme was that of "koinonia," or authentic community. Koinonia encompasses the belief that we must reject the differences between us to create a society where class distinction is nonexistent and the poisons of racism, sexism and nationalism disappear.

In the subculture of prison, practicing community was another story. The prison experience had bonded us in community, but it also separated us not only from the outside world but also from each other. In an environment where few comforts existed, men learn to "get theirs" at all costs. Prison life heightens distrust and suspicion. The emotional responses we honed in order to cope with our imprisonment, and the survival strategies we'd mastered to navigate the predatory environment conflicted with the concept of "koinonia."

For the first few months of the program, I struggled to find a foothold. I considered dropping out, but Bill Webber urged me to persevere. He suggested that I sharpen my skills as an observer of human behavior because in learning how to deal with others, I would gain mastery over myself. I would learn to understand my emotions, he said, and to feel again. In every confrontation I faced, whether with a prisoner, an officer or an outsider, I tried to apply what I was learning in the seminary to gain insight into my fellow man and the world around me. For the first time in years, I started to feel empathy.

One night, while sitting in Bill's ministry class in the basement of the chapel, I met Robert Gangi, the executive director of the Correctional Association of New York. Gangi had spent years educating the public about the need to repeal the Rockefeller drug laws. He was, and still is, a tenacious and articulate activist. Bill Webber had invited him

to speak to our class about the Rockefeller drug laws. I was eager to meet Bob in person because I'd read many of his op-eds and letters-to-the-editor in *The New York Times*. He wrote eloquently about the injustice of the very same laws that incarcerated me. His presentation was as powerful as his writing.

After class, I stayed behind to talk to Bob. When I told him about my case, he asked if I had applied for clemency. I told him I'd thought about it but wanted to wait until I had my master's degree from the seminary. I wanted to be fully armed when I applied. He told me that I should try—I had nothing to lose—and to get the process going because there were many hurdles to overcome. He was right.

I knew several prisoners who had applied for clemency. None of them made it, not even a guy from I knew from Honor Block who was sentenced to twenty years to life under the Rockefeller drug laws, Nick Perez, who'd applied three times. Nick patiently instructed me about the process.

In order to be eligible, you had to have served one half of your sentence. Next, you needed to submit an application to the governor. If the application was accepted, a case file would be opened and the clemency board would investigate your case and scrutinize your prison record. Information and opinions were gathered from superintendents, the parole board, prosecutors and judges. From the hundreds of applications reviewed each year, only a dozen or so ended up on the governor's desk.

Clemency is an extraordinary remedy that governors traditionally issue only at Christmas time. In New York, where Governor Pataki was elected on a tough-on-crime platform, only nonviolent offenders had a chance. Violent offenders could apply but they were wasting their time. Even though I was a drug offender, I knew that my chances were slim. I began doing research in the law library and found a how-to manual written by an advocacy organization.

The manual was a godsend. It outlined the critical components of an effective clemency application. I designed a three-part application. The first part was a five-page letter to the governor. The second part

outlined my achievements while incarcerated and included my art, my education and my writing. The third part contained twenty letters of recommendations from various people. The letter read:

> Dear Governor Pataki:
>
> I am a first-time, non-violent offender who has served over 10 years of a 15-to-life sentence for the sale of four-and-one-half ounces of cocaine. At the time of my arrest I was self-employed, married and the father of a beautiful girl.
>
> I worked in a gas station in the Bronx installing car radios and alarms. I was a solid citizen of my community until my downfall. A member of my bowling team asked me if I wanted to make extra money by delivering cocaine for him. I had no idea of the dangers associated with drug activity. This led to my arrest and subsequent conviction.

I went on to tell the governor how I discovered my talent as an artist while incarcerated and how my self-portrait, *15 Years to Life*, had been exhibited at the Whitney Museum. I knew that gaining political support was crucial, so I started writing to politicians asking them for letters in support of my clemency. I wrote to every member of the New York State Legislature pleading for help. Day and night, I sat behind my typewriter composing letters, praying that someone would read them. It was a long and frustrating process. I tried to figure out how to write a letter that would get politicians to support me, and experimented for over a year, developing my pitch as I went along. Some letters were short and to the point; others were more detailed and long-winded. In some I took a humble tone; in others I championed my cause with the passion of a man fighting for his life. I enclosed newspaper articles that had been written about me, along with letters of support from teachers and members of the clergy.

I began keeping a log of every letter I sent. In addition to the contents of the letter, I even recorded the shape, size and color of the envelope I used to mail it in. Eventually, I developed what I considered the perfect clemency letter: a three-paragraph summary of my case and accomplishments, accompanied by three letters of support and four newspaper articles.

Despite my efforts, almost all of my requests were denied. Even Bob Gangi, the man who suggested I apply for clemency, would not write a letter of support. Most politicians never even responded. I was on the verge of giving up when Senator Joseph Galiber decided to stick his neck out. I'd written to him three times. It took almost a year to convince him, but finally his letter arrived. He stated:

> I am writing to support the Petition for Executive Clemency submitted by Anthony Papa. According to the information that is available in our files, Mr. Papa was incarcerated for sale and possession of four-and-one-half ounces of cocaine and had served 10 years of a 15-years-to-life sentence. During his period at Sing Sing Correctional Facility, Mr. Papa has only received one minor citation for disobeying a direct order. Since his incarceration, Mr. Papa has participated in numerous educational programs offered in the prison system and has recently earned a Master's Degree from the New York Theological Seminary.
>
> Mr. Papa has also been the focus of a number of newspaper articles. Mr. Papa continues to strive for self-development and improvement through his love for art. He also continues to work as a Teacher's Aide for Academic Studies at Sing Sing Correctional Facility. The Director of the New York Theological Seminary, George W. Webber, has also indicated by letter his strong support for Mr. Papa's Clemency Petition and will "guarantee that he finds employment...upon his release." I believe Mr. Papa is capable of transition back into his community and has the potential to make a significant contribution. I support Anthony Papa's Executive Clemency Petition and ask that you give due deliberation and consider his early release. If there are any questions or concerns, please call me.

Senator Galiber's letter compelled me to launch a final, massive mailing. In January of 1996, I mailed 240 letters to state and federal legislators. I highlighted Galiber's letter to show that my appeal merited consideration. Of the 240 letters, I received twenty-one responses and two letters of support: one from Senator Alton Waldon, Jr. of the 10th District and one from Assemblyman Willis H. Stephens, Jr. of the

91st District. The rejection letters were rich and full of novel reasons to withhold support.

For example, Congressman Dan Frisa of the 47th District sent a reply written by his Chief Counsel, Steven G. Leventhal. It stated:

> I am counsel to Congressman Dan Frisa. Congressman Frisa asked me to respond to your letter of January 30, 1996. Congressman Frisa admires the courage of people who overcome adversity to accomplish good work, as you clearly have done during your period of incarceration. The support of New York State Senator Joseph L. Galiber for your Executive Clemency Petition is a strong sign that your petition merits serious consideration. As you know, Congressman Frisa is a member of the United States Congress, and is not an official of the New York State government. Therefore, he is not a part of the normal process for evaluating or granting petitions such as yours. You have taken the appropriate step of enlisting the support of your State Senator. You may also wish to contact your representative in the New York State Assembly. Congressman Frisa wishes you good luck in your effort to receive Executive Clemency.

Most politicians dreaded taking on the drug issue. Given the nation's raging war on drugs and the billions of dollars the government spends on it, they didn't want to get involved. Why should they? There was nothing to gain. Doing so could only hurt their careers. Nevertheless, my energy for my clemency appeal was endless. I knew that I needed mountains of support and started reaching out to everyone I knew, and even people I didn't know. Getting support from behind bars wasn't easy as I was limited in my ability to meet people. My friend Andrea Miller became my greatest champion and link to the outside world. She launched a clemency campaign on my behalf and created a chain letter, a page in length, outlining my case and requesting support. The letter pointed out the excessive sentences meted out to nonviolent drug offenders and how they undermined the judicial process by forcing judges to adhere to strict mandatory sentences. Attached to the letter was a tear-off page that recipients could copy and mail to potential supporters.

Suddenly, it seemed, my twenty letters of support mushroomed to over two hundred. The most important letter to me was written by my daughter Stephanie.

Dear Governor Pataki,

I would like you to give a great deal of consideration to the clemency appeal of my father, Anthony Papa, who is a first-time offender. He was convicted of a drug charge and given fifteen years to life for having four ounces of cocaine. I feel that this is a ridiculous sentence. I feel this way because there are murderers, rapists and other brutal criminals who receive less time than my father has already served, and that's 10 years.

My father is not a violent man. He just made a terrible mistake that he would never make again. If anyone knows that, it would be his family and his close friends. I would know most of all. My father has been in prison most of my life, since I was six. I am now 18. He has missed out on everything I ever did in the last ten years. To him, I'm still a little girl. Don't you think that taught him a lesson? I'm his only child and he missed the opportunity to see me grow up. He has missed out on ten valuable years of his own life, which to me is punishment enough. He tries to be a good father and does what he can for me but he can't do much from where he is.

He is a model inmate, and anyone who knows him could tell you my father is a good man. He has accomplished a lot in his ten years at Sing Sing. He has finished school and received a Master's Degree. He teaches an art class and had his art displayed at the Whitney Museum, which doesn't let just anyone in. He has done as much as he could with what little freedom and life that he has. He knows he did wrong and would never do it again. He has learned his lesson the hard way. After reading this letter, I hope you will consider clemency for my father, Anthony Papa, an inmate at Sing Sing.

I began carrying around a leather briefcase that my friend Herman Rivera gave to me in exchange for a painting. Herman was serving twenty years under the Rockefeller drug laws. I packed the briefcase with letters of support and newspaper clippings, which I deposited into the hands of potential supporters in my travels throughout the prison. Whenever I ran

into a potential supporter—a teacher, an outside visitor, a sympathetic nurse—I launched into a well-rehearsed pitch for clemency. It became clear to me that the greatest asset an artist had was not his necessarily his work but his ability to sell it. The same held true in the art of clemency.

Christmas arrived and with it came the despondency that descends over prisons everywhere during the holidays. Loneliness sets in like a damp wind on a stormy day. Men known for bluster grow quiet. Behind the granite walls, the sadness is as palpable as it is inescapable.

The governor announced his choices for clemency. I was not one of them. The good news was that of the two individuals he chose, both were sentenced under the Rockefeller drug laws. The better news was that I didn't receive a letter of rejection; my appeal was still under review. If your appeal was rejected, you had to wait a full year to re-apply. I would have to wait until December of 1996 for another shot. I was disappointed, but not without hope. Every day, I told myself that I had a good chance and continued to work hard to gather support. The first year that I applied for clemency, over 300 other prisoners did as well. The next time around I would have to do something to distin-guish myself. Again, I decided that my best strategy would be to gain media exposure through my art, and I devised different ways to carry out my plan. In January, I submitted ten pieces of art to the 30th Cor-rections on Canvas exhibit in Albany. The show directors published a catalogue and distributed it to the thousands of people who attended the show. It listed sponsors of the show and statements of support by politicians, even one Governor Pataki, who five years later would close the show because of a minor protest.

More importantly, the catalogue listed the artists by name and the titles of their work. As I flipped through the previous year's catalogue, I came up with a brilliant idea. I would use the titles of my paintings as an appeal for clemency. After all, the show was held in the Legisla-tive Office Building, through which hundreds of activists and politically concerned citizens passed every week. I listed my paintings as follows:

SING SING

CODE NO. TITLE	PRICE	ARTIST
SS1 Support My Clemency	108.00	PAPA
SS2 Please Write The Governor	108.00	PAPA
SS3 I've Spent 11 Years	108.00	PAPA
SS4 In Prison For Passing an Envelope	162.00	PAPA
SS5 I've Learned My Lesson	108.00	PAPA
SS6 I'm Sorry And Rehabilitated	216.00	PAPA
SS7 It's Just A Waste	108.00	PAPA
SS8 Of Tax Dollars Keeping Me	81.00	PAPA
SS9 A Non-Violent 1st Time	54.00	PAPA
SS10 Rockefeller Offender in Prison	108.00	PAPA

I received over a hundred letters from people who visited the show. They all agreed to write letters to the governor on my behalf. The timing was perfect, because it coincided with an exhibit sponsored by the New York Theological Seminary that would open in Manhattan on July 1. Several times a year, the seminary sponsored shows featuring the work of different artists. The president, William Howard, had selected me as the artist whose work would be shown over the summer. The challenge was how to organize a show from prison.

My only way to communicate with the outside world was by mail or phone. The mail was too slow and we could only make collect calls. Moreover, the administration limited our phone list to a maximum of fifteen individuals, and each phone number had to be approved by the administration. If I wanted to add or drop a number, it took a good week. The prison did this for security reasons, basically to prevent inmates from running phone scams. Some prisoners got around it by using three-way phone lines. It was against the rules to engage in a three-way conversation, and staff would periodically monitor calls to check that it wasn't happening. The penalty was a Tier II misbehavior report, which would not look good to the clemency board.

I decided to take the risk and asked my mother to install a three-way line. Now, I could call people without losing valuable time. Andrea

offered to hang the show at the seminary, as did Hans Hallenbeck, a volunteer at Sing Sing. Hans taught in the Certificate of Ministry Program, which the students from my seminary class developed when the governor ended all the prison college programs. To fill the void, we designed a thirty-credit college course based on the seminary program, which eventually expanded to five different prisons in New York.

The show took a great deal of planning. The first thing I did was order a guide from De Haviland Fine Arts Company on how to plan your own show. Called "The Show Planner," it outlined the six simple steps of organizing your own art show. The first step was to find a location. Done. The second step was to design an invitation. I decided to use my self-portrait. My friend Michele Stoddard printed the invitations and even posters as well. Next, I needed to inform the press. This step was critical. I spent hours writing and rewriting a media alert to spark the interest of jaded New York City journalists. I decided to name the show *15 Years to Life: An Exhibit Depicting the Experience of Imprisonment*. I compiled a list of over fifty print and broadcast journalists and asked Andrea to send the press release. I then developed a mailing list of over 150 interested individuals and organizations, including criminal justice advocates, community organizations, art galleries and churches. I also placed an ad in *Art Times*, a widely distributed industry publication. Since I didn't have any money for the ad, I convinced the editor to accept a watercolor in lieu of payment.

Next was planning the hanging of my work. I asked for a map of the floor plan with wall measurements. Since all of my work was at Andrea's house, I had to consider each piece carefully and try to visualize how they would fit. From my calculations, I figured I could hang thirty-two paintings. Next came the framing. Only about half of my pieces were framed. I asked my Aunt Connie if she would pay for the frames with her credit card. I called my mother and used her three-way line to contact an outfit that sold picture frames. I placed my order and told them that my aunt would call and pay with her credit card. The company sent the frames to the Millers' house, and they framed the pieces themselves. They did a beautiful job.

On June 29, 1996, a day before the opening, my pieces were hung at the New York Theological Seminary. The show was to run through August 23. The artist's reception was planned for 5:30 on July 11. In over a decade of painting and participating in art shows, I'd never had the chance to actually attend a show and had to rely on second-hand accounts of what happened. I decided to be there in a different way. I asked my friend Hans to blow up the Associated Press photo of me standing in my cell. He generously agreed and enlarged the image to life-sized proportions and placed it on poster board. I wrote a statement for Andrea to read at the opening:

Good evening everyone. Thank you all for attending this exhibit. I'm sorry I could not be here physically, but I am here with you spiritually through my art. I want to thank President Howard and NYTS for allowing me to express myself here at the seminary. NYTS is a very progressive institution that remains on the cutting edge, implementing innovative approaches to theological education, reaching those in the most barren places. It is here in this desert, this wilderness, that I have discovered myself. God works in mysterious and wonderful ways. I have taken this affliction called imprisonment in perspective. I've examined it well, turning it inside out, eating and drinking it, sleeping with it, discovering how it lives and thrives on an unsuspecting society that is blinded by negative propaganda. Prison is a complex process that is, for the most part, misunderstood. A multi-level, gut-wrenching experience that lives in the heart and soul of not only the prisoner, but those outside of its physical reach.

The mothers, wives, children and families of the imprisoned also feel its all-consuming pain. When you view my art, open up and let these images that surround you enter your soul. Absorb the feelings and emotions that I have felt for over the last decade viewing the world through barbed wire, steel and concrete walls. This art speaks out for the disenfranchised, for those who are forgotten and oppressed, those whom society would like to forget. My message is clear. We are only human beings who have made mistakes, nothing more. When you walk away from this exhibit, I hope you bring with you a new understanding of the prison experience and one individual's plight in trying to transcend the stigmatizing label of being a convicted felon. Enjoy the show. I hope to see you at my next exhibit in person.

To gain clemency support from the people who attended, I put together a one-page flyer urging viewers to contact the governor on my behalf. The flyer contained commentary about my work from Les Rodgers, a gifted writer and fellow seminarian. I am eternally grateful to Les for what he wrote:

Anthony Papa's art has won broad acclaim. A *New York Times* reporter wrote, 'Mr. Papa has become an accomplished surrealist painter.' The Associated Press noted, 'His paintings have brought him distinction both inside and outside prison walls.' And the *Gannett Suburban Newspaper* stated that Papa's art 'creates caustic political statements in vivid colors.'

As Papa's friend, I know that all of this is true. But there is more to Papa's art, something that the uninitiated eye might miss. It captures the experience of time in prison, the moment-by-moment experience of the pains of imprisonment. In this sense, Papa's art is existential and intentionally exaggerated. Papa finds symbolic expression of imprisonment, for example, in the blades of the many yards of razor wire woven around the sides, tops and bottoms of the many yards of multiple fences, which stand as guards protecting the thirty-foot walls, electrified fences and the well-armed guard towers from the prisoner's touch—these blades loom large in Papa's art.

Papa often depicts these blades against the background of the Hudson River. In *Trinity*, for example, each blade represents a double-edged sword, cutting the fabric of life between beauty and ugliness, between the freedom of the Hudson and the pathos of imprisonment, an all-consuming reminder about on which side of life the prisoner lives. *15 Years to Life—Self-Portrait* captures the emotional experience of this discovery, when Papa realized that the best years of his life would be lost floundering in the belly of the beast.

But his deeply felt pain and sense of hopelessness matured into political consciousness. Papa expresses this consciousness in *Politics of Reality*, which depicts the politics of misery in its cultural manifestations—religious values and national pride— destroying the quality of human life. The destructive machinery of government finds its alter ego in *Corporate Asset*. Here, Papa paints an image of an industry of misery

—what has lately been dubbed the prison industrial complex—legislated by small-minded, mean-spirited, tough-on-crime politics. *Nightmare of Justice* portrays the effects of the politics and industry of crime. They affect Papa where they affect every prisoner in the body and soul of his life. *Fry Chicken, Not People* takes the corruption of the American criminal justice to its logical conclusion, the death penalty. In this painting, the death penalty is the consummate symbol of political power: George Bush taking to himself the omnipotence of God, Papa lying in a coffin, a tombstone echoing Thrasymachus' ancient quip: 'Justice is the advantage of the stronger.' It is true, but there is also strength in perseverance. In *Metamorphosis*, Papa offers testimony to his own tenacity of spirit and refusal to give up. The change came for Papa when he picked up a paintbrush, then the hand of freedom was his own, and he has been painting his way to freedom ever since, turning barbed wire into butterflies.

I had prepared for the show the best that I could, knowing that the response from the media would be critical in my attempt to paint my way out of prison. As the reception approached, I couldn't sleep. So many things could go wrong—only a handful of people might show. My story was important to me but would the world really care? I was one of thousands of drug offenders serving a long sentence for a nonviolent crime. And as the woman from the Students' Art League had said, my art carried the stain of incarceration.

On July 11, the reception was held and over one hundred people attended. The media coverage was beyond my wildest dreams. Donatella Lorch of *The New York Times* wrote a piece that appeared on the front page of the Metro section titled "Survival Found at the Tip of a Paintbrush." The article spanned the entire page and jumped to a double-page spread inside. There were photographs of six of my paintings, which the reporter described as "a psychological chronology of Papa's life in prison… His reality is a canvas of rage and sorrow, fear and hope. There is no subtlety, no ambiguity." And later: "In one caustic self-portrait, an intravenous bottle containing a wristwatch drips into a skeletal torso enclosing unbalanced scales of justice." In another painting, she

noted, "razor wire metamorphoses into butterflies on the delicate back-drop of the Hudson River."

The New York Law Journal published a glowing article under the headline, "Punitive Justice is Protested in Artwork by Sing Sing Inmate." Richard Stratton, editor of *Prison Life* magazine, arrived with a film crew to record the event for an upcoming documentary on art in prison. Global Vision came and filmed my artwork for use in its acclaimed show, *Rights & Wrongs*, covering international human rights abuses.

The exhibit came off perfectly and gave me the exposure I desper-ately needed to distinguish myself from the hundreds of other prisoners seeking clemency. In October, Parole Officer Joni Johnson contacted me and told me that I had made the cut for clemency. This was good news, but it only meant that my application would be considered along with many, many others. She informed me that I would be called to appear in front of a special panel of Parole Commissioners for an interview. If the commissioners approved me, I would then enter the final round. If they rejected me, I would be eliminated and have to wait another year. Johnson submitted a favorable report on my behalf. Everything was working in my favor.

On the morning of November 19, I received a notice that I was to see the parole board that evening. I stayed in my housing area the entire day, ironing my state-issued greens over and over, checking and double-checking for wrinkles. I even ironed my socks. I paced back and forth and rehearsed the points I would make. I had made a list of possible questions they could ask me and written out my responses. I worked on tone, facial expression and various words to emphasize when the time came. I didn't want to leave anything to chance.

When chow was announced at 5 p.m. and I still hadn't been called, I started to panic. What if they'd made a mistake? What if there had been some bureaucratic screw-up and I hadn't made the cut after all? Maybe the media coverage was actually working against me and made the governor's people skittish about releasing a potential political activist, someone who'd speak out against the drug laws? Maybe all of the articles about me would actually be my downfall, not my savior.

Suddenly, I felt like a fool, standing there and waiting in my over-ironed greens, with what little hair I had left neatly combed.

And then came the call. At 7 p.m., I was to appear before the clemency board. The well-rehearsed lines dissipated from my mind as I walked through the prison corridors with the other three men who had also made the cut and would see the board the same night. One of them was my friend, Sal. I had actually helped him write his clemency application. Like me, Sal was sentenced under the Rockefeller drug laws. We'd become distant once we learned that we'd both been approved. We were fighting for the same thing, and now we were competitors.

The hearings were held in a trailer that was formerly part of the old visiting room. The escort officer placed me in a separate area and told me to wait until I was called. My adrenalin pumped wildly. I tried breathing exercises to relax. Finally, the officer appeared. "You're up," he said, and escorted me to the trailer.

Before entering, I was told to assume the position for a weapons search. Thankfully, he only conducted a pat frisk, not a body cavity search. I entered the room and quickly scanned my surroundings. To my left, a man in a dark suit sat at a small table. A woman and two men, one white and one black, sat directly in front of me behind a long table covered with stacks of files. They were the parole commissioners assigned to review clemency appeals. A single chair was placed before the center of the table for me.

"Please sit," the black commissioner said. He opened up the discussion by explaining that they had read my file and were "quite impressed" with my accomplishments. "We really don't have a lot of questions for you, Mr. Papa," he said, "although there are a few points we would like clarified."

"Yes, sir," I said. My voice sounded too loud in the small room.

"Mr. Papa," he started, "could you tell us how you feel about the crime you committed?"

I was fully prepared for this question. "Yes, sir. I take full responsibility for my crime and feel great remorse for what I did. I was young and stupid and learned my lesson. I lost my wife and daughter, my family.

I have learned about the dangers of drugs and the gravity of the crime I committed," I replied.

The commissioners nodded their heads in unison. I recalled the advice from my parole officer. Be remorseful and humble. Don't go into rambling rhetoric that might give them information they don't need to know. I kept my answers short and sweet, but I knew that the other men would do the same. I decided to go out on a limb. "Commissioners," I said, clearing my throat. "I think that you have asked me some good questions, but I also feel that you forgot to ask me a very important question that I would like to have the opportunity to answer."

The female commissioner moved her chair back, audibly scraping the floor in the process. "And what question is that, Mr. Papa?" she asked.

I leaned forward and put my hands together, palms facing upwards in a gesture of supplication. "I believe that the main reason for this hearing is to determine whether or not I am a safe risk for release. In other words, what are the chances that I'll return to a life of crime and embarrass the governor?" I said.

Once again, the commissioners nodded in unison. "That, Mr. Papa, is indeed the crux of this inquiry," one of them said. "Could you answer that for us?"

I immediately launched into a speed-dial quick speech outlining why I was a good candidate for clemency. I felt as if I were performing an oral argument in front of the Supreme Court. My words would determine my fate. One of the key points I made was that I was a team player and if given the opportunity to regain my freedom I could assure them I would be an upstanding citizen and uphold the law to the fullest extent. I supported this point with the fact that I was a first-time non-violent offender who had taken advantage of every rehabilitative program the prison offered. I had an excellent institutional record and because of my education I would be a safe bet. I cited the results of an exploratory study that was recently prepared for the Division of Ministerial Studies for the Department of Correctional Services. Conducted by the Center for Social Research, early results showed that the rate of

recidivism for inmates who possessed a graduate degree in religious studies was significantly lower than that of a control group.

I ended it there. I thought that was it, when the female commissioner spoke up. Maybe she saw the glimmer in my eye reflecting a future activist who would turn against Governor Pataki. Maybe it was female intuition. "Mr. Papa, you come here today asking us to endorse your bid for clemency," she said. "But drugs are a dangerous scourge in society. They have ruined tens of thousands of lives and destroyed communities beyond repair. And yet, you ask us to support you for clemency. Let me make one thing clear: the decision rests with us. We do not have to let you go even if the governor grants you clemency. Do you understand that, Mr. Papa?"

"Yes Ma'am," I replied. "I do."

The hearing was over. The black commissioner thanked me for coming. I approached the board, shook their hands and thanked them for their time and consideration of my appeal. As I walked to the door, the man who'd been sitting to my left approached me. "Mr. Papa, could you tell me more about that study you mentioned?" he asked. I told him I'd be glad to send him a copy of the report. It turned out he was James Murray, director of the Clemency Board. I had been sending him information during the entire clemency process.

It was over. I'd done the best that I could and felt it went well. Three days later, my parole officer confirmed my feelings. I had won the board's approval and was now in the final stage.

Meanwhile, the prison was being deluged with media requests for interviews, so many in fact that the administration tried its best to stem the tide. As always, they cited "security reasons." An Assistant Deputy Superintendent named Eli Rillo was assigned this duty, which was perfect given his obvious dislike for prisoners. Rillo was the administration's "go-to" guy, the man they'd "go to" to do their dirty work. He was also in charge of handling tours of the prison and media interviews. Rillo didn't appreciate the extra work from me and began a campaign to stop the interview requests.

The day that the *New York Times* reporter was scheduled to interview me, Rillo summoned me to his office. He told me that he didn't have time to handle the extra work and added that he didn't understand why there was so much interest in a prisoner like me anyway. He went on to say that he didn't have to grant these interviews, and that he'd decided that the only condition under which he'd allow them was if no photographs would be taken. I stood there and listened, knowing it was a no-win situation. I could have argued that DOCS policy does not permit assistant deputy superintendents to deny media interviews based on their workload, but I knew that challenging Rillo directly was not a good idea.

Instead, I returned to the block and called *The New York Times*. I asked them to call James Flateau, director of the Public Information office in Albany and lodge a complaint. If they didn't intervene, I said, the photographer who had already been approved and was probably en route to the prison would likely be turned away at the gate.

The interview was to be held in the visiting room of the prison. I arrived early and waited. A half-hour later, a sergeant escorted the *Times* reporter through the door, along with the photographer and her equipment. Albany had overturned Sing Sing's decision! I was amazed. During the interview, Rillo made an appearance in the visiting room. The minute I saw him, I asked the photographer to take some photos of me in true paparazzi form making sure that Rillo could see. He was steaming mad, but this time he couldn't do anything about it.

Every contact I had with the media became increasingly important because my freedom depended not only on the exposure but the letters of support it generated. Every opportunity I had to get my story out was a step closer to gaining my freedom. However, Rillo kept trying to stop me. I found out that *Gulliver Magazine* had contacted the prison requesting permission to interview me, but Rillo purposely held up the paperwork. Baldy, Dennis' clerk, told me about it. I went to see Dennis and convinced him to let me see the request from the magazine. I took down the information and immediately called the magazine. Through a three-way line I spoke to an editor who gave me the California phone

number of the writer assigned to the piece. He conducted the interview by phone, and the piece was published despite Rillo.

This infuriated him. He went to the extent of calling the New York Theological Seminary in New York City and saying that the prison was being overwhelmed with interview requests based on the show they'd sponsored of my work. Because of his workload, he said, he could not and would not accommodate these requests and asked that the seminary stop channeling them to the prison. The same day, I found out that a writer for *Hope* magazine had contacted Rillo, who denied his request for an interview. I wrote to Sing Sing's Superintendent, telling him that Rillo was violating Departmental policy by denying these media requests.

My actions did not go unnoticed. My counselor, Mr. Brown, told me to slow down. He said that my behavior was aggravating the administration. Apparently, Superintendent Keane had even inquired whether Brown had sent the clemency letter he'd written on my behalf to Albany. His intention was to withdraw his support.

I could have slowed down; after all, my freedom was at stake. But now I had a forum in which I could advocate against the atrocities of imprisonment and the war on drugs, and the world was listening to what I had to say. I had become a voice for the voiceless, representing the marginalized and disenfranchised. Eleven years of my life had been spent in prison for a first-time, nonviolent crime and there were thousands more like me in prisons throughout the state. Should I speak out against these unfair laws and risk clemency, or stay quiet and become part of the system that oppressed me and so many men and women like me? I struggled with this greatly.

On December 23, 1996, I was working out in the yard with my friend Carlos. "Hey Papa," a prisoner called out. "The officer in charge wants to speak with you." I put down the barbell and walked to the guard's desk.

"Papa, the First Deputy Superintendent wants to see you," he said. My heart sank. I knew I was in trouble. The week before I'd had another run-in with the administration. My heart pounded as the officer handed



me a pass to go to the administrative building. "Sit down and have a seat," the cop in the waiting area said. I sat on the same wooden bench that I'd sat on several weeks before when I was ordered to strip down six paintings.

I had been charged with attempting to smuggle Departmental policy directives out of the prison. In fact, I'd used the directives in a series of paintings. The paintings were my response to being subjected to three body cavity searches by a new jack guard who was trying to harass me. Three times, he had me bend over and spread my buttocks to see that I wasn't carrying contraband. Afterward, I was so enraged that I wanted to file a grievance against him for dehumanizing me. I went to the law library and found twenty-three pages of directives outlining policy and procedure for the search and control of contraband. I was amazed at the different kinds of searches described, from mouth and anal cavity searches to "radiological detection" searches. Instead of filing an official grievance, which I feared could hurt my chances for clemency, I removed the directives, cut them into various shapes and sizes, and glued them onto my paintings. When I tried to mail the paintings to Garret Brown, an art dealer from New York City who'd expressed interest in my work, the package room officer called the sergeant. After inspecting the art, he said that he had to send the pieces to the front office for review. I asked him why.

"Papa," he said. "Have you lost your mind? Look at this." He pointed to a drawing, in the middle of which I'd glued a memo from the Superintendent to the inmates. It discussed the rising number of incidents known as "throwings," where prisoners threw urine and feces at guards. The memo warned that inmates who committed such offenses would now be charged with felonies. It then asked us to turn in any inmates we knew who engaged in such conduct. Basically, it was a snitch request, and snitching violated the convict code. I enlarged the Superintendent's name and titled the painting, *Shit Attack*.

The administration gave me an ultimatum: either remove all traces of the directives or the pieces would be destroyed. Before I did anything, I called my lawyer and told him I wanted to sue the prison for violating my First Amendment rights. I had a constitutional right to

create, didn't I? Danny told me to clam down and think about the consequences. My clemency application was pending. Why jeopardize my freedom now? After I calmed down, I realized that he was right. The stress of everything was getting to me.

I stripped down the work but decided not to cave into the administration completely. The next day I got more copies of the documents and made diagrams of my paintings with outlines depicting where the pieces belonged. I then mailed the paintings and the policy directives separately to Andrea. One day, I would be able to glue them on myself. But as I waited for the First Deputy Superintendent, I doubted that day would be coming anytime soon. In all likelihood, they'd inspected my outgoing mail and discovered my covert strategy. In all likelihood, the move would cost me my clemency. The thought of another three years in prison sent chills down my spine.

How could I have been so stupid? I asked myself over and over. I sat hunched over on the bench, holding my head in my hands, when Deputy Superintendent Greiner appeared at the gate, about four feet away from me. The rear-door officer opened the gate and I stood up to greet him. "Let's go," he said.

Greiner was a law-and-order type who'd worked his way up through the ranks from CO to First Dep. I followed him to a small room, and he told me to take a seat. I said I preferred to stand; I wanted it to be over as quickly as possible. I looked him in the eye before he spoke, trying to gauge the severity of the situation, but I couldn't read anything from his expression—no frown, no grimace signaling that I'd violated "security," nothing but a blank, open expression. Now I was truly scared.

"Anthony Papa," he started, and then exhaled and looked at the floor. He lifted his head and looked me in the eye. "I just got off with the governor. He has granted you clemency. Congratulations."

I fell against the wall and cried. Great, gut-wrenching sobs sprang uncontrollably from my throat. I hadn't cried like that in years; the feeling was indescribably good. His words echoed in my eyes in strange, muffled tones, like sounds in a dream. "… granted you clemency." After twelve long years, I was going home.

I was so elated I could barely contain myself. The urge to leap, jump, and kick my heels in the air was irresistible. On my way out of the building, I stopped at the guard's desk near the visiting room. "I'm free!" I shouted at the top of my lungs. "The governor granted me clemency!" The officer beamed and extended his hand from behind a barred window to congratulate me. "Way to go, man, way to go." Good news in prison was like a precious gemstone; everyone wanted a piece of it. I walked to my parole officer's building to tell her the good news. Next, I found Dennis Manwaring. "Dennis! I did it! I'm going home!" Again, the tears came and the most awesome feeling of relief rushed through me. We embraced and I thanked him for everything he'd done for me over the years.

On my way back to the dorm, I stopped along the road that circled the yard near Honor Block. Fist in the air, I yelled out my good fortune to the prisoners. Shouts and whistles erupted from the yard. Feeling as if I were flying, I made my way to the school building to tell the guys in the law library.

As I walked past the officer at the desk, my mind was so electrified that I forgot to show him my ID card. "ID, Papa!" he barked, adding that anyone else would have given me a misbehavior report. I stifled the urge to laugh. All I could think of was how I wouldn't have to put up with this crap anymore. "Officer, I'm sorry, I just found out that I was granted clemency from the governor. I'm not thinking straight."

"You'd better start thinking straight," he said. "Don't forget you're still a prisoner." He was in his glory in charge of school. Nothing was more important to him than being able to make grown men feel like shit.

I returned to the dorm. As I walked through the checkpoint, I raised my arms in victory. "I'm free!" I yelled. My friend Carlos rushed over and lifted me off my feet with his hug. The first call I made was to my mother. She wasn't home, so I called my Aunt Connie and then my daughter. When I told her the news, we both broke down in tears. It was the first time I'd cried openly in front of other prisoners, and I didn't care. My only thought was that I was going to be a father again. "We can start over, Stephanie," I said. "I can be a real father to you."

That night, I turned on the radio to see if the governor's clemency choices had made the evening news. To my surprise, several radio stations repeatedly announced my clemency. "Award-winning artist Anthony Papa was granted clemency today by Governor Pataki." The next day I called Andrea Miller. She said that the *Daily News* had already contacted her for a brief telephone interview. The next morning, a guard handed me the article. In classic *Daily News* style, the headline shouted: "Pardoner in Crimes—Gov. Grants Clemency to Artist & Six Others." Sergeant Mack, a collector of my work, stopped by my housing area and gave me two additional articles. "Pataki Grants Clemency to Sing Sing Artist," said the headline in the *Gannett Suburban Newspaper.* My plan had worked. I had painted my way out of prison.

1. Paul F. Knitter, *No Other Name: A Critical Survey of Christian Attitudes Toward the World Religions,* Orbis Books, 1985

My Walk in the Sun

I STARTED TO TELL EVERYONE I knew about my good news, but within a few days, I realized that it was better to remain quiet. Some prisoners were envious, especially men who were in for violent crimes and had little chance for parole. One of the governor's recent bills had ended parole for violent offenders. They had to serve 85% of their sentences before being released.

I had to be careful during those final few days in the prison. Everyone knew about men who were set up by ruthless cons or sadistic guards in the days or hours before their release. I'd heard jailhouse stories of men who had one foot out the door when they were viciously assaulted, had boiling oil thrown in their face, were pushed down stairs or suddenly found with a bag of dope in their possession. I decided to lay low and stay focused on getting out in one piece and on time. My parole officer said she'd do her best to speed up the process, but in all likelihood, it would take a few weeks.

On Christmas Eve, 1996, I went to church in the small chapel where I'd spent hundreds of hours praying for freedom and begging God for strength. Father Ron asked me if I wanted to announce my good fortune, but I told him I didn't think it would be a good idea. He understood. "It's been a tough year," he said. He was referring to the unprecedented number of suicides that had occurred over the past year. News of a hanging never surprised me. In fact, I'd often wondered why

there weren't more. So many men at Sing Sing knew they would grow old and die behind bars. I thought of George and Max, my first "prison neighbors," both serving life sentences, now well into their sixties.

Like escapes, suicides make a prison look bad. The job of the Correction Department was the care, custody and control of inmates. Bodies hanging from sheets in desolate cells were bad for morale. That December, the Superintendent issued a memo, which read as follows:

SUBJECT: HOLIDAY BLUES

During the holiday season, stay focused on hope and don't allow yourself to become so depressed that you might want to give up. If you find yourself feeling down, here are some suggestions:

- Reach out to other men
- Become involved in facility programs
- Turn to one of our many faith communities for support
- Request to be seen by the Facility Mental Health staff

Please remember that there is always help through staff and the Chaplains. Care enough to want to help yourself through someone else. May joy and peace be yours during the holiday season.

The time came to sort through my belongings and figure out what I wanted to keep and what I wanted to give away. I started by throwing things out. For years, I'd kept my important papers and documents in several cardboard boxes under my bed. Inside were things like receipts for art supplies and permits used to prove ownership of the items I owned. For example, my typewriter and the watch I wore. Without the permits the guards would confiscate the items during routine searches. The hardest thing to discard was my legal work. It filled three banker's boxes and represented thousands of hours of legal research and writing, hundreds of letters to and from the courts and my lawyers. Like most prisoners, I had always considered my legal materials my most valuable possession, as they were my one link to freedom. Now they

were worthless. When I dumped the box into the garbage bin, I felt as though a great weight had been lifted from my shoulders.

In the days that preceded my release, I felt the part of my brain that had been shut down for so many years suddenly open. I was filled with ideas; images and possibilities that made me want to live again. Freedom was so near. All those years of pure hell would soon be behind me, or would they? As I sorted through my belongings, all of the things I'd accumulated as a prisoner that came to define my life, I began to wonder if I could ever really purge the prison experience from my being. I wondered whether and how I could overcome the stigma of being an ex-con. There, too, I'd known men who after so many years on the inside couldn't make it on the outside. I'd seen some men leave Sing Sing and return within a year. Nearly 30,000 prisoners were released from New York State correctional facilities every year. Many disappeared into the growing mass of faceless and hopeless ex-offenders who walked through the prison gates only to see that the society they once knew as their own had left them permanently behind. Some men could never catch up. Would I be one of them?

At the time, I was living with seventy-three other men packed two to a cubicle. A guard stationed on a platform in the middle of the housing unit watched our every move. What would it feel like to sleep in my own room with a door that closed behind me? What would it feel like to come and go as I pleased, to sleep late if I wanted, to play music, drive a car, to make love? The more I thought about it, the more nervous I became. Would I be able to adapt to life as a free person or would I fall flat on my face?

I snapped out of it and picked up a pad of paper. I decided to capture the moment of transition by writing a letter to myself. I wrote my name and mother's address on the envelope and mailed it the day before I left. I wrote:

Hi Tony,
This is you speaking to you on the day that you will become a free man. It is 6:58 am. After waking up at 2:30 in the morning, you have not been back to sleep. Remember where you were. Never forget it.

Part of you will die here forever. No longer will you be a slave to oppression. You will be a free man and you will go forward. Don't look back. Good luck, Tony. Be Strong.

As soon as word got out that my departure was imminent, I was swamped with requests for everything that was in my cubicle, even from cons I didn't know. That's the way prison was—too many men with too many needs. Plus, it was a tradition for departing inmates to give away their property to those who'd stay behind. My neighbor Hugo, who was serving a twenty-to-life sentence for murder, asked me to contact his daughter once I got home. She hadn't spoken to him for over ten years. I gave my typewriter to a guy who was doing time for drugs. He had borrowed it everyday for several months to write appeals for his release. I knew he could use it. I gave most of my belongings, including cassette tapes and clothing, to my buddy Carlos. He was a good guy doing fifteen-to-life for murdering someone when he was drunk. He'd done a lot of favors for me over the years. He worked in the woodwork shop and made frames for my paintings, which he'd smuggle out in a wheelbarrow under the guise of discarding garbage.

When the time came to leave, I left quietly, saying my goodbyes to a few close friends to avoid attracting attention. Anything could go wrong in those few final hours. I gathered up my mattress and state-issued clothing to return to the state shop. If you didn't return them, the prison deducted their costs from your commissary account.

Slowly and methodically, I walked to the command office of Tappan. I wanted to savor the moment. The officer told me to wait outside for a van that would bring me "up the hill" to the maximum-security part of the prison to be processed. A few prisoners walked by and nodded. I didn't know if they knew I was going home, and I didn't want to tell them. I just wanted to leave. After nearly thirty minutes, I started getting nervous. By 8 a.m., the doors of the housing units would open and everyone would be let out to report to their program assignments. Just then, as I was taking in the view of the Hudson for a final time, someone tapped me on the shoulder. I jumped and quickly turned around. It was Big Don from the law library, the ultimate black gangster. Don was

into everything, from drug dealing to greeting cards to extortion. He ran with an Asian gang and was bad news. Big Don was the one guy I didn't want to see before I left, and there he stood before me like the grim reaper.

"Hey, man, I heard you're leaving us," he said, not sounding particularly happy for me. It came out more like a threat.

"Yeah," I mumbled. "I'm outta here." We looked each other in the eye. I knew he wanted to ask me to do him a favor.

"Listen," he said, "I want you to take care of something for me."

I kept my eyes on him. "What's that?" I asked.

"There's a guy I want you to talk to when you get back to the city," he said. He thrust out his chest and stood at full height. Muscle-bound and wide, he had the presence of an icebox. Big Don was what we called "an enforcer." He was a vicious dude who I'd seen beat other men senseless, usually over a bad bag of dope, but sometimes just for the hell of it. While most guys tried to avoid trouble in the joint, Big Don looked for it. That's how he did his time. Stabbing someone was recreation for him, like lifting weights to the average con. When he joined my art class and brought in his Asian crew, he almost had the class shut down because of his big mouth and vicious ways. He was an operator and I didn't want to have any part of his bullshit.

"So, look, you go see this guy and bring the stuff in on a visit ..." he was saying. When he finished telling me how we could "make a lot of money," I didn't answer. The irony struck me—the past twelve years of my life had started and ended with the same proposition.

"So motherfucker, you gonna answer me or what?" he said.

My heart beat rapidly. This was just what I didn't want to get into. I had to think fast. "Yeah, sure, Don, no problem. Sorry, man, my mind's on New York. I'm kind of nervous, you know, about getting out and all."

"Just chill, man," he said. "We can make some money, some big money. Just bring me in a few packages." Just then, the van arrived.

"I gotta go, Don," I said. I put my hand out, but he didn't go for it. "Let me get your phone number," he said. He opened his army jacket and pulled a small pad and pen from the inside pocket. His coat was

thick enough to stop a blade. He wore it that way on purpose. I scribbled down a number and handed it to him.

"You sure it's good?" he asked.

"Don, would I kid you about that?" We shook hands and I hurled my mattress into the back of the van. As we drove up the hill, I turned and waved goodbye, thinking about the look on his face when he dialed the bullshit number I'd made up. That's what you learn in prison, how to con a con.

The CO who was assigned to process me used to work the night shift in A Block. I glanced at him in the rearview mirror and remembered how we called him "Peeping Tom." I'd be sitting on the toilet in my cell with a sheet drawn across the bars when he'd quietly peel back the sheet to see what I was doing. Most guards would just rip it down—hanging sheets was a violation—but Tom would just stand there and stare.

The bus pulled up to the front of the hospital, which was connected by tunnel to the back of A Block and 7 Building. Another tunnel branched off to the left, which led to solitary confinement and the state shop. The prison was full of tunnels, long, dark, dangerous corridors that had seen countless assaults. We passed the commissary, the barbershop and finally reached the state shop. The guard told me to put my property on a table and follow him to a room in the back. The room was full clothing for prisoners who were going home or to funerals. I'd been there once before when my Uncle Frank died. The prison gave me a cheap brown suit to wear. I'll never forget the look on my relatives' faces when I entered the funeral parlor. I felt ashamed—utterly contemptible is more like it—as I stood over his coffin trying to pray in handcuffs.

This time, I planned things differently. When I left, I wanted to walk out feeling good about myself. I'd ordered clothing from a catalogue; my mother footed the four-hundred-dollar bill as a welcome-home gift.

"Where are my clothes?" I asked the CO. He pointed toward the racks of donated and bargain store clothing—raincoats, suits, jackets, shirts and ties. There were even sneakers, boots and dress shoes. Several

large boxes with my name on them were piled along the wall. I ripped open the cardboard and prayed that everything I'd ordered arrived. "Yes!" I shouted. Everything was there: black leather jacket, jeans, shirt, sweater and a pair of black leather cowboy boots. I put on the clothing and walked to the mirror. I stood there in awe. For the first time in twelve years, I was wearing civilian clothing. The pants felt too big; the jacket felt too small. I stumbled when I walked in my boots. Even the black silk boxer shorts I'd ordered didn't feel right. My body was conditioned for prison greens, not street clothes.

"You look like a rebel," said the guard.

"That's the point," I answered. He laughed.

I couldn't believe how different I felt. In the mirror before me stood a person, not one of the masses in a prison uniform. I had my identity back, and yes, the guard was right. "Rebel" was exactly the image I wanted to project when I walked through the gate, a man who hadn't been broken by the system. I'd seen too many prisoners leave that way, cowering men dressed in cheap state suits carrying the identity of the prison right out into the free world with them. I was lucky. That wasn't going to happen to me. I'd made sure of it.

From a banker's box, I removed an Eddie Bauer watch that my friend Ben had sent me to wear home. Also in the box was my graduation ring from the New York Theological Seminary, which I'd hid in my typewriter for two years because it was considered contraband. The only jewelry prisoners could wear was wedding rings. On the face was the Biblical image of the sower. I was very proud of that ring. When I wanted to wear it, I would, in fear it would be confiscated. But what really blew my mind was a small envelope tucked away at the bottom of the box. It was marked "Personal Property." I opened it and found about a dozen religious medals that had been sent through the mail by my mother Lucy. The prison had confiscated the medals during the years I had spent there. "Bastards," I said to myself as I tightly clutched the medals in the palm of my left hand.

"You ready to go?" the guard asked. I glanced down at my watch. "It's time," I said. "Twelve years is long enough."

He got on the phone and called the transportation sergeant to get a van to take me to the gate. "Yeah, yeah," he said wearily into the receiver. "Asshole," he mouthed to me. It was amazing how differently he treated me now that I looked like a civilian. I actually felt camaraderie between us. "How the hell am I going to process him without a van?" he yelled. A few seconds later he slammed down the receiver and looked at me apologetically. "Sorry, Papa, but he's not releasing a van until the count clears," he said. "It's gonna take at least about another hour." I knew about the count. They had counted me five times a day for the last twelve years. Another hour was nothing.

He asked me if I wanted to wait outside. "Sure," I said. "Okay, but under one condition," he said. "No contact with any prisoners. You're a civilian now, you understand?"

"Yeah, sure," I said, not fully comprehending what he meant. He escorted me by a bullpen used for holding prisoners. I stopped, thinking that he would place me in it until the count cleared. I waited for him to unlock the door.

"No, not you, that's for prisoners," he said. It finally struck me. In the eyes of the administration, I was no longer "a prisoner." The feeling was so overwhelming that I almost broke down and cried. He tugged my sleeve and led me to a small area across from the bullpen. A big sign hung overhead stated: "No inmates allowed beyond this point." I slowly stepped over the line and leaned against a metal fence. A few feet away, a group of guards were smoking cigarettes. I waited for one of them to say something to me, to give me an order or tell me I didn't belong there, but nothing happened. They flicked their butts and walked past me without a word. Amazing.

About ten minutes later, a crew of prisoners en route to the state shop was herded into the bullpen. "Oh shit! Look, man, it's Papa," one of the cons yelled out. "Yo, bro, what's happening?" said another. From my vantage point outside the cage, they looked like animals. I thought about how the guards saw us like that every day. Everything about the prison environment reinforced their perception of us as violent predators, as animals to be caged, cuffed, and shackled. At what point did we begin to identify with that image ourselves?

One of the guys was a young Italian kid from Brooklyn. We'd taken a parenting class together. He was nineteen years old when he was sentenced to twenty years for murder. Shortly after he came to prison, his girlfriend gave birth to their baby and decided to end the relationship. There was nothing he could do about it. I remember the day he broke down in class because he'd never get to see his daughter.

He looked over at me and smiled. "You look sharp," he said. "I like your boots."

"Thanks, man." I didn't know what else to say. It felt different talking to him now. He pressed his face against the fence and wished me luck. "Don't fuck up," he said. "You got the world by the balls now. Go out there and be strong." I nodded and looked at the ground. The feeling that came over me was a mixture of sadness and guilt. Just then, a black Muslim from my religion class called out to me. "Hey Papa! Don't forget a brother. Take down my ID number. Write me and send me a food package. I'm doing bad!" he said. I returned to the guard's office. It was too much.

"Hey guard, how much longer?"

"The count should clear soon. I'm calling the watch commander's office now," he said. He picked up the phone and dialed.

"Okay, let's go. They're ready for us. Now remember—no contact with prisoners."

"Right," I said, picking up my bag, a green canvas Land's End tote bag that Ben had sent me in addition to the watch. I remembered him telling me that everyone carried one these days. I had a lot to catch up on.

We walked through more tunnels and down a flight of stairs. Just then, I saw Dragon, one of Big Don's boys. I froze.

Dragon was a young Asian guy who was doing life for murder. Once he stabbed a clerk in the law library when the guy made a play for him. Dragon had a slim physique and long, flowing black hair. The clerk had written him a love letter, a big mistake. Dragon looked soft but he wasn't. He was a violent individual. And now there we were, only a few feet between us, my freedom just minutes away. Could Don have dialed the

number and found out I'd bullshitted him? Did he send Dragon to deliver me a beat down, or worse? He passed without a word.

We walked through the long corridor past the Special Housing Unit where prisoners were held in solitary confinement. My mind kept focused. I was taking my last steps as a prisoner. The guards at the gate saw me and automatically opened the gate—like magic. I looked like a civilian to them, but I still felt like a prisoner. We made it to the first floor of the hospital building where the watch commander's office was located. This was where the administration ran the prison. My escort officer told me to wait outside while he got the necessary clearance for my release. While I waited, my friend Chiodi, a fellow seminarian, walked toward me and extended his hand. As I took a step toward him, the guard ran out of the office and put his body between us. "Step back!" he said to Chiodi, placing a hand on his chest to make a point. He looked at me. "I told you, no contact with prisoners." Chiodi backed up without a word. We looked at each other and knew that our relationship had changed, at least in the eyes of the prison. I was slowing beginning to feel my new identity, as if twelve years had suddenly been exorcised from my being.

The last person I would see was Dennis Manwaring, the man who had paved my way to freedom by introducing me to the Whitney. He almost walked right by me. "Dennis," I said, "It's me, Tony!" He turned and squinted, still not recognizing me. I took off my hat and shades; he jerked his head back in surprise. "Well, look at you," he said. "Best of luck to you, Tony." A tear rolled down his cheek.

CHAPTER 13

The Reality of Freedom

ON JANUARY 23, 1997, at 1:15 p.m. on a cold, blustery afternoon, the steel fortress door of Sing Sing prison slid open and I walked out a free man. My heart beat wildly as I waited for the door to close behind me. I had to hear that noise. It would tell me they hadn't made a mistake.

Beside me stood Sister Marian Bohen, an instructor from seminary. She'd offered to wait with me until the count finally cleared and they let me go. She held my hand tightly, waiting patiently for the moment. "Five more minutes," said the guard at the gate. I was nervous. I kept thinking that somehow they would try to pull me back into the nightmare. My mind was racing, not forward to the future but back to the times when I'd almost broken down. I thought of the day that I received the letter from the judge denying my final appeal and realizing that I'd exhausted all of my legal remedies. I remembered the time that my dream of exhibiting at the Whitney almost disintegrated before my eyes when the curator said only murderers could apply. I thought about being called to the First Deputy Superintendent's office just weeks before and thinking I'd blown my bid for clemency because of my art.

And now, here I was, standing outside of the prison. Finally, with a loud, grinding clang, the massive door closed shut behind me. A cold gust of wind shot up from the river and pitched me forward as I took my first steps as a free man. I turned and looked up at the guard towers,

stifling the urge to shout. As I walked up the sloped paved road leading to the parking lot, I glanced down at my feet. The silver tips of my cowboy boots seemed to glow. I felt like I was floating.

My friend Linda Magano waited for me in her pickup truck at the gate. She offered to take me to lunch and then drive me home to the Bronx. I had met her when she wrote an article for a local paper about me. She was there with a reporter from the *Suburban Gazette*.

What followed next was culture shock; there was no period of gradual adjustment. The transition from prisoner to civilian was swift and dizzying. We went to eat at a local restaurant. As I sat at the table, everything around me seemed like foreign objects. I held in my hands things that I hadn't touched for years—silverware, a bottle of ketchup, a cup that was glass instead of plastic. The steak I ordered tasted too good to believe. I was enjoying it so much I didn't want to stop eating to answer the reporter's questions. I wanted to savor the taste forever. An embarrassing thing happened just before we left, which made me realize that the prison was still with me. When I stood up from the table, I grabbed my knife and fork and walked with them toward the door. In the mess hall, you had to leave with your utensils in your hands and drop them in a bin near the exit.

After lunch, Linda drove me home. Her pickup truck was filled with my paintings and other property from prison. When I entered my mother's apartment house in the South Bronx, welcome home signs and balloons filled the halls. I felt like I was stepping back in time, or out of a dream. Seconds later, my mother burst from her door and ran toward me, arms outstretched, tears streaming down her face. We hugged and cried. I felt my knees grow weak. After so much practice at hiding my feelings, the emotional onslaught overpowered me.

An hour later, the phone started ringing off the hook. I did interviews with *The Daily News* and a few other papers, but for once, I had only a half-hearted desire to speak with the press. I just wanted to relax with my family and friends.

Two days later, I attended a show of my work for the first time. The exhibit had been planned six months before, and I was grateful that my

parole officer had expedited my release so that I could attend. Nearly a hundred people showed up. It was held in a downtown performance space called Solo Arts, and it was there that I had my first taste of the New York City nightlife. I met a beautiful woman named Luciana Leuzzi, who five years later would become my wife and mother to our son Anthony, Jr. She was a Brazilian beauty and a talented dancer who stole my heart and gave me the love and care I had been deprived of for twelve years. It was love at first sight.

Soon after, Luciana invited me to sublet an apartment with her on the Lower East Side. I hadn't painted since I'd left prison and was just commissioned to reproduce my painting *15 to Life* for a forthcoming TV show called *Oswald Penitentiary* (OZ). I bought some art supplies and set up my easel in the living room. The blank canvas stared back at me. I had trouble getting in the mood. The more I tried, the more stuck I became. It was strange. I paced for a good thirty minutes, trying in vain to find some source of inspiration. Without the pathos of the prison guiding me, I lost my motivation.

I went to the bathroom, turned on the faucet and splashed cold water on my face. As I stood and dried my hands on a towel, I immediately felt as if I'd been transported back to my 6' x 9' cell. A feeling of comfort came over me, and I got an idea. I moved my easel into the bathroom and started painting. The ideas came, my hands moved. I painted in there for hours. Several weeks later, for better or worse, I told the story to a reporter at *The New York Times*, who then published an article titled, "Tony Papa's Creative Block: In Prison he was Picasso; Outside It's Another Matter." When the piece came out, I was taken aback, but I knew that the reporter was right. Life on the outside wasn't as easy as I'd thought, at least when it came to art.

For several months, I struggled to pursue my dream of supporting myself as an artist. I shopped my work around to numerous galleries, only to be met with rejection. Most galleries said that my work was too scattered or it didn't match with the style of the other artists they represented. I was running out of money and needed a job. I couldn't believe how expensive everything was. It hit home when I ordered a

draft beer in a restaurant that cost me five bucks. The last time I'd ordered a draft, in 1984, it cost less than a dollar.

I contacted David Plant, a partner at Fish & Neave, a prestigious New York City law firm that specializes in intellectual property law. I had met David several years before in Sing Sing when I was in the seminary program. David and other members of his church visited regularly, and he'd told me to contact him when I got out. He commented that my skills as a jailhouse lawyer might translate into a paralegal position at his firm. I was nervous, but I called.

"Come to my office," he said. "We'll talk." His office was located on the 50th floor of a midtown skyscraper, directly across from Radio City Music Hall. The view was unbelievable. When I went to the men's room, I stood at the urinal for several minutes trying to figure out how to flush it. David walked in and saw me struggling. "Tony, just step back," he said. I did and stared in awe as the urinal flushed by itself.

Life was so different. The technological advances that occurred while I was locked up astonished me. David had arranged a meeting for me with the director of the paralegal department, who graciously took me on a tour of the firm. The next week I was hired and assigned to an office with two female paralegals, Ebony Cotton and Mimi Head. Mimi was a character. She was a right-wing Republican from upstate New York with little sympathy for drug offenders. It didn't surprise me when I found out that her father, a police officer, had run a background check on me. After a while, we became friends, but the incident showed me the power of the ex-con label.

In my spare time, I volunteered with various activist groups who regularly visited the State Capitol to advocate for repeal of the Rockefeller drug laws. We'd make the three-hour drive and meet with whichever legislators would listen to us. I remember once going with Robert Gangi, director of the Correctional Association, and a group of articulate ex-cons he'd lined up to speak with members of the New York State Legislature. The reality of politics smacked me in the face, when during the meeting a politician said that while he knew that drug law reform and rehabilitation were necessary and right, he didn't "want to

look soft on criminals." It made me furious. A bunch of ex-cons jumped in, arguing that prisoners would only come out like animals if the state continued on its punitive path and cut needed programs. The Assemblyman interrupted him with a wave of his hand. "We all understand that," he said, "but the Democrats just lost three seats in the House and we attribute it to appearing soft on crime. We can't afford to lose any more seats!"

"So that means that change will never occur," I shot back. "You politicians are more concerned with your careers than implementing changes that would make the system work better." He shrugged and didn't reply. After several equally dismal meetings, I knew that I was wasting my time. Trying to convince politicians who were more concerned about keeping their jobs than doing what was right was hopeless. I realized that the only way to change the laws was to change public opinion, thereby influencing politicians.

CHAPTER 14

So Close Yet So Far

JUNE 6, 1997. The sun gleamed down on the surface of the water as I looked across the river from the window of the train. It was a familiar sight, but it felt different seeing the Hudson River from inside a train instead of inside the prison. The surrounding mountains looked even more beautiful than I'd remembered. When I was in prison, I used them as a calendar to mark the changing of the seasons. I felt most inspired in springtime, when the emerald foliage emerged from the winter sleep.

As the train grew nearer to the prison, haunting memories flooded my mind. My body became tense, and I gripped the edge of the seat to steady myself. It was a familiar feeling. My entire body tightened as if in a vise. The fear was still there. I closed my eyes and began to pray, wishing that the fear would pass. In less than an hour, I would be on national TV. I had to relax.

"Ossining!" the conductor announced. I opened my eyes and inhaled deeply. "You're not a prisoner anymore, Tony," I told myself. "You can do this." I forced myself to exit the train. It would have been so easy to turn back. I searched for a cab at the taxi stand at the end of the platform. My eyes traveled up the hill to the hulk of the prison above the river. The day was my forty-second birthday, almost five months after my release. I had struggled with my identity. My direction in life was unclear until I spoke at Spottford Correctional Facility for

youth in front of an audience of ten- to fifteen-year-old boys and girls dressed in prison uniforms. They were being molded into becoming victims of the prison industrial complex. It was then I decided to use my story as a vehicle to become an agent of change and transformation. It was a perfect opportunity to educate the public about the system.

I was there to be interviewed by C-Span, which was doing a show on prison reform in the 20th century. It was a special feature retracing the journey of Alexis de Toqueville, a French aristocrat who came to America in 1820 to study the American penitentiary. Back then, the concept of the penitentiary, a place where convicts would be reformed through silence, work and prayer, was a progressive concept. Before the advent of the prison, most criminals were simply tortured or killed. In keeping with de Tocqueville's itinerary, C-Span's first stop was Sing Sing. On the perimeter of the prison, they'd set up a mobile studio in a big yellow bus chock-full of high-tech equipment. Truth be told, I'd never even heard of C-Span when they contacted me. I thought it was some mom and pop cable show. The satellite dish and TV cameras, even on the roof of a nearby house, told me otherwise.

I knocked on the door of the bus and the producer came out. He introduced me to his assistant and quickly reviewed the format of the show. I would comment on various footage from the prison that they'd shot earlier that day and answer questions from the host, Brian Lamb, who'd be linked in from Washington, D.C.

"Sound good?" the producer asked. I nodded tentatively. "Great! Glad to have you on board," he said in a tone too cheerful for the surroundings.

I thought that was it, but then he continued. "Now, accompanying you on air will be James Gondles, executive director of the American Correctional Association." I knew Gondles. He was an ex-sheriff and head honcho of an agency that cons loved to hate. "You will be debating him on various aspects of penal reform," the producer said.

Great, I thought. Here I am on parole, on the grounds of the prison that released me less than six months ago, on my goddamned birthday for that matter, debating an ex-sheriff about prison reform. What could be worse? The answer to that question would come shortly.

The producer gave me fifteen minutes to collect myself. Since it was a warm spring evening, I decided to pay a visit to my old home. I could see the guard tower about fifty yards away. I stared, and slowly walked toward it.

The grounds surrounding the prison were desolate, not a civilian or guard in sight. The night air was quiet and still. The prison loomed eerily ahead. I stopped at the jagged rock pile at the base of the granite wall enclosing the prison. Parts of the wall looked as though they had been carved from the rock itself. I faced the mighty guard tower and strained to detect any movement inside. Nothing, not even the shadow of a rifle.

Slowly, I removed a small camera from my jacket pocket. I raised my arm and was about to snap a photo when a voice from the sky bellowed: "Drop the camera! No pictures allowed!"

It echoed against the rocks, sending a chill up my spine. I felt the adrenaline rip through my veins. Suddenly, my eyes made contact with the guard in the tower. He was watching me through a pair of binoculars. I stared at him. He stared back. A confrontation! As we locked in position, my mind drifted back to the days when I was ordered to do almost everything. To eat, to sleep, to stop "disgracing myself in front of other visitors" when I'd committed the "violation" of kissing a woman after seven years without affection. My fear turned to anger. To hell with it, I thought. I raised my arm, camera in hand and ready to shoot, when all of a sudden I saw the guard respond in kind. He leapt from his post in a move for his rifle. Just as his body flashed before my eyes, I clicked. For added measure, I proudly held up my middle finger. And then I ran.

The last I saw, he was heading for his rifle. I remembered a time in the yard when the guards used their rifles to break up a fight, how the sharp crack of gunfire tore through the blue sky, sending seagulls into a twirling frenzy. The tower guard was trained for moments like this and he would be justified for shooting at me. After all, I was an ex-prisoner on facility grounds, who had just breached security by taking a photo when I'd been ordered to drop the camera.

I ran as fast as I could toward the bus, crouching and ducking behind parked cars along the way. I reached the door and pounded with my fist. "Quick! Open up! They're after me!" I yelled. A good thirty seconds passed before the door swung open. I leapt up the stairs and told the producer what happened. "Any moment the guard's gonna call for backup," I said, gasping for breath. And no sooner did I utter those words than a corrections van raced by the studio.

The van circled the area where I'd stood just minutes before. This is it, I thought. They're coming to get me. At a minimum, my parole officer would violate me and I'd spend months in Westchester County Jail fighting for my freedom—again. I thought of the look on David Plant's face, the partner at Fish & Neave who'd given me a job. Sitting on the black leather couch in the studio on wheels, I lowered my head and prayed. "Please, God, don't let me go back."

"They're gone!" the assistant said. They'd circled the lot for about ten minutes and then left. They never even checked the bus. I was relieved and invigorated, ready to go on national television to tell the world my story.

The story I would tell that night was a story I've told hundreds of times since and will continue to tell until the Rockefeller drug laws are repealed. My travels have taken me to Albany dozens of times, to Washington, D.C. and the steps of City Hall. I've met with the Governor who granted me clemency. I learned to channel my anger into activism. My appearance on C-Span on the night of my birthday, when I feared losing my freedom once again, led to a fortuitous partnership.

A viewer named Randy Credico was watching and contacted me after the show. Randy is as fierce a fighter in the war on drugs as he is in his capacity as director of the William Moses Kunstler Fund for Racial Justice. Together, we co-founded the activist group, Mothers of the New York Disappeared, named for the thousands of mothers and family members from New York's poorest neighborhoods whose relatives have disappeared behind prison walls. The idea was based on the Argentina Mothers of the Disappeared, who had fought for over twenty-

seven years against a dictatorship that murdered nearly 30,000 people during its reign of terror between 1976 and 1984.

Our group, Mothers of the New York Disappeared, changed the way the war on drugs was fought in New York by putting a human face on the issue. We achieved this by generating tremendous publicity from weekly protests that we'd stage in Rockefeller Center, holding up pictures of family members who'd been swallowed up by the drug laws. We attracted judges, students, politicians, religious leaders, and even the granddaughter of Nelson Rockefeller to the fight. Our efforts helped change public opinion. A recent New York Times poll showed that 87% of New Yorkers support reform. Yet the drug laws remain unchanged.

Out of the mix, one courageous politician emerged: Assemblyman Jeffrion Aubry of Queens. Despite tremendous in-party pressure to soften his stance, Jeff Aubry has stood firm on a bill he introduced in the Assembly calling for total repeal of the Rockefeller drug laws. He refuses to accept the Governor's lukewarm proposals, none of which contain the most critical component of restoring discretionary power to judges. Prosecutors still control the game, and their power goes unchecked. This is not a hallmark of democracy.

As this book goes to press, there are over 17,000 drug offenders locked up in New York prisons. In 1973, the state's total inmate population was only 12,500. It cost New York approximately $2 billion to construct the prisons to house convicted drug offenders. The operating expense for confining them comes to nearly $590 million a year. Since 1982 thirty-three prisons have been built in primarily upstate rural Republican districts, filling them with non-violent drug offenders. The greatest supporters of the Rockefeller Drug Laws have been the District Attorneys who live and die by their rates of conviction.

The most sinister aspect of the government's war on drugs has been the institutional racism they perpetuate. Despite government research that consistently shows that the majority of people who use and sell drugs are white, fully 94% of the inmates in New York prisons for the sale or possession of drugs are African-American or Latino. To put a

finer point on it, the incarceration rate for white males in New York is 565 per 100,000. For black men, it is 3,525 per 100,000. New York locks up black people at a higher rate today than South Africa did at the height of apartheid.

I had the opportunity to meet Governor Pataki in 2002 during a special session he held with the Mothers of the New York Disappeared to garner support for his version of drug law reform. His bill would grant relief to a select group of offenders but it fell short of true reform. He complained that the Democrat-controlled Assembly was holding our loved ones hostage by blocking his bill as they waited for full-scale reform. We were faced with a moral dilemma: Should we support the Governor and free some of our loved ones, while leaving the worst part of the laws in tact, only to incarcerate future generations, or would we hold out for true reform?

The mood in the room was tense. Randy Credico called on the mother of a young man serving a fifteen-year-to-life sentence for a first-time drug conviction. She was dying of cancer, too weak to visit her son, and pleaded with the Governor to allow them to spend their final days together at home. One story was more pitiful than the next. The Governor seemed genuinely saddened. Yet, I thought, if he really wanted to change the laws, he would have—with a stroke of his pen. I raised my hand to comment.

"Governor Pataki," I started, "I want to thank you for granting me my freedom. I would also like to thank you for granting clemency to three other individuals who are here with us today. Finally, I want to applaud you for being the first governor in twenty-nine years to openly call for reform.

"I share your concern for the nonviolent offenders who have already served lengthy sentences and are ready to reenter society but cannot due to the mandatory minimums required under the Rockefeller drug laws.

"However," I said, "we have met with Sheldon Silver, Speaker of the Assembly, and he has assured us that would not pass your legislation. So we ask, if you truly want to help those held hostage by politics, can you use your powers of executive clemency to perform a rescue mission?"

The governor looked at me like I was out of my mind to ask such a request. He responded that executive clemency was used only in extraordinary circumstances. His office would continue to examine special cases and grant clemency to those who merited it. It was a polite way of saying no. But inside, I knew that he would not risk his political career for us. We walked out not supporting the governor's proposed legislation. Immediately after the meeting, Pataki's office sent out a press release thanking us for meeting with him and blaming the legislature for the quagmire. It was a way of spinning the unsuccessful meeting into positive press for the governor. In his seven years of office, Pataki had become an expert at dancing around the issues.

Six months later, after Governor Pataki was soundly re-elected, he announced his latest proposal. It was packaged as an effort to help close the state's $10 billion budget gap. The picture in *The New York Post* showed the governor holding a yellow Monopoly "Get out of jail free" card. He was proposing a rescue mission: early release for 800 nonviolent drug law offenders. It was a token gesture that would leave over 17,000 drug offenders in prison and the worst feature of the laws intact, namely the absence of judicial discretion in sentencing offenders to prison. The governor's deal was unacceptable. In my years of protesting New York's drug laws, I was used to pushing boulders uphill, but now it seemed we had hit a plateau. Then suddenly, on February 24, 2003, opportunity knocked and we were able to pull off a move that revolutionized the movement.

I was at my desk when my computer beeped, signaling that someone had signed the guest book on my website, 15yearstolife.com. I decided to set up the website to make my artwork and information about the Rockefeller drug laws available to millions of people on the World Wide Web. The email was from a woman named Ashley at AndrewCuomo.com. No message was included, which was odd. Usually, I would get a comment about my artwork or the drug laws, but all I knew was that someone from the Cuomo campaign had logged on to my website. I was curious and wrote back. I mentioned in my email that I had helped Andrew Cuomo put together a press conference the

year before and that he'd displayed my self-portrait *15 Years to Life* at the conference to promote his platform on drug law repeal in his bid for governor of New York State.

Ashley wrote back and told me she was working for Cuomo and researching the Rockefeller drug laws. I decided to take a chance and ask if Cuomo would speak at our rally on May 8, the 30th anniversary of the laws. She said he was extremely busy but she'd check. The next day, an aide called and said that Cuomo would be delighted to speak but he wanted to do more to raise the visibility of the campaign to repeal the drug laws. He offered to bring Russell Simmons, the famous hip-hop mogul, into the movement. I knew of Simmons' history as an activist. He had founded the Hip Hop Action Summit Network, an organization that used hip-hop to bring about social change. I knew that Simmons could organize thousands of people to join the movement for repeal. At the May 8 press conference at the Hyatt Hotel in midtown Manhattan, Simmons, Cuomo, and the New York Mothers of the Disappeared announced the "Countdown to Fairness." Simmons gave the governor thirty days to repeal the drug laws or he would organize a massive protest, promising to bring 100,000 people to City Hall on June 4. On the stage with him was an amazing array of celebrities: Susan Sarandon, Tim Robbins, Jay-Z., P. Diddy and many others.

A flood of publicity ensued, including public service announcements on major radio stations by leading rappers urging the hip-hop community to attend the June 4 rally. The pressure began to mount as Governor Pataki's approval rating dropped to an all-time low of 37 percent, mainly due to the bad economy. Again, Pataki sent Criminal Justice Coordinator Chauncey Parker to meet with Russell Simmons to try to stop the Countdown to Fairness, but Simmons wouldn't budge. Meanwhile, the coalition grew as organizations such as the NAACP, the National Urban League and the ACLU signed on and turned out for what became the largest drug war protest in history.

Over 50,000 people showed up despite the cold and rainy weather. A huge concert-type stage was erected, a far cry from our usual makeshift stages of plywood set on the back of a pickup truck and a

barely audible sound system. Now, thanks to Simmons and Cuomo, we had state-of-the-art equipment and massive, 100-foot video screens flashing images from the stage to the thousands of protesters that flooded lower Broadway. Faces from the stage included such media giants as Mariah Carey, Jay-Z. and others. It was amazing. The press turnout was bigger than I'd ever seen. I was on a high the entire time, convinced that the unprecedented event would finally compel the governor to repeal the Rockefeller drug laws. I was wrong.

Over the next two weeks, Simmons decided to relax his position on repeal and work with the governor on reform. Heated debates within the coalition erupted, pitting the moderates against the hard-line activists. As activists, we wanted nothing short of repeal of the laws and full discretion restored to the judges. Although Simmons was truly concerned with saving lives, as a businessman he also wanted a deal. On June 19th, Russell Simmons and his staff flew to Albany to meet with the governor. He was accompanied by his advisor, Debbra Small from the Drug Policy Alliance, a major policy player in the war on drugs in the United States. It was the last day of the legislative season. An historic, seven-hour meeting took place as Governor Pataki, Senate leader Joseph Bruno and Assembly leader Sheldon Silver sat down with Russell Simmons to hammer out a drug law deal. At midnight, Randy Credico called me from Tulia, Texas, where we were fighting to free the "Tulia 46," forty-six men and women caught in a racist drug sting initiated by a corrupt narcotics officer that led to nearly 10% of the town's black population behind bars. Randy said it looked like a bad deal was likely and the chance of full-scale repeal was slim to none. We panicked. Our dream had become a nightmare. Would watered-down reform become the change we had worked so hard for?

The next morning, every major New York paper reported the outcome of the meeting. "No Deal," said the *New York Daily News*. In fact, not only was no deal made, but a controversy erupted over Simmons' infiltration into New York's notoriously cloaked back-room politics. "The nation has plenty of strange state legislatures," wrote *The New York Times*, "but lately New York's seems to be edging near

the head of the pack. How many, for instance, have called on a hip-hop mogul to negotiate one of the most important reforms in their state's history?"

Several days later, Cuomo, Simmons and the Mothers of the New York Disappeared all received letters from the State Lobbying Commission threatening investigations and heavy fines for alleged violations of lobbying expenditures. This was a form of political intimidation so others would not get involved in the struggle. Meanwhile, state legislators were furious that they were unable to push through their last-minute deals because the governor spent the final hours of the legislative session behind closed doors with Simmons trying to negotiate drug law reform that never materialized.

In the end, although we didn't win repeal, we didn't lose with reform. More importantly, we showed the governor that we wouldn't back down in our fight to free the nearly 17,000 nonviolent drug offenders in New York state prisons and reunite them with their families. We showed them once again that our spirit was strong and we would fight until the end for repeal. The struggle continues.

Epilogue

ON FEBRUARY 5, 2004 Anthony Papa and group members of the Mothers of the New York Disappeared traveled to Buenos Aires, Argentina, to pay homage to the Argentinian Mothers who had inspired them. An historic meeting took place between two groups fighting for social justice. The Argentinian women of the Madres de Plaza de Mayo Linea Fundadora agreed that the Rockefeller Drug Laws of New York State had to be abolished. Too many men and women had "disappeared" because of these draconian laws, just as in Argentina where 30,000 family members had also disappeared because of its dictatorship. A letter was written by the Madres to Governor George Pataki urging him to change the laws. For both groups of mothers, worlds apart, they are connected by their respective struggles. One day it is hoped that both groups find peace when justice is found.

Acknowledgements

For Lucy, Luciana, Anthony Jr., Stephanie, Angela, Connie and Joe

To be successful in advocating positive change, one must keep pushing the idea out to the public. My job as an artist/activist is to create ways to allow this issue to become thematic and memorable, akin to a moving poem or a haunting melody. I want to thank the many friends and associates who have helped me carry out this concept.

Noah Lukeman, my agent, for not giving up on my dream, and through sheer perseverance and determination getting the job done. Adam Parfrey, my publisher, for bringing this story out to the world. Jennifer Wynn, a great writer and friend whose insight on criminal justice issues were very important in our collaboration. Cris Cozzone, a great photographer, for his help in getting me started with this project; Fielding Dawson, my writing teacher and friend; Randy Credico, a gifted political comedian and the best organizer in the United States; The William Kunstler Fund for Racial Justice and the fine work it has done to fight for social change through the efforts of Marge Ratner Kunstler and her daughters Emily and Sara <Kunstler.org>; the members of Mothers of the NY Disappeared, which are too many to all name but I will mention a few—Julie Colon, Teresa Aviles, Regina Stevens, Wand Best, Evelen Sanchez, Ron Gant, Gary Goodrow, Mrs. Arenas, Mrs. Hernandez, Mrs. Gorden; Rockefeller Drug War survivors

Veronica Flournoy <ronifeller.com>; Jan Warren; Terrance Stevens (Director of <InArmsReach.org>); Elaine Bartlett (Director, of <LifeonTheOutside.com>); Judge Jerome Marks for his friendship and outstanding activism responsible in helping several individuals to obtain executive clemency; Al "Grandpa" Lewis, one of our strongest supporters that has been with us since the beginning of our struggle.

Jason Flom, Peter Greer and Tom Galisano: philanthropists that have given generous support; Ashly Cotton of the Andrew Cuomo Campaign; Ben Chavis of <hiphopsummitactionnetwork.org>; Julie Stewart and Monica Pratt of Families Against Mandatory Minimum Sentencing <FAMM.org>; Nora Callahan of <november.org>; Mary Elizabeth Fitzegerald and Julie Mormando of <justiceworks.org>; Tony Newman, one of my best friends and an amazing "spin wizard" who is the communications director of Drug Policy Alliance <drugpolicy.org>; DPA leader Ethan Nadelman who does outstanding work in the field along with Mat Briggs and Michael Blaine <realreform2004.org>; Anita Martin and Paul Samuels of Legal Action Center <lac.org>; Deborah Small of Breaking The Chains <breakchains.org>, Tom and Polly Haines, along with Paul Bennett of PRDI; Joann Page, Darcy Hirsh and David Rothenberg of <FortuneSociety.org> and the many other organizations across the United States that have been outspoken in this struggle.

WBAI radio <wbai.org> and its program director Bernard White, and Amy Goodman of <DemocracyNow.org> for helping me get my story told while I was in prison; individuals in the media who continue to report on this issue, including Jennifer Gonnerman of the *Village Voice*, and author of *Life on the Outside*; Ellis Hennican of *Newsday*; Bob Herbert and Al Baker of *The New York Times*; Juan Gonzalez of the *Daily News*; Catherine Crier of Court TV along with her producer Cole Thompson; Charles Grodin; David Borden of <stopthedrugwar.org >; Don Hazen of <alternet.org>; Preston Peet of <Drugwar.org>.

Reverend Bill Webber, my spiritual father at Exodus Transitional Community <etcny.org>, along with its director Julio Medina; Jazz Hayden, Director of NYC Unlock The Block <demos-usa.org; Bob & Nancy Steed;

Karen and Matt Shriver; Mike and Emily Graziani; Chris and Charlie Brustman Jr.; Tanya Norwood; Roberto Gonzales, Melissa McNeel; Tom Eddie; Roland Acevedo; Dr. Sam Schwartz; Dr. Joe Victor; Pauline & Al Rodi; Leo Blohar; Marcio Leuzzi; Edda Adami; Valerie Vande Panne; Vinny Quiles; Irene Webb; Jodi Peikoff; Barrett Stuart of BS Productions, and of course all of those who have endorsed this book.

WAR IS A RACKET

The Antiwar Classic by America's Most Decorated General

By General Smedley D. Butler • Introduction by Adam Parfrey

General Butler's notorious 1933 speech, "War is a Racket," excoriates "the small inside group" that "knows what the racket is all about." The Feral House edition provides more rare anti-imperialist screeds and an exposé of a Congressional inquiry into Butler's whistleblowing of a coup d'état attempt by big business against Franklin Delano Roosevelt.

5 x 8 • 160 pages • paperback original • ISBN: 0-922915-86-5 • $9.95

SNITCH CULTURE

How Citizens Are Turned into the Eyes and Ears of the State

By Jim Redden

"Explained away as a response to the 'War on Drugs' and 'teen murders,' we now have a high-tech surveillance system monitoring every man, woman and child. Jim Redden has written a scary, fascinating, and important examination of the pervasive use and abuse of informants in the United States." —Katherine Dunn

"Very spooky and very highly recommended."—Paul Lappen, *Midwest Book Review*

5½ x 8½ • 235 pages • paperback • ISBN: 0-922915-63-6 • $14.95

ERIK JAN HANUSSEN

Hitler's Jewish Clairvoyant

By Mel Gordon

In the early '30s, Hanussen founded a tabloid publishing empire that blended occult belief with radical politics. In 1932, he predicted that Adolf Hitler, then reeling from a series of electoral setbacks, would soon rule Germany as an unfettered and extralegal dictator. Hanussen's relationship with the National Socialists ended when German Communist journalists revealed the Berlin clairvoyant's Jewish origins. He was murdered in April 1933.

Cloth original • 6 x 9 • extensively illustrated • 296 pages • ISBN: 0-922915-68-7 • $24.95

TO ORDER FROM FERAL HOUSE:

Individuals: Send check or money order to Feral House, P.O. Box 39910, Los Angeles CA 90039, USA. For credit card orders: call (800) 967-7885 or fax your info to (323) 666-3330. CA residents please add 8.25% sales tax. U.S. shipping: add $4.50 for first item, $2 each additional item. Shipping to Canada and Mexico: add $9 for first item, $6 each additional item. Other countries: add $11 for first item, $9 each additional item. Non-U.S. originated orders must include international money order or check for U.S. funds drawn on a U.S. bank. We are sorry, but we cannot process non-U.S. credit cards.